Dallas Museum of Art
Walker Art Center, Minneapolis

Jim Hodges:
Give More Than
You Take

Edited by Jeffrey Grove and Olga Viso
with texts by Bill Arning, Susan Griffin,
Jeffrey Grove, Helen Molesworth, and Olga Viso

Published on the occasion of the exhibition *Jim Hodges: Give More Than You Take*, co-curated by Jeffrey Grove and Olga Viso and co-organized by the Dallas Museum of Art and the Walker Art Center.

Dallas Museum of Art
Dallas, Texas
October 6, 2013–January 12, 2014

Walker Art Center
Minneapolis, Minnesota
February 15–May 11, 2014

Institute of Contemporary Art
Boston, Massachusetts
June 5–September 1, 2014

Hammer Museum
Los Angeles, California
October 5, 2014–January 17, 2015

Major support for the exhibition is provided by Amanda and Glenn Fuhrman, John and Amy Phelan, Cindy and Howard Rachofsky, and The Andy Warhol Foundation for the Visual Arts. Additional support is generously provided by the Ames Family Foundation, Anonymous in honor of Olga Viso, the Chadwick-Loher Foundation/ John and Arlene Dayton, Dirk Denison and David Salkin, Ann Hatch, Karen and Ken Heithoff, Dean Johnson and James Van Damme, Jeanne and Michael Klein, Agnes and Edward Lee, Toby Devan Lewis, Martha MacMillan, Michael J. Peterman and David A. Wilson, Pizzuti Collection, Donna and Jim Pohlad, Dallas Price-Van Breda, Penny Pritzker and Bryan Traubert, and Robin Wright and Ian Reeves.

Major support for the catalogue is provided by

Sotheby's

First edition © 2013 Dallas Museum of Art/Walker Art Center

Available through D.A.P./Distributed Art Publishers, 155 Sixth Avenue, New York, NY 10013. www.artbook.com

Library of Congress Cataloging-in-Publication Data

Jim Hodges: give more than you take / Edited by Jeffrey Grove and Olga Viso; with texts by Bill Arning, Susan Griffin, Jeffrey Grove, Helen Molesworth, and Olga Viso.
 pages cm
"Dallas Museum of Art, Dallas, Texas, October 6, 2013–January 12, 2014, Walker Art Center, Minneapolis, Minnesota, February 15–May 11, 2014, Institute of Contemporary Art, Boston, Massachusetts, June 5–September 1, 2014, Hammer Museum, Los Angeles, California, October 5, 2014–January 17, 2015."
 Includes bibliographical references and index.
 ISBN 978-1-935963-02-8 (alk. paper)
1. Hodges, Jim, 1957-—Exhibitions. I. Grove, Jeffrey D., editor of compilation. II. Viso, Olga M., 1966- editor of compilation. III. Hodges, Jim, 1957- Works. Selections. IV. Dallas Museum of Art. V. Walker Art Center. VI. Institute of Contemporary Art (Boston, Mass.) VII. Hammer Museum.
 N6537.H564A4 2013
 709.2–dc23
 2013027949

Production Credits
Assistant curator: Eric Crosby
Design director: Emmet Byrne
Editor: Michelle Piranio
Editorial assistance: Eric Crosby, Eric Zeidler
Production manager: Dylan Cole
Imaging specialist: Greg Beckel
Imaging assistance: Kayla Kern
Indexer: Candace Hyatt

Printed and bound in Italy by Gruppo Editoriale Zanardi

Front and back covers:
Jim Hodges *and still this* (details) 2005–2008 23.5k and 24k gold with Beva adhesive on gessoed linen 89 x 200 x 185 in. (226.1 x 508 x 469.9 cm) overall The Rachofsky Collection and the Dallas Museum of Art through the DMA/ amfAR Benefit Auction Fund Photos: Brad Flowers; courtesy Dallas Museum of Art

Front papers (in order of appearance):
Jim Hodges *Untitled (scratched sky I–IX)* 2011 scratched and incised archival pigment prints 80 x 59 1/2 in. (203.2 x 151.1 cm) each I–II, V–VII, IX: Courtesy Gladstone Gallery, New York and Brussels
III: Collection Marilyn and Larry Fields
IV: Collection Gayle and Paul Stoffel
VIII: Private collection
Photos: Ronald Amstutz

Jim Hodges *Untitled (scratched sky X)* 2012 scratched and incised archival pigment print 80 x 59 1/2 in. (203.2 x 151.1 cm) Collection Howard and Donna Stone Photo: David Regen; courtesy Gladstone Gallery

Nos. 1–4:
Jim Hodges *ghost* (details) 2008 glass sculpture in multiple parts 35 x 22 x 22 in. (88.9 x 55.9 x 55.9 cm) overall Private collection, London Photos: Stephen White; courtesy Stephen Friedman Gallery, London

Back papers:
Jim Hodges *that day (blue)* 2009 pastel, saliva on paper in ten parts 30 1/4 x 22 3/4 in. (76.8 x 57.8 cm) each Collection Barbara Gladstone Photos: David Regen; courtesy Gladstone Gallery

Contents

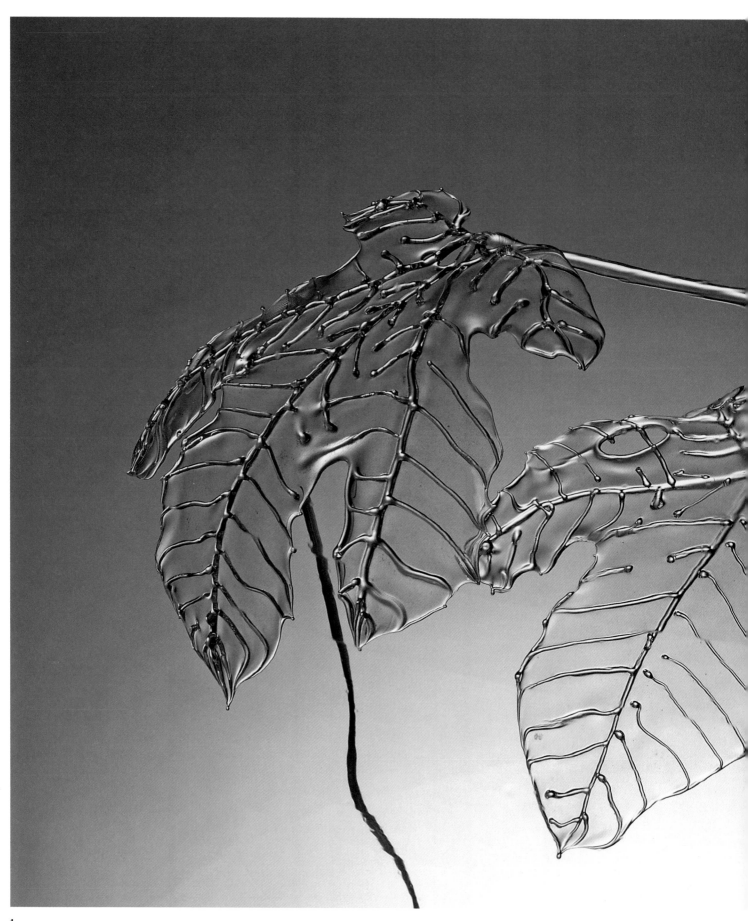

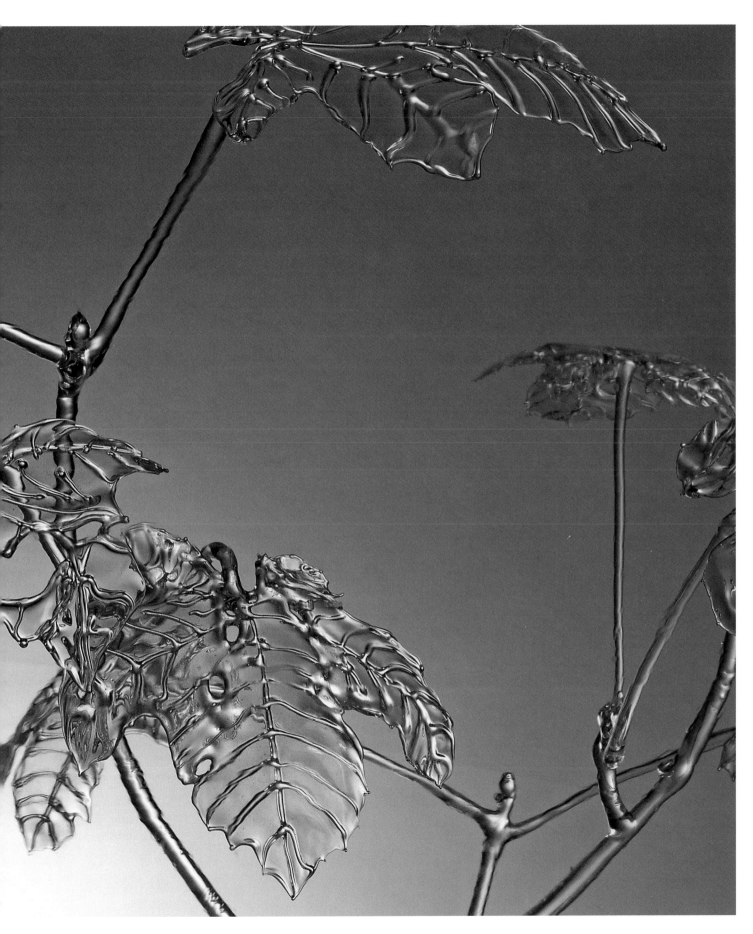

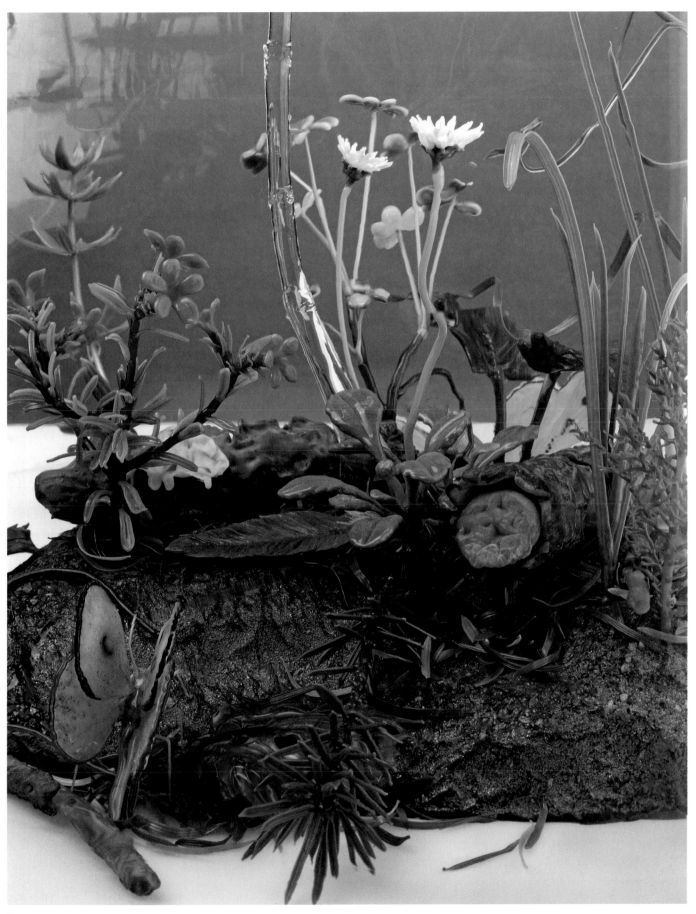

Foreword

With quiet determination, Jim Hodges has over the past twenty-five years produced one of the most affective bodies of sculpture and installation work of any artist of his generation. Although his art has been exhibited widely in group exhibitions and solo projects in the United States and Europe since the early 1990s—and particular facets of his work have been the subject of smaller exhibitions and publications—there has not yet been a comprehensive survey in this country that fully reveals the breadth and complexity of Hodges's sensibility. Similarly, there has not been a significant scholarly publication produced that positions his art critically within the context of its time and broader contemporary artistic practice.

Co-organized by the Dallas Museum of Art and the Walker Art Center, *Jim Hodges: Give More Than You Take* provides this much-needed assessment and offers unique insight into the artist's thoughtful and attuned vision. Experience and materiality have been defining subjects of Hodges's explorations in all media since the beginning of his career. Convening modest objects that reveal his deft understanding of how simple gestures can inform material meaning alongside room-size installations that transform the viewer and the environment through sensory experience, *Jim Hodges: Give More Than You Take* allows—for the first time—a more complex appreciation of his original vision and consistent methodology.

Born in Spokane, Washington, in 1957, Hodges came of age in New York City in the mid-1980s. As a student at Pratt Institute, he began his explorations in painting, a medium he eschewed early on in favor of a more process-based and drawing-centered practice. This was a critical time in the country's culture wars when many artists became activists, creating artworks as statements in the discussion around identity politics, artistic censorship, political repression, and the AIDS crisis. Much of Hodges's early work emerged against this backdrop and has often been read through the lens of this history. Indeed, his signature use of floral motifs and ephemeral materials in works of the 1990s connects his objects to the art historical traditions of *vanitas* and *memento mori*, intended to remind viewers of the inevitability of death and the passage of time.

Yet, throughout his career, Hodges's aesthetic has consistently embraced metaphors related to nature, vibrant color, and optimistic light, as well as more romantic notions such as love and beauty, two compelling themes from which he has never shied. His devout attention to the emotional interplay between viewer and object is a distinctive characteristic of his singular vision, one that does not waiver but instead continues to flourish and mature, as evidenced by the ambitious new work that debuts in the current exhibition.

What distinguishes Hodges as a pioneer in the 1990s is the unassuming manner in which he ushered in a new visual language of generosity and restraint amidst the more acerbic and didactic ethos of the time. Along with his close friend and colleague Felix Gonzalez-Torres, Hodges was a persuasive voice among a generation of artists whose work marked a determined shift in the contemporary art world of the mid-1990s. Mining quotidian objects and the antinomies of art and activism, Hodges and Gonzalez-Torres proposed a more poetic mode of expression in which form and content twined with beauty and politics, establishing a potent equivalence.

Hodges's easy adoption of such themes and subjects confused and confounded critics of the period; many did not appreciate his understated and measured resistance to polemic, though others did recognize the work's more subversive potential. As Bill Arning and Helen Molesworth each persuasively argue in this volume, Hodges's unabashed embrace of sentiment was radical—a liberating gesture that emphatically brought the complexities of human nature and spaces of public and private contestation, particularly around the AIDS crisis, dramatically into the spotlight. We are grateful to Arning and Molesworth for their personal, eloquent, and highly nuanced articulations of this complex and deserving subject in texts that expand upon and challenge a limited public and critical understanding of Hodges's oeuvre to date. In addition, poet and essayist Susan Griffin contributes a sequence of stirring reflections inspired by Hodges's art and his experience-based practice; her poetic reveries and reminiscences offer an evocative model for approaching the work from personal experience.

We are grateful to co-curator Jeffrey Grove for his thoughtful and far-reaching essay, which provides essential documentation of Hodges's career, early development, and at times radical evolution. Grove evocatively contextualizes Hodges's art like never before, situating it against the broader cultural, art historical, and sociopolit-

ical backdrop of the 1980s and 1990s, as well as considering an eclectic range of key artistic and literary figures critical to Hodges's development, from Walt Whitman to Charles E. Burchfield to Paul Thek. Grove's contribution is complemented by Olga Viso's essay, which includes an insightful interview with the artist. The text examines, among other things, the transformative nature of Hodges's work, its engagement with the everyday, and the prevalence of literary corollaries. Together these writings illuminate Hodges's relationship to artists of his own generation and earlier ones, affirming the unique hybrid nature of his work in the face of prevailing artistic idioms.

Jim Hodges: Give More Than You Take is co-curated by Jeffrey Grove, senior curator of special projects and research at the Dallas Museum of Art, and Olga Viso, executive director at the Walker Art Center. We are immensely pleased to have partnered as institutional co-organizers of this timely and important survey. It was born of the friendship of the two curators with the artist, as well as with each other, and reveals their shared respect for Hodges, with whom both have had long independent working histories. Viso first worked with Hodges in the late 1990s as a curator at the Hirshhorn Museum and Sculpture Garden in Washington, DC. With then chief curator Neal Benezra she commissioned a new work for inclusion in the period survey *Regarding Beauty: A View of the Late Twentieth Century*. In Minneapolis, Hodges's *Untitled* boulders, acquired by the Walker in 2011, grace a prominent place on its campus. Grove first worked with Hodges in 2001 at the Cleveland Museum of Art. In Dallas, the Museum and the active private collecting community have worked in unison to bring together the largest group of Hodges's work anywhere in the world.

We are grateful to our exhibition tour partners, the Hammer Museum in Los Angeles and the Institute of Contemporary Art in Boston, for their participation in the four-city national tour. The Hammer's director Ann Philbin and senior curator Anne Ellegood were early champions of the exhibition, as were ICA Boston's director Jill Medvedow and chief curator Helen Molesworth. For their early, lead financial support of the exhibition, we are ever thankful to The Andy Warhol Foundation for the Visual Arts, especially president Joel Wachs and program officers Rachel Bers and James Bewley. In addi-

tion, many exhibition lenders, including the artist's deeply committed collecting community, were staunch supporters from the beginning, and we are immensely grateful in particular to Amanda and Glenn Fuhrman, John and Amy Phelan, and Cindy and Howard Rachofsky for significant leadership gifts early in the planning of the exhibition. Their generosity inspired a confederation of individuals and foundations to join them as supporters, and we are indebted to Jeanne and Michael Klein, Agnes and Edward Lee, and the Pizzuti Collection for their major contributions. We are also thankful for the very generous support of the Ames Family Foundation, an anonymous donor in honor of Olga Viso, the Chadwick-Loher Foundation/John and Arlene Dayton, Dirk Denison and David Salkin, Ann Hatch, Karen and Ken Heithoff, Dean Johnson and James Van Damme, Toby Devan Lewis, Martha MacMillan, Michael J. Peterman and David A. Wilson, Pizzuti Collection, Donna and Jim Pohlad, Dallas Price-Van Breda, Penny Pritzker and Bryan Traubert, and Robin Wright and Ian Reeves. Sotheby's supported the production of this striking publication, and we offer our thanks to Lisa Dennison, chairman, Sotheby's North and South America, and Nina Del Rio, senior vice president, director of museum services.

Finally, we are most grateful to Jim Hodges for his unwavering commitment to this project and his willingness to share of himself so generously with all of us through this exhibition.

Olga Viso
Executive Director
Walker Art Center

Maxwell L. Anderson
The Eugene McDermott Director
Dallas Museum of Art

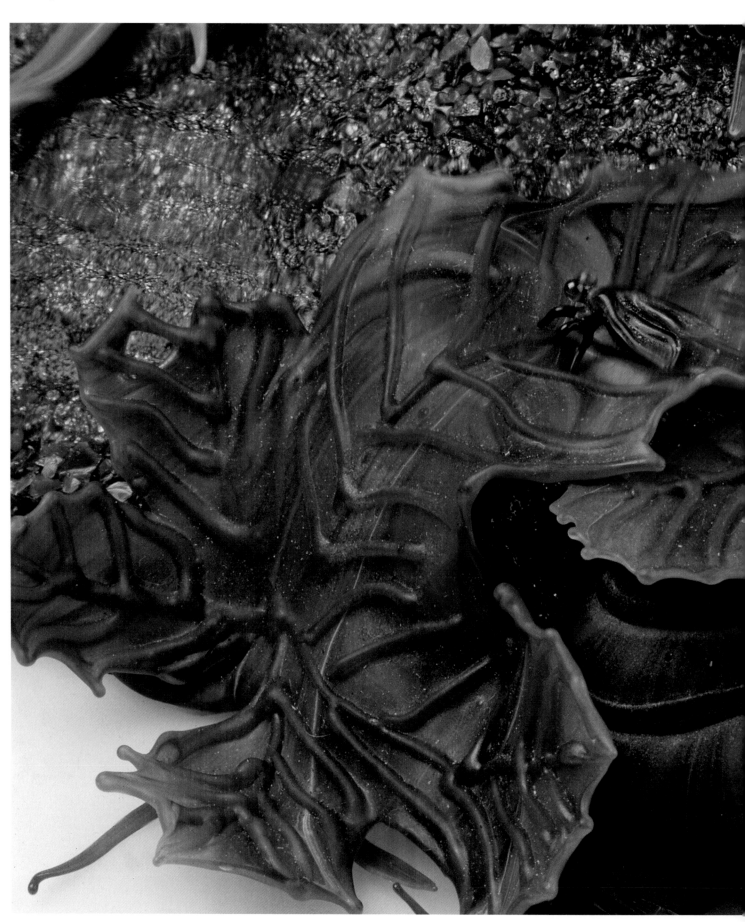

Acknowledgments

Jim Hodges's work inspires not just curators, collectors, critics, and supporters around the world, but also those closest to him. A testament to this reality is the stellar team that surrounds him in his studio. Our sincere appreciation and inestimable debts of gratitude go to Hodges's colleagues Lara Day, Jessie Henson, Carlos Marques da Cruz, and Eric Sharff for supporting the artist and us in bringing this project to fruition. In addition, the extraordinary galleries with which Hodges has worked over the years have partnered with us closely and diligently to ensure the success of this exhibition. We greatly value the support of Barbara Gladstone, as well as director Molly Epstein, at Gladstone Gallery, New York; Stephen Friedman, along with senior director David Hubbard and gallery manager Mary Tagg, at Stephen Friedman Gallery, London; and Anthony and Celeste Meier, as well as senior director Rebecca Camacho, at Anthony Meier Gallery, San Francisco. Carla Chammas, Richard Desroche, and Glenn McMillan of CRG Gallery, New York, gave the artist his first gallery exhibition in 1994 and have been consistent and stalwart champions of his work ever since. We appreciate their insight and friendship over the years.

Perhaps in part because of the artist's general affability, open nature, and aversion to self-promotion, the true range of Hodges's accomplishments is not well known (another reason this survey is so critically needed). A function of this condition is a certain misunderstanding related to his artistic production. Yes, he is careful and methodical in the creation of his art, and he does not hand over control of its production to an army of assistants. Hodges is, however, ambitious, and since 1987 he has created more than thirteen hundred original works of art. This made the challenge of selecting those to be included in the exhibition even more daunting, and we appreciate the understanding of all the artist's committed collectors. We must therefore extend our heartfelt thanks to the individual lenders who have generously agreed to part with their works for the length of the exhibition: Glenn and Debbie August; Adrienne and Peter Biberstein; Marilyn and Larry Fields; Mimi and Bud Floback; Annabel Fuhrman; Glenn and Amanda Fuhrman; Barbara and Michael Gamson; Andrea and Jim Gordon; Barbara Zomlefer Herzberg; Jim Hodges; Sheila and Bill Lambert; Lillian and Billy Mauer; Meryl Lyn and Charles Moss; Eileen Harris Norton; Marlene and David Persky; John and Amy Phelan; Penny Pritzker and Bryan Traubert; Jeff, Mary, and Martha Rathmanner; Heidi L. Steiger; Gayle and Paul Stoffel; Flavia and Guilherme Teixeira; James Van Damme; and Sharon and Michael Young. Our thanks also go to those individuals who have agreed to lend anonymously.

We are equally grateful to many lending institutions and organizations and their kind and cooperative staffs: Art Institute of Chicago; Cejas Art, Ltd., Miami Beach, Florida; Centre Pompidou, National Museum of Modern Art, Centre for Industrial Creation, Paris; Cranford Collection, London; CRG Gallery, New York; Fabric Workshop and Museum, Philadelphia; Stephen Friedman Gallery, London; Gladstone Gallery, New York and Brussels; High Museum of Art, Atlanta, Georgia; Anthony Meier Fine Arts, San Francisco; Pérez Art Museum Miami; Pizzuti Collection, Columbus, Ohio; Rachofsky Collection, Dallas; and Whitney Museum of American Art, New York. For their assistance in securing key loans we would also like to recognize Acquavella Galleries, New York; Dirk Denison; The FLAG Art Foundation, New York; McCabe Fine Art, Stockholm; Neal Meltzer Fine Art, New York; Allan Schwartzman; Marc Selwyn; and Zlot Buell + Associates, San Francisco.

From its inception in September 2009, this exhibition has been an equal collaboration between the two curators and the two institutions. We owe a great debt to Eric Crosby, assistant curator, visual arts, Walker Art Center, and Meg Smith, curatorial assistant for contemporary art, Dallas Museum of Art, for their significant administrative and curatorial contributions to this project. Both provided unflagging, cheerful, and crucial support in various areas of research and coordinated the multiple meetings, dueling schedules, and exhaustive logistics involved in such an undertaking. Meg also maintained the constantly evolving checklist and facilitated loan negotiations, while Eric prepared the well-researched and essential exhibition history and bibliography that appear in this volume, and was a critical partner in the organization of the exhibition and in overseeing the details of this publication and its design.

This beautiful publication was executed with compassion and flair by Emmet Byrne, design director at the Walker. Michelle Piranio edited the book with consideration and care. We are deeply grateful to each of them and to the writers who contributed moving essays and texts: Bill Arning, director, Contemporary Art Museum,

Houston; Helen Molesworth, Barbara Lee Chief Curator, Institute of Contemporary Art, Boston; and Susan Griffin, critically acclaimed poet, essayist, playwright, and screenwriter. We value each of these colleagues greatly for their support, dedication, and expertise in helping us realize this exhibition and publication.

Key individuals from both museums have also contributed in countless ways. On behalf of the Walker Art Center, we recognize the efforts of David Galligan, deputy director and chief operating officer; Darsie Alexander, chief curator; Andrew Blauvelt, chief of audience engagement and communications; Mary Polta, chief financial officer; Christopher Stevens, chief of advancement; Marla Stack, special projects fundraising director; Rob Sherer, annual fund director; Kerstin Beyer, associate director of membership; David Goldstein, associate director of visitor services; Leslie Friedlander, executive assistant to the director; Laurel Jensen, exhibitions administrator; Aimie Dukes and Ian Miller, administrative assistants; Dylan Cole, design studio manager; Pamela Johnson and Kathleen McLean, editors; Greg Beckel, senior imaging specialist; Gene Pittman, photographer; Barbara Economon, visual resources librarian; Ryan French, director of marketing and public relations; Paul Schmelzer, web editor; Meredith Kessler, assistant director, public relations; Jessica Rolland, assistant registrar for exhibitions; Cameron Zebrun, director, program services and his team; David Dick, carpentry shop supervisor; Sarah Schultz, director of education and curator of public practice; Ashley Duffalo, program manager, public and community programs; Courtney Gerber, associate director of school and tour programs; and Christina Alderman, assistant director, family and youth programs. We are especially grateful to Philip Bither, McGuire Senior Curator, performing arts, and Doug Benidt, associate curator, performing arts, for their invitation to Hodges to curate the Walker's Sound Horizon contemporary music series during the run of the exhibition in Minneapolis.

At the Dallas Museum of Art, staff, both former and current, worked diligently and thoughtfully to make this project possible. Maxwell L. Anderson, The Eugene McDermott Director, steadfastly supported this endeavor, and his predecessor, Bonnie Pitman, was the critical advocate for originating this exhibition with the Walker. Key staff supporting this project in Dallas also include Robert Stein, deputy director; Olivier Meslay, associate director of curatorial affairs and senior curator of European and American art and the Barbara Thomas Lemmon Curator of American Art; Ann Bergeron, associate director of external affairs, development and marketing; Tamara Wootton-Bonner, associate director of collections and exhibitions; Joni Wilson-Bigornia, exhibitions manager; Elizabeth Donnelly, exhibitions assistant; Jessica Harden, director of exhibition design; Reagan Duplisea, associate registrar, exhibitions; Gabriela Truly, director of collection management; John Lendvay, head preparator; Mike Hill, preparator; Chip Sims, head carpenter and shop manager; Jeff Guy, chief financial officer; Brenda Barry, controller; Elizabeth Wilcox, assistant controller; Jill Bernstein, director of public relations; Brooke Molinaroli, director of marketing; Kimberly Daniel, public relations specialist; Barbee Barber, director of visitor services; Mandy Engleman, director of creative services; Eric Zeidler, publications manager; Nicole Stutzman-Forbes, chair of learning initiatives and DMA League Director of Education; Stacey Lizotte, head of adult programs and multimedia services; Carolyn Bess, director of programs, education; and Alexander Unkovic, McDermott Curatorial Intern, 2012–2013.

From a personal perspective, we owe our respective partners, Clint Smith and Cameron Gainer, enormous thanks for their unconditional support. Our deepest gratitude is reserved for Jim Hodges, not simply for entrusting us with this exhibition, but also for choosing to trust us implicitly. In doing so, he allowed a high degree of access into previously undisclosed areas of his personal and professional lives. It resulted in a genuine collaboration that we are delighted to share.

Jeffrey Grove
Senior Curator of Special Projects & Research
Dallas Museum of Art

Olga Viso
Executive Director
Walker Art Center

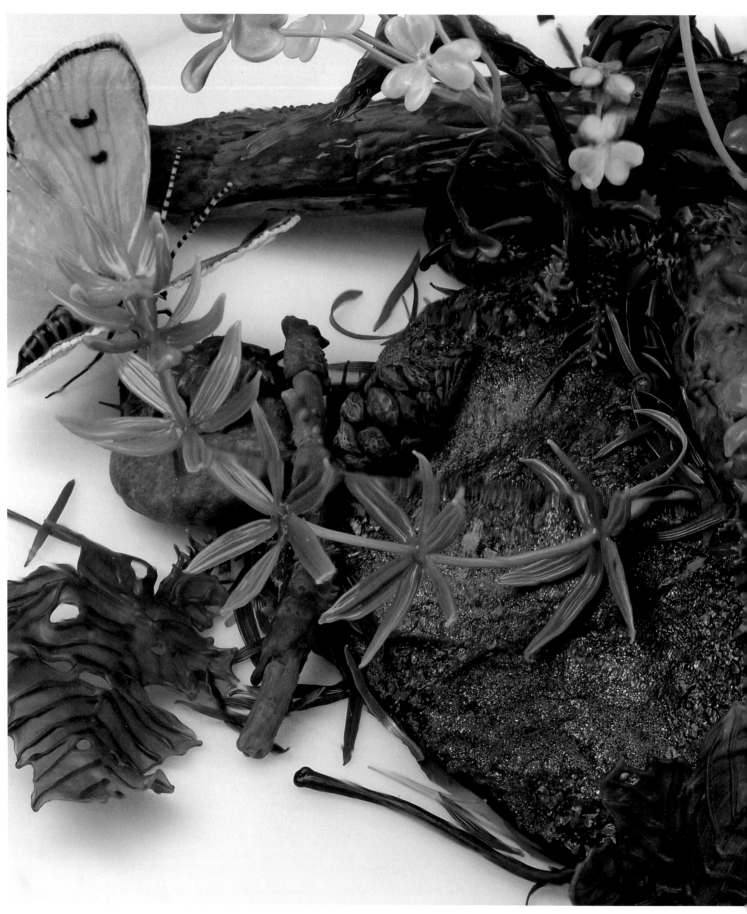

Endlessness

Jeffrey Grove

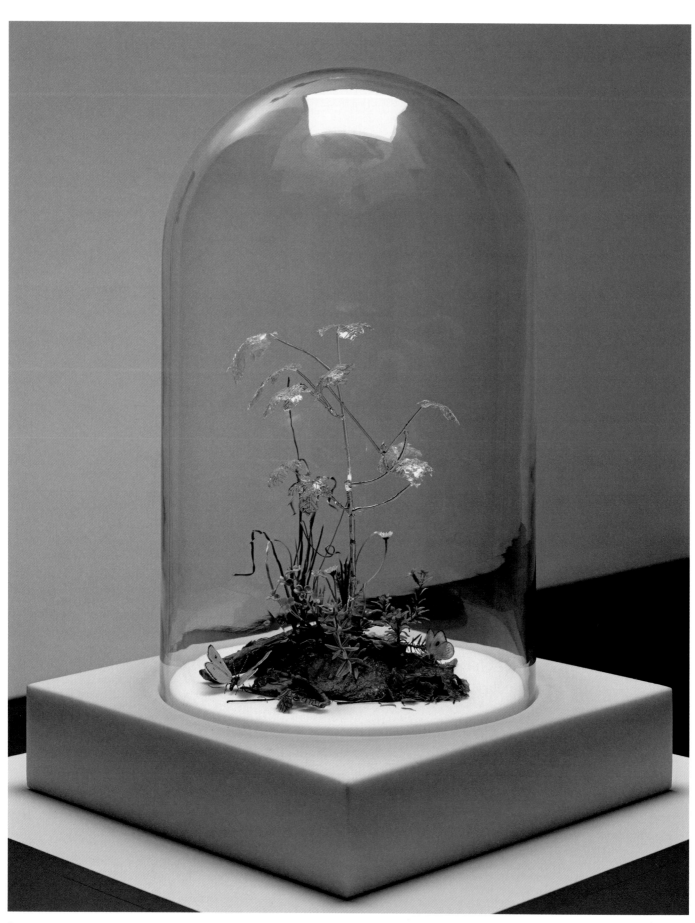

"I found my voice in the woods." —Jim Hodges

I.

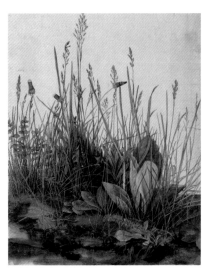

7

Dense and lively, silent and verdant, the woods Jim Hodges grew up exploring during his youth in Spokane, Washington, remain a reserve of visual reference and symbolic meaning. The circadian rhythms and cycles of regeneration in the woods form a well of inspiration to which the artist has returned time and again. Nature reveals itself in the fractured light, dazzling color, and elusive mysteries that echo throughout his work. It is present in his earliest drawings, collages, and installations, and poignantly reimagined in later work such as *ghost* (2008; Nos. 1–6), an epic meditation on Albrecht Dürer's 1503 watercolor *The Great Piece of Turf* (No. 7), which celebrates the majesty hidden in an overlooked corner of nature. Hodges may have found his voice in the woods, but it was in a far darker and more threatening place that he sharpened it: the streets of New York.

Dismantling form and content, and challenging his own assumptions about what it means to be an artist, Hodges spent the years 1987–1991 struggling to locate something in his work he considered to be "primitive and real." [1] Before producing the works that would cement his reputation—delicate drawings of flowers on napkins and dazzling curtains of artificial flowers—he had long engaged in a reductive process of creation through destruction. Reflecting on this tumultuous stage in his evolution, Hodges confessed that the work he was making then was "gritty and dirty, digging toward a primitive authenticity." [2] As revealed in the opening sequence of *Blue Velvet*, David Lynch's 1986 thrilling dismemberment of small-town innocence, beyond the white picket fence, burrowing beneath the tulips, and lurking behind the shiny façade of our bucolic idylls, there often hides a more complex and menacing reality.

Hodges was born in 1957 into a Catholic family, the second of six children. He earned his BFA at Fort Wright College in Spokane in 1980, and then moved to Brooklyn in 1983 to attend the Pratt Institute, where he received his MFA in 1986. That same year marked a prophetic turning point for the artist. He met the collector Elaine Dannheisser, who, in exchange for his part-time work as an art handler, gave Hodges a studio in the basement of her foundation on Duane Street. In a process he describes as his "first major artistic crisis," Hodges became painfully aware that his ambitions were not being realized as a painter and that he was making paintings he "hated." Following the advice of a former professor, Scott Patnode, and in spite of what Hodges deemed his own "better judgment," he abruptly rejected the path he had been on and abandoned painting. [3] This psychological shift also revealed itself physically in Hodges's work. He became more adventurous in his use of materials, choosing porous and ephemeral matter over more permanent substances. His work became increasingly self-reflexive, and he began to chart far darker terrain than he had explored previously in his art.

Darkness for Hodges denoted both a mental and a physical state. His basement studio had no windows, and he had decided to limit his use of color, restricting himself to black and shades thereof. He gradually became more comfortable with strategies of assemblage and an altogether more casual approach to making art, though he was still torn by a dedication to the traditional ways of

1–6. Jim Hodges *ghost* 2008 glass sculpture in multiple parts 35 x 22 x 22 in. (88.9 x 55.9 x 55.9 cm) overall Private collection, London Photos: Stephen White; courtesy Stephen Friedman Gallery, London

7. Albrecht Dürer *The Great Piece of Turf* 1503 watercolor, gouache on paper 16 x 12 3/8 in. (40.8 x 31.5 cm) Albertina, Vienna

8

8. Jim Hodges *New AIDS Drug* 1990
photocopies 8 ½ x 11 in. (21.6 x 27.9 cm)
each; overall dimensions variable
Collection Shelley Hirsch

working he had absorbed in school. Much of what he was producing now was simply discarded. His practice expanded to incorporate detritus pulled from the streets: dirt, water, building supplies such as tarpaper and spackling, and the occasional pilfered office supply, including staples and tape. As he came to increasingly question the nature of drawing, he continued to explore ephemeral materials and gestures in the quest to reshape his approach.

Hodges was also coming out. Like many young men at the time, he was exploring his sexuality during this "research period," through nighttime excursions to New York's dance clubs and underground S and M bars. [4] The subcultures, fetishes, and sexual practices Hodges encountered in those dark spaces infiltrated his art as both inspiration and substance. "These late-night adventures were being recorded in my work, taking form in materials like plastic, leather, rubber, Crisco, lace, candles, mirrors, and chain," Hodges remembers. "My studio was a laboratory or a garbage dump depending on how you looked at it." [5] He was also developing a deeper interest in issues of temporality, and began incorporating commercially based reproductive processes, including photocopies, into constructions such as *New AIDS Drug* (1990; Nos. 8, 146–157) and *The you between air and ground* (1988; No. 9). Both contain the early trace of signatures developed more fully in Hodges's later work: repetition, folding, cutting, and dispersal.

Two works from this period, *Good Luck* (1987; No. 10) and *Deformed* (1989; No. 11), illustrate Hodges's deft understanding of how simple gestures and subtle acts of manipulation could transform familiar objects into powerful totems latent with signification otherwise absent in their original form. Ghoulish and menacing, *Good Luck* is nothing more than an unraveled ski mask, frayed at the edges and pinned to the corner of a room. *Deformed* is a Bonwit Teller shopping bag sliced and splayed open, pinned to the wall. Each object engages the architecture of the space in which it is installed to complete its meaning, and each has a title that is at once casual and unassuming, but incredibly specific. Of the various possible meanings for the phrase "good luck," the one Hodges imagined is less a cheery send-off than a beleaguered warning, perhaps a reflection of the artist's abject mind-set at the time. Both works share the bricoleur's aesthetic, foreshadowing themes Hodges would explore more broadly in later works. The netlike shape of *Good Luck*, for instance, insists on claiming an overlooked corner, as many of his later spiderwebs would do, and the mechanically reproduced flowers decorating the bag used to make *Deformed* presage Hodges's representations of "real" fake flowers in numerous drawings and sculptures that followed.

The pretty purple pansies on Bonwit Teller's iconic shopping bag are not just innocuous decoration; they are also a historical indicator of effete homosexuality. And combined with the signification of the cruciform in the ruptured bag, they aid in the construction of a site conflating sexuality, religion, and persecution. It cannot be coincidental that in choosing to fashion *Deformed* from a Bonwit Teller shopping bag, Hodges identified the iconic emblem of a store whose window displays were once designed by Andy Warhol, the most influential queer artist of his generation. [6] Hodges is critically aware of the history of art, and his work often discloses this affinity, even as he has endeavored to liberate his art from historical conventions. The work he was making at this time was out of step with much of what the New York art world valorized, notably the discordant strains of Neo-Expressionism, Neo-Geo, and the Pictures gener-

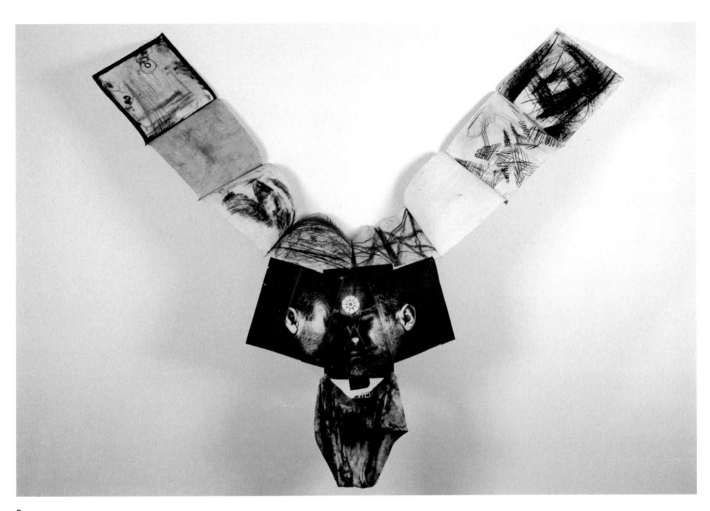

9

9. Jim Hodges *The you between air and ground* 1988 charcoal on paper, photocopies, cotton, collage 60 x 60 x 12 in. (152.4 x 152.4 x 30.5 cm) overall Collection the artist

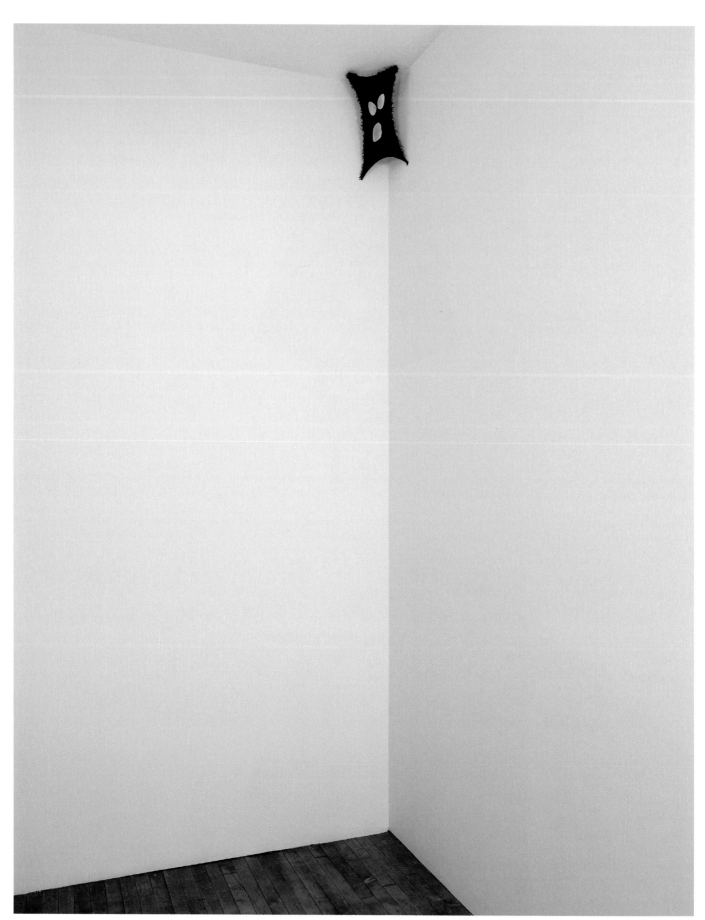

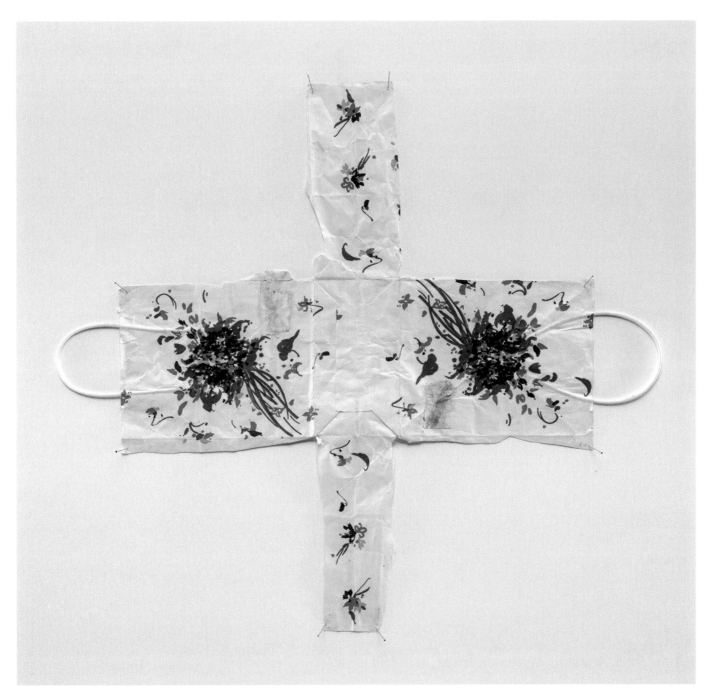

11

10. Jim Hodges *Good Luck* 1987 altered
ski mask approx. 18 x 19 in. (45.7 x 48.3 cm)
Collection the artist Photo: Ronald Amstutz

11. Jim Hodges *Deformed* 1989 altered
shopping bag 30 ¹/₂ x 34 in. (77.5 x 86.4 cm)
Collection the artist Photo: Ronald Amstutz

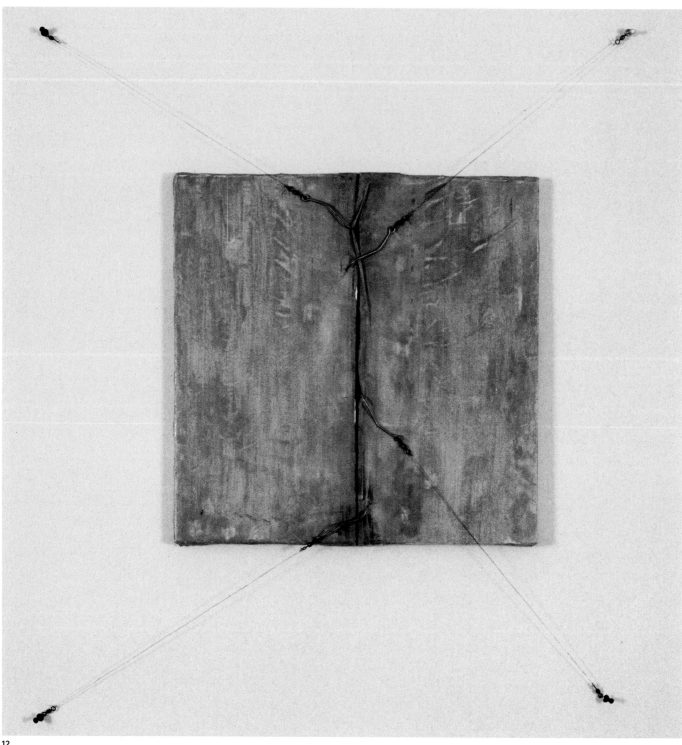

12

12. Jim Hodges *Flesh Suspense* 1989–1990
latex, gold foil, glass, wax, makeup, transpar-
ent tape, electrical tape on canvas with fish-
hooks and monofilament 38 x 29 in. (96.5 x
73.7 cm) overall Collection the artist

ation of appropriation artists whose works still define textbook analyses of art in the 1980s and early 1990s. He eschewed the urban and suburban figuration of artists such as Jean-Michel Basquiat and Eric Fischl, rejected the muscular and vaporous expressionism of Julian Schnabel and Francesco Clemente, avoided the patterns of Philip Taaffe, and skirted the political binaries of Barbara Kruger and Jenny Holzer. Nor did he embrace the fiery declarations of artists such as David Wojnarowicz, whose work plaintively addressed New York street life and the effects of the AIDS crisis.

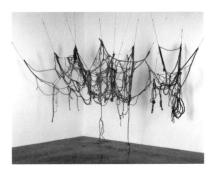

13

Instead, Hodges's subtle methodology seems more aligned with the sensibilities of Italian Arte Povera artists from the late 1960s and early 1970s, and with the approach of Eva Hesse and Richard Tuttle, two artists not particularly in fashion in the late 1980s, but of keen interest to Hodges. He identified not only with the fetishistic nature of their work, but also with the way each artist self-reflexively liberated the practice of drawing, prying it from the genre's perceived history. Hesse's and Tuttle's art from the 1960s constituted a dramatic dematerialization of the syntax demarcating the languages of painting, sculpture, and drawing. Tuttle's practice embraced paradox and contingency, while Hesse's liminal gestures expanded the conception of drawing. [7] Each artist articulated personal experience through materiality, which for Hodges represented an "endlessness of possibility." [8]

Hodges concedes that his own practice at this time was "unstable." He was also acutely aware that the cultural and sexual landscape he occupied was being dramatically recast. "Bombs were dropping outside…. People were dropping like flies … and I am thinking, I am going to be next." [9] Hodges was working only three days a week to prioritize time for making art. Poor, and perhaps a bit on edge, he no longer had an apartment and was living illegally in his studio. When Elaine Dannheisser found him sleeping there, she kicked him out. Shortly thereafter, he decided to become sober. Among the first works he made after getting clean was *Flesh Suspense* (1989–1990; No. 12).

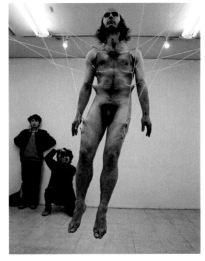

14

Aggressive and direct, *Flesh Suspense* is rendered in substances evocative of human skin. Incorporating latex, gold foil, wax, makeup, cellophane, electrical tape, fishhooks, and monofilament on canvas in a provocative stew, this diptych-like work appears not only as a violent rupture in Hodges's development, but also as a deeply conscious acknowledgment of his connection to art history. *Flesh Suspense* is rent through the middle, its halves pulled apart, recalling images of a chest cavity being split open for surgery or similarly harrowing scenes. Hesse's hanging sculptures (No. 13) and Tuttle's drawings come to mind, as do associations with other artists who have grappled with myth, fable, and fairy tale in their work. Notable examples include Titian's *The Flaying of Marsyas* (circa 1576), a cruel depiction of a tale from Ovid, in which the Satyr is flayed alive, and countless depictions of Doubting Thomas, the biblical apostle who thrust his finger into the open wound on Christ's side.

More contemporaneous associations may be found in the performances of Stelarc, who achieved notoriety in the late 1970s and early 1980s for his public suspensions in which the artist had his body hoisted into space by means of hooks inserted into his skin (No. 14). [10] The works of Hannelore Baron and Salvatore Scarpitta also resonate. Baron, a German-Jewish immigrant and Holocaust survivor, gained recognition in the late 1960s for her intimate and highly

13. Eva Hesse *No title* 1969–1970 latex, rope, string, wire dimensions variable Whitney Museum of American Art, New York; purchase, with funds from Eli and Edythe L. Broad, the Mrs. Percy Uris Purchase Fund, and the Painting and Sculpture Committee © The Estate of Eva Hesse; courtesy Hauser & Wirth Photo: Ralph Liberman

14. Stelarc *Event for Lateral Suspension* March 12, 1978 Tamura Gallery, Tokyo Photo: Anthony Figallo

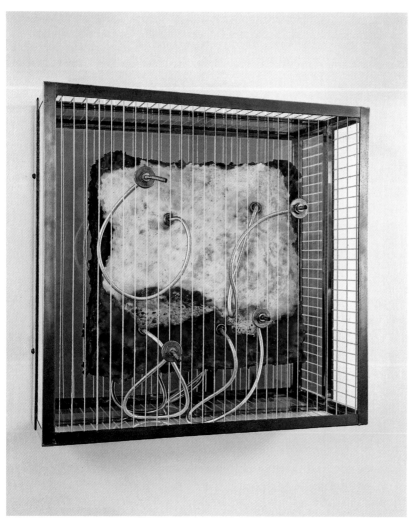

15

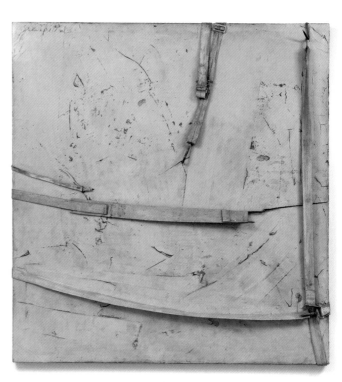

autobiographical collages and constructions that incorporated scraps of paper, faded fabrics, and annotated drawings with numeric inscriptions, often stitched together (No. 17). Scarpitta is a Californian who attended Beverly Hills High School, though he is often presumed to be Italian, no doubt because of the clear influence of Lucio Fontana, Alberto Burri, and Piero Manzoni on his work. Scarpitta became known early in his career, in the 1960s, for creating paintings that he metaphorically "attacked" and then "healed." In *Tishamingo (for Franz Kline)* (1964; No. 16), for example, after building up the surface through multiple layers, he scratched and gouged it and attached straps and hooks, as if to restrain it in a straightjacket. [11]

More precisely, *Flesh Suspense* is likely indebted to the example of Paul Thek, an artist not adequately recognized in his lifetime for his prodigious body of work incorporating performance, drawing, sculpture, and complex installations. Thek came to the attention of and influenced a younger generation of artists retrospectively, through a series of gallery exhibitions in New York in 1989, 1990, and 1991. Hodges saw these and was no doubt impressed, particularly by the *Technological Reliquaries*, startling works that Thek produced from 1964 to 1967. These jarring sculptures, composed of wax and other materials, depict slabs of flesh and fragmented limbs encased in prisonlike boxes and Plexiglas vitrines that vaguely connote strange machines or scientific contraptions, as in *Untitled (Four Tube Meat Piece)* (1964; No. 15). [12] The effect of seeing what appears to be organic animal and human parts encased in crisp containers is surreal and provocative, and for Hodges, it was in some way cathartic. He has described *Flesh Suspense* as "a compression of all the unraveling and wildness that preceded it … a formalization of the madness in a historic medium … literalizing the body symbolically and playing with formal issues of painting and sculpture. It was also intended to remain, not disappear and decay." [13]

Hodges recognized this commitment to producing obdurate, sustainable objects as the outcome of a new consciousness. Around this same time, Bill Arning, then director of White Columns, an alternative space in New York, offered Hodges a show as part of their White Room series. The artist had conceived the installation he wanted to create, but needed the financial resources to produce it, so with renewed purpose and newfound clarity, he staged a two-day exhibition in the summer of 1991 called *The Everything Must Go Show!* Equal parts performance art and garage sale, the event was held in Hodges's studio. Art was hung everywhere, including the ceiling; walls were painted with lyrics of sentimental songs, and used-car-lot flags hung from the ceiling. Drag queens doubled as security guards and sales girls. The event was a success, generating the funds Hodges needed to produce a signal work in his career, *Untitled (Gate)* (1991; No. 18). [14]

17

II.

Gate is a magnificent construction: a net of chains in ever decreasing gauges that progresses from large links to delicate jewelers' mesh. It is also an eight-by-ten-foot room that one cannot enter, painted the most beautiful shade of blue. Both a physical structure and a conceptual conceit, it is a literal and metaphoric threshold—a three-dimensional rendition of Hodges's imagination, previously

15. Paul Thek *Untitled (Four Tube Meat Piece)* from the series *Technological Reliquaries* 1964 wax, metal, wood, paint, plaster, resin, glass 16 $^1/_8$ x 16 $^1/_4$ x 5 $^3/_8$ in. (41 x 41.3 x 13.7 cm) Kolodny Family Collection Photo: Orcutt & Van Der Putten; courtesy Alexander and Bonin, New York

16. Salvatore Scarpitta *Tishamingo (for Franz Kline)* 1964 mixed media, straps 65 x 60 x 5 in. (165.1 x 152.4 x 12.7 cm) © Estate of Salvatore Scarpitta Photo: Ryan Sullivan; courtesy the Estate of Salvatore Scarpitta and Marianne Boesky Gallery, New York

17. Hannelore Baron *untitled* 1977 cloth, ink 8 x 7 $^3/_8$ in. (20.3 x 18.7 cm) Courtesy the Estate of Hannelore Baron

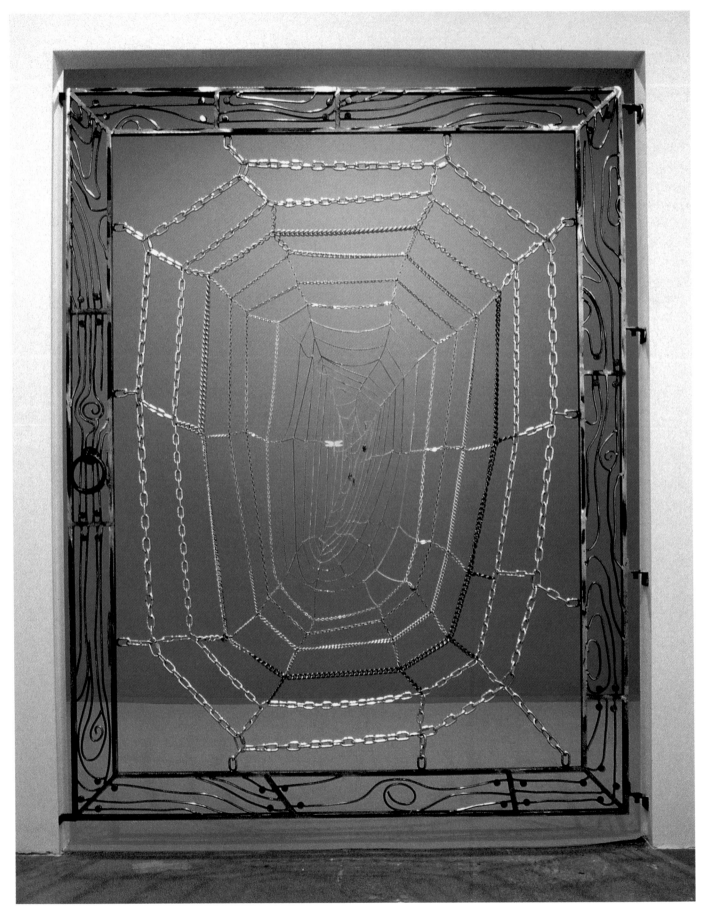

inaccessible and now made visible. A solid, Minimalist gesture, *Gate* introduced to a larger public an iconic motif within Hodges's practice: the spiderweb. As one critic noted, early examples began to appear "as shy spider webs … clinging to the corners of various group shows in Manhattan." [15] Sometimes they were small and simple, just a teeny web pinned into a corner; occasionally they were large and dense, with many grouped in layers folding upon one another. Some incorporated the petals of broken artificial flowers or were woven into, and interwoven with, domestic materials such as clothing, scarves, and rope.

The spiderweb is a potent symbol associated from ancient times to the present with cycles of life and death, entrapment and entanglement. These universally understood correlations are no doubt one reason so many writers have found in Hodges's webs analogies to the evanescence of life and the devastation of AIDS. His webs are never populated, however; they represent what has been abandoned, suggesting associations with memory and neglect. From the earliest example, a tiny web from 1989 made with copper chain, to the last complex web produced in 2001 in white brass chain, Hodges produced numerous variations on this theme. [16] *Gate* is significant for many reasons. It was his first theatrical expression of a web and the first in a series of architectonic installations he produced at crucial moments in his development. [17] It also introduced elements latent in his thinking and manifested a desire to push the animated nature of his work in a new direction by exploring notions of verisimilitude in a more free-spirited manner.

Gate's modulated web is suspended within a frame of welded steel wires describing the striations, swirls, and gnarls of knotty wood planks. This design finds its companion in a group of three *Wanted Poster* drawings Hodges also produced in 1991, each of which portrays a tattered scroll of paper unfurled and nailed to a knotty pine wall (Nos. 19, 145). The *Wanted Posters* are of interest not only because the ostensible subject of each is absent, but also for the art historical legacy Hodges was claiming with this image. One thinks of American painters from the late nineteenth century working in the trompe l'oeil tradition, such as John F. Peto and William Harnett (No. 20), both of whom rendered still-life compositions of letters and papers pinned to plank walls. The *Wanted Posters* are also distinguished in Hodges's oeuvre by their exaggerated facture, and the artist acknowledges that when he was making them, he was thinking not only of Disney and Warner Brothers cartoons, but also of the cartoonlike black-ink posters of Mike Kelley. The original wanted poster, of course, is a relic of the late nineteenth century, associated in popular imagination with an outlaw culture of the Wild West, a romantic mythology Hodges admits to secretly embracing. His ancestors had emigrated from Ireland and settled in Minnesota, and his great-great-grandparents were among the earliest homesteaders in Alberta, Canada, at a time when, as the artist describes it, "there were simply no roads to take one there." [18] Hodges identifies deeply with the American pioneer spirit and recognizes in himself the temperament that propelled his own ancestors on that hardscrabble quest: "That insistence … it's where I come from … what I strive for." [19]

Another crucial, if less discussed, influence on Hodges's worldview is the distinctly American form of pantheism expressed in the writings of Walt Whitman, Ralph Waldo Emerson, and Henry David Thoreau. A perhaps too simplistic

19

20

18. Jim Hodges *Untitled (Gate)* 1991 steel, aluminum, copper, brass, paint, electric lighting 78 x 60 x 2 ¼ in. (198.1 x 152.4 x 5.7 cm) gate; 96 x 120 x 96 in. (243.8 x 304.8 x 243.8 cm) room Collection the artist

19. Jim Hodges *Wanted Poster 3* 1991 ink on paper 24 ½ x 18 ½ in. (62.2 x 47 cm) Collection Glenn and Amanda Fuhrman, New York; courtesy the FLAG Art Foundation

20. William Harnett *Mr. Hulings' Rack Picture* 1888 oil on canvas 30 x 25 in. (76.2 x 63.5 cm)

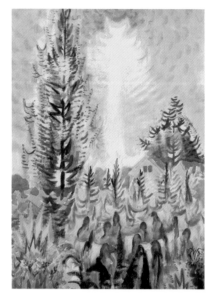

21

22

21. Charles E. Burchfield *Drought, Sun and Corn* 1961–1962 watercolor, charcoal on paper, mounted 39 ³/₄ x 27 in. (101 x 68.6 cm) Courtesy DC Moore Gallery, New York; reproduced with permission from the Charles E. Burchfield Foundation

22. Jim Hodges *In the Dark Cave, Part 3 of 6* 2007 charcoal, saliva on paper and cloth 22 x 15 in. (55.9 x 38.1 cm) Private collection, New York

articulation of this complex philosophical and ethical position would state that pantheism represents the belief that God is not a separate force from nature, and that spirit, body, and universe are one and the same. Clues to Hodges's own pantheistic tendencies are often expressed obliquely through references he has made to his work, as when he described, all in the same breath, his early interest in the "idea of oneness, of a kind of complete wholeness of time compressed into an instant," and of being captivated by "the potential and fullness of experience, [the] limitlessness of things … mind, body, color, space, proximity, distance, memory, psyche, and spirit." [20]

Hodges's personal theosophy and lifelong connection with nature echo throughout his work in all media, but are particularly evident in his dedication to drawing. In this practice, he has always worked in a sequential manner, but at periodic junctures he has made groups of drawings that stand as discrete series. Among these are *A Certain Kind of Alone #1–#6* (1994; No. 24), a group depicting crepuscular scenes of the southern swamp variety punctuated by Hodges's signature spiderwebs, their pattern pricked into the surface and revealed through the white of the paper; *Being in a Place I–X* (1998; No. 23), which records a light-infused wood of conifers and evergreens evoking both the dense forests of the upper Northwest and the scrubby stands of trees along the Eastern seaboard; and three later series that are far less literal, with descriptive representation often morphing into suggestive abstraction: *through an opened gate I–VI* (2007) and *In the Dark Cave, Part 1–Part 6* (2007), both made using his own saliva, and *on the way between places* (2009; Nos. 25-29), the largest group he has created to date, comprising twenty-one sheets.

All of these drawings describe lively, animated spaces that almost buzz with a trancelike intensity, recalling the symphonic *musica universalis* that ancient philosophers proposed unified the different life forms populating our universe. [21] Far from heretical, the humanist conception of a "music of the universe" is a philosophy that has been expressed in the teachings and writings of numerous world religions, including the Judeo-Christian faiths. One passage in the King James Bible, for instance, reads in part, "the mountains and the hills shall break forth before you into singing, and all the trees of the field shall clap their hands" (Isaiah 55:12). [22]

Many of Hodges's drawings seem to vibrate with an ineffable music of the universe, and for this reason conjure an association with another individualistic American artist, Charles E. Burchfield. Described as a "mystic, cryptic painter of transcendental landscapes, trees with telekinetic halos, and haunted houses emanating ectoplasmic auras," [23] Burchfield is best known for his emotive watercolor paintings in which the sky, trees, and flowers pulse with colorful rays of life. Comparing Burchfield's radiant *Drought, Sun and Corn* (1961–1962; No. 21) to Hodges's lush *In the Dark Cave, Part 3 of 6* (No. 22) suggests a range of affinities between the two men, though Burchfield's consistently vibrant palette departs from the monochrome dimension of much of Hodges's work. Particularly in Burchfield's later period, color is never absent. Indeed, color was as much the subject of his painting as were the images he ostensibly depicted. [24]

Even though Hodges is often identified with and heralded for his use of color, he has created a prodigious amount of work in monochrome. All of the drawings in the series above, depicting nature in some form, are rendered in

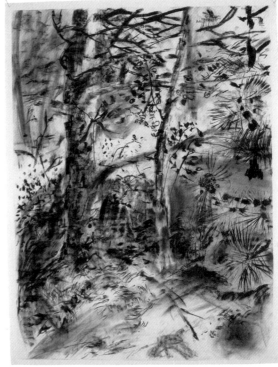

23

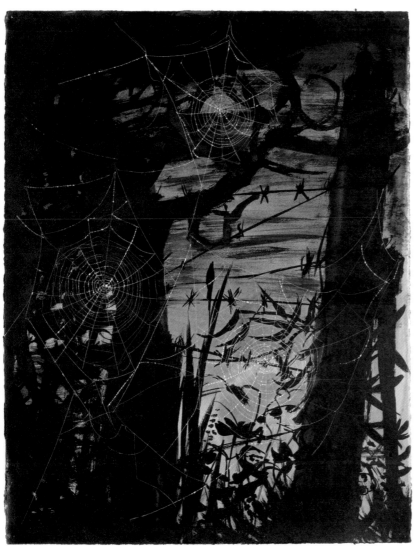

24

23. Jim Hodges *Being in a Place II* 1998
charcoal on paper 30 x 20 ¹/₂ in. (76.2 x
52.1 cm) Private collection

24. Jim Hodges *A Certain Kind of Alone #5*
1994 sumi ink on paper 30 ¹³/₁₆ x 22 ¹/₂ in.
(78.3 x 57.2 cm) Whitney Museum of
American Art, New York; purchase, with
funds from Steven Ames and the Drawing
Committee, 2007.40 Digital Image © Whitney
Museum of American Art

25. Jim Hodges *on the way between places
(1 of 21)* 2009 charcoal, saliva on paper
30 x 22 ¹/₂ in. (76.2 x 57.2 cm) Collection Flavia
and Guilherme Teixeira Photo: Ronald Amstutz

26. Jim Hodges *on the way between places
(3 of 21)* 2009 charcoal, saliva on paper
30 x 22 ¹/₂ in. (76.2 x 57.2 cm) Collection Flavia
and Guilherme Teixeira Photo: Ronald Amstutz

27. Jim Hodges *on the way between places
(6 of 21)* 2009 charcoal, saliva on paper
30 x 22 ¹/₂ in. (76.2 x 57.2 cm) Collection Flavia
and Guilherme Teixeira Photo: Ronald Amstutz

28. Jim Hodges *on the way between places
(9 of 21)* 2009 charcoal, saliva on paper
30 x 22 ¹/₂ in. (76.2 x 57.2 cm) Collection the
artist Photo: Ronald Amstutz

Jeffrey Grove

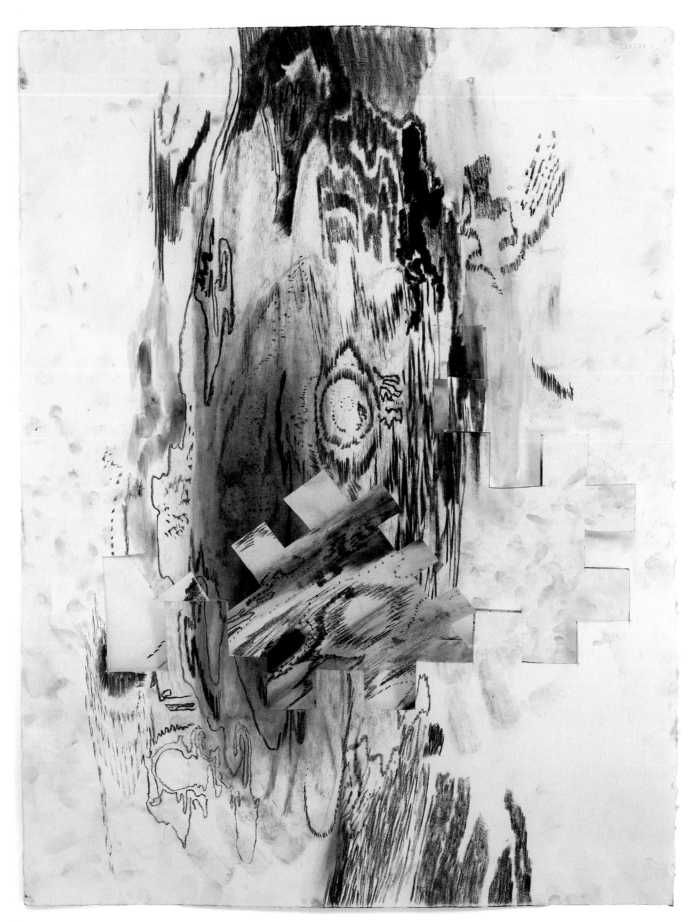

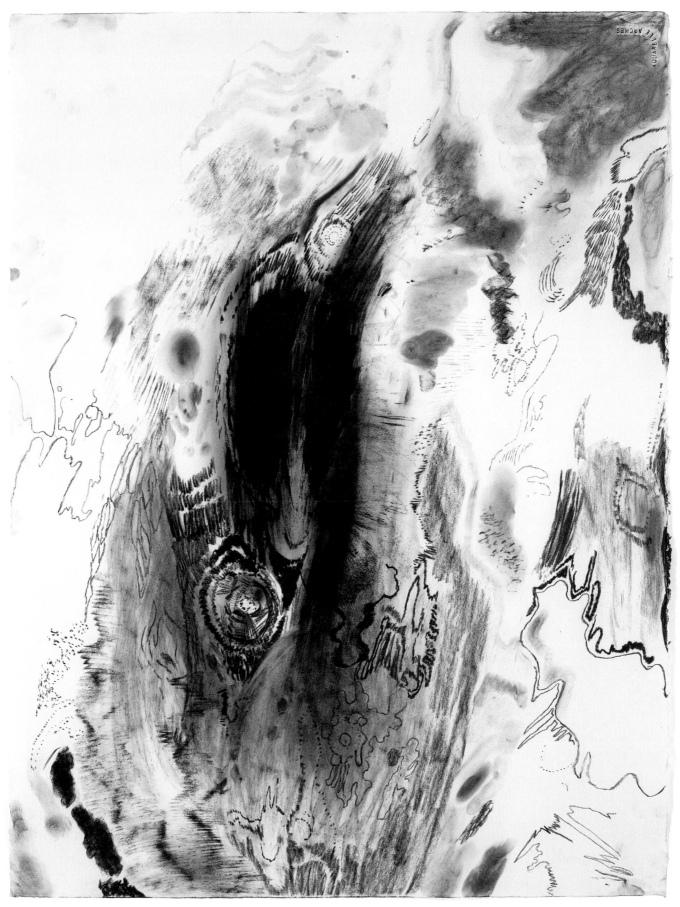

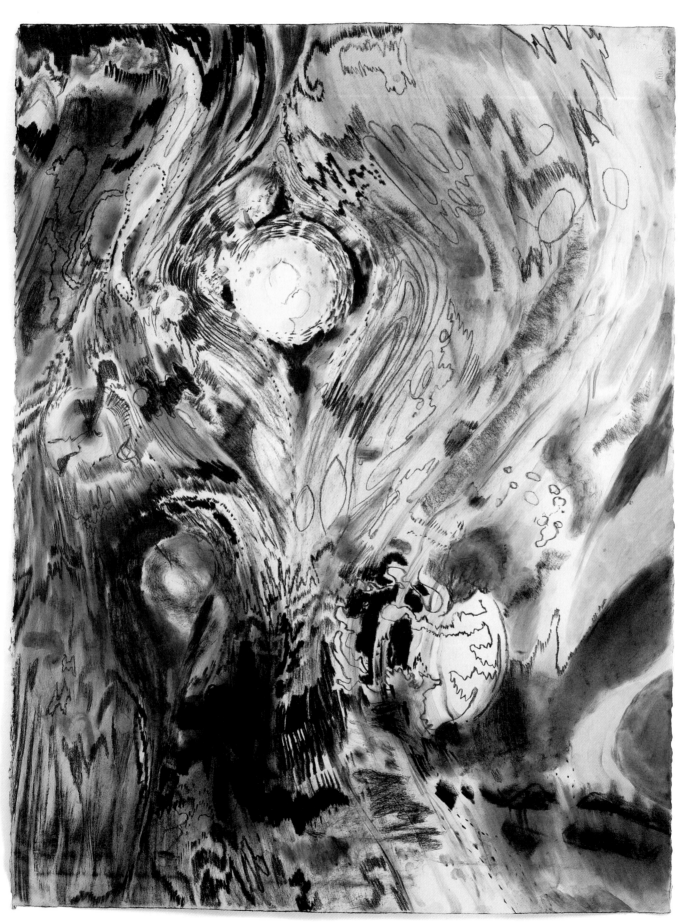

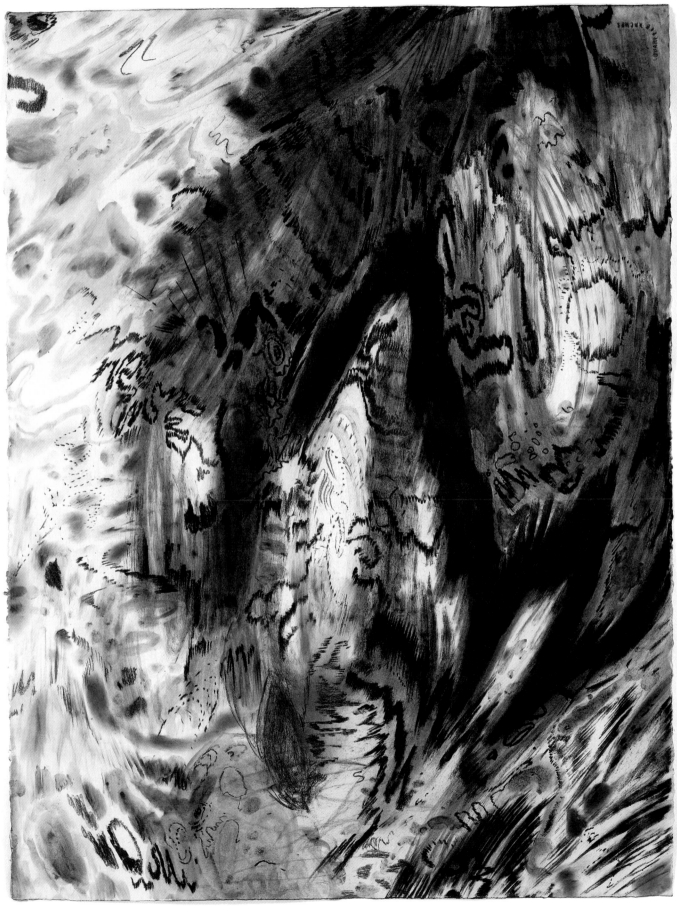

black and white, in media ranging from ink and tempera to graphite and charcoal. Exceptions are found in the *Drawing on Clouds* cycle (No. 30), fifteen drawings from 1994, and the *nothing named* series (Nos. 67–68), twelve drawings from 2012, all of which should in fact be considered collage. It is of further interest to note that, aside from a few plein-air drawings, [25] Hodges's depictions of flowers, woodlands, and sylvan spaces untouched by human presence are all improvisations on nature—products of the artist's imagination rendered exclusively in the studio, and not drawn from direct impressions or observations of nature.

In a dialogue with Ian Berry published in 2003, Hodges observed that when he stopped painting in the 1980s, he stopped using color—from roughly 1987 to 1992 it was essentially absent—and that it was not until he began using fabric flowers in his sculpture that color was "reintroduced." [26] It seems pertinent that when Hodges decided to "embrace" color again, it was not through a subtle appropriation or sublime simulacrum of nature, but through the use of a material that is the very antithesis of nature: fake flowers. The ten remarkable curtains Hodges created from 1995 to 1998, composed of thousands of disassembled artificial flowers, were notable (and highly prized) not only for their delicate beauty and subtlety of gesture—through a simple act Hodges transformed a coarse signifier of low culture into high art—but also for their startling originality (Nos. 36–37). These works felt completely fresh and new, although a sympathetic predecessor may be found in the glorious floral fabric collages Joe Brainard produced in the late 1960s (No. 31).

While Hodges's floral curtains remain his defining expression in this idiom, he had first explored the use of artificial flowers in two earlier works, *A model of Delicacy* (1992; No. 33), which combined a chain spiderweb with disassembled flowers, and *A possible cloud* (1993; No. 34), which is notable for being the first of three works Hodges made in collaboration with his mother, Ramona. Completed over a period of one month, *A possible cloud* is an enormous sheet of cotton netting punctuated with a random pattern of petals and leaves from deconstructed flowers sewn onto its surface. Able to be configured in any number of ways, this form floats like a cloud, relying on its position in space for definition. The qualities of transparency, ethereality, and mutability that infuse this piece were suggested in earlier works, but relate even more closely with the delicate sketches of flowers rendered on napkins that make up the various incarnations of *A Diary of Flowers*, which Hodges began composing a year earlier, in 1992.

A possible cloud might also be the first expression of ideas that were later manifested in other areas of Hodges's practice. Shortly after completing it, he created a number of works that deployed disassembled flowers in a variety of ways. Among the first such works were those in which he pinned the individual elements of artificial flowers to the wall, as in *Changing Things* (1997; No. 35). *Untitled (Threshold)* (1993–1994) was an architectural rejoinder to *Gate* that suggested a floral portal one might imagine walking through. And in *a line to you* (1994; No. 32) and *Not Born This Way* (1994), floral elements float upward from a pile on the floor or meander across a wall to the floor. *A possible cloud* is also a precursor to *Here's where we will stay* (1995; Nos. 72–73), a vast theatrical scrim composed of dozens of silk and nylon scarves sewn together and suspended in space.

Hodges explored the filmy transparency of scarves in several works from 1994, including *Good Morning*, *Here*, and *Our Strength*, all of which incorporated

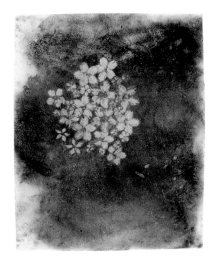

30

31

29. Jim Hodges *on the way between places (11 of 21)* 2009 charcoal, saliva on paper 30 x 22 ¹/₂ in. (76.2 x 57.2 cm) Collection the artist Photo: Ronald Amstutz

30. Jim Hodges *Drawing on Clouds/About Stars* 1994 charcoal, silk on paper 24 x 19 in. (61 x 48.3 cm) Collection Jennifer McSweeney

31. Joe Brainard *Untitled (Garden)* 1967 fabric collage 37 x 27 ¹/₂ in. (94 x 69.9 cm) Collection Kenward Elmslie Used by permission of the Estate of Joe Brainard

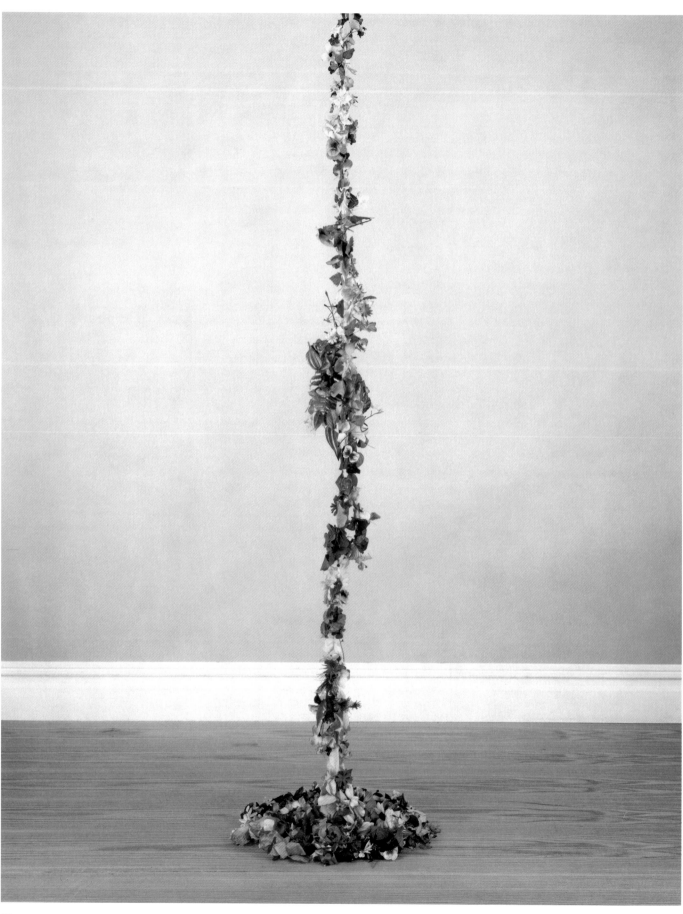

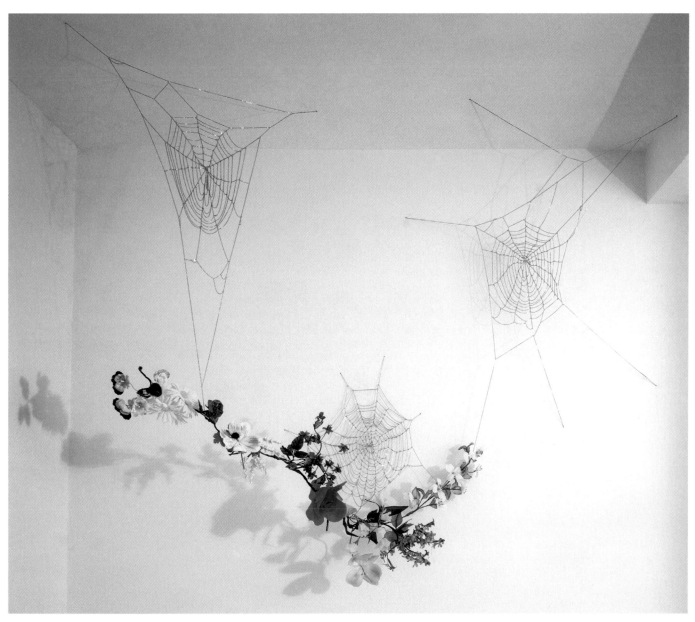

33

34

32. Jim Hodges *a line to you* 1994 silk, plastic, wire with thread 211 in. (535.9 cm) length overall Collection Glenn and Amanda Fuhrman, New York; courtesy The FLAG Art Foundation

33. Jim Hodges *A model of Delicacy* 1992 white brass chain, silk, wire 56 x 64 x 17 in. (142.2 x 162.6 x 43.2 cm) overall Private collection

34. Jim Hodges *A possible cloud* 1993 cotton, silk flowers 288 x 288 in. (731.5 x 731.5 cm) overall Private collection

35. Jim Hodges *Changing Things* 1997 silk, plastic, wire, pins in 342 parts 76 x 148 in. (193 x 375.9 cm) overall Dallas Museum of Art; Mary Margaret Munson Wilcox Fund and gift of Catherine and Will Rose, Howard Rachofsky, Christopher Drew and Alexandra May, and Martin Posner and Robyn Menter-Posner Photo: Brad Flowers; courtesy Dallas Museum of Art

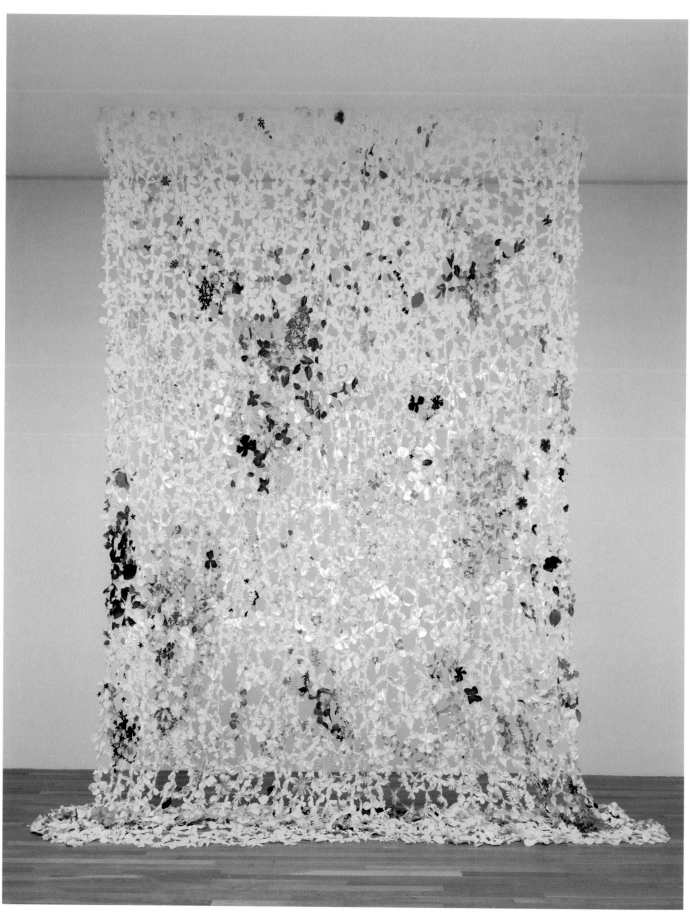

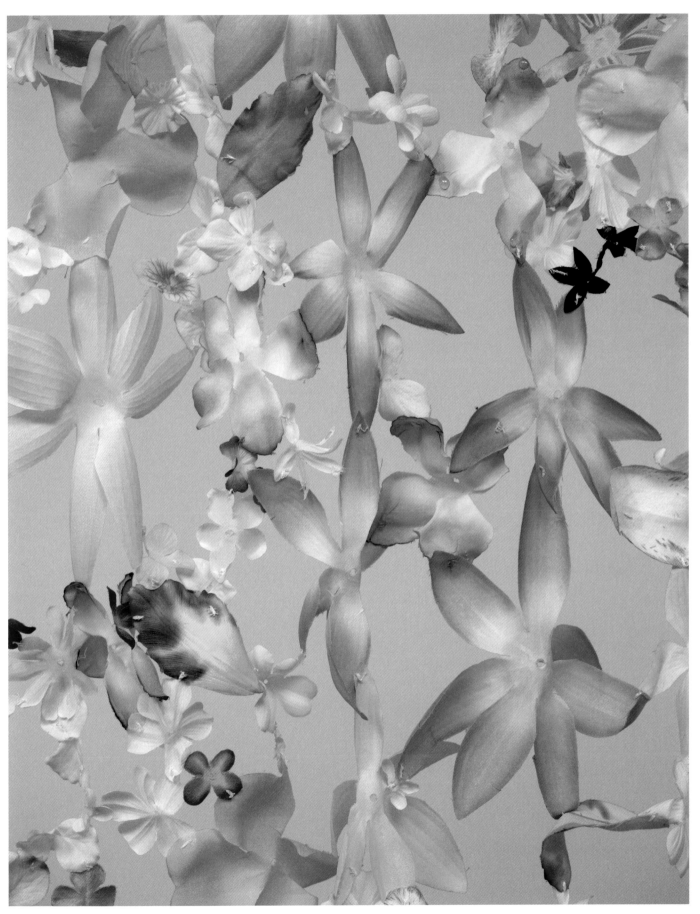

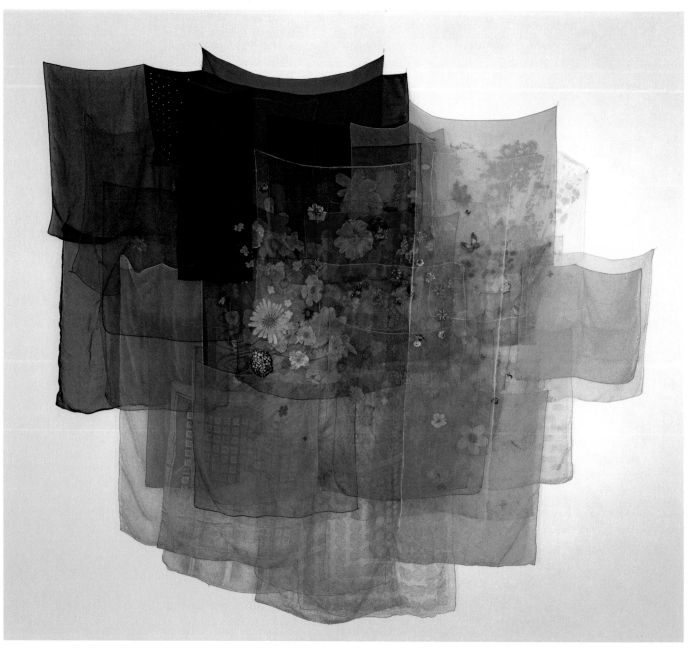

38

36–37. Jim Hodges *You* 1997 silk, cotton,
polyester, thread 192 x 168 in. (487.7 x
426.7 cm) overall Fabric Workshop and
Museum, Philadelphia Photos: Brad Flowers

38. Jim Hodges *With the Wind* 1997 scarves,
thread 90 x 99 in. (228.6 x 251.5 cm) overall
Collection Glenn and Amanda Fuhrman,
New York; courtesy The FLAG Art Foundation
Photo: Alan Zindman

his chain webs, and the sculptures *Wherever we are* (1996) and *With the Wind* (1997; No. 38). Hodges's scarf sculptures also express concepts he explored in constructions from the late 1980s, including *The Rhythm Within* (1988), in which he collaged elements of drawings, found objects, cloth, and other materials into three-dimensional assemblages that cascade from the wall. This typology—residing somewhere in the space between painting and sculpture—finds interesting correspondences not only in the works of Hesse, as previously discussed, but also in the *Hoarfrost* paintings that Robert Rauschenberg produced in the 1970s. To create those unusual works, Rauschenberg combined elements of photography, collage, and printmaking, exploring fabric as an unstretched support to which he applied images using photomechanical processes (No. 39).

39

III.

In 1994 Hodges had his first solo exhibition in a commercial gallery in New York City. Situated in a townhouse on East Seventy-First Street, CRG (now located in Chelsea) provided a paradoxically uptown debut for this decidedly downtown artist. The show included the monumental *A Diary of Flowers* made from 535 napkins, *A possible cloud*, and related drawings, spiderwebs, and pinned-flower pieces. The response was immediate and affirming. Yet, in those first reviews of Hodges's career, a curious semiotics was established. In her generally laudatory take on the exhibition, Roberta Smith described it as the artist's "wistful gallery debut." Characterizing his art as part of "the current fascination with an ephemeral, implicitly mournful art," she concluded by recognizing Hodges's "poetic sensibility." [27]

Reviews appearing in numerous national art publications shortly thereafter parroted Smith's example. Susan Harris observed that Hodges's work was "imbued with a wistful quality that questions the essence of beauty and time." [28] Reagan Upshaw remarked that the flowers Hodges disassembled and attached to the wall were "symbolic of precarious beauty," maintaining that it was "hard not to see Hodges's choice of subject and medium ... as a metaphor for a community of artists ravaged by AIDS." [29] Matthew Weinstein reiterated Smith's and Harris's characterizations of *A Diary of Flowers* as "wispy" and, like Smith, commented on the artist's "poetic sensibility." He also made note of the "ethereal" aspects of Hodges's work as well as its "feminine" properties. [30] Though such observations were not without merit, the discourse quickly homed in, at times indiscriminately, on such language to describe Hodges's work, often with a seeming disregard for the visual evidence.

In the cultural moment during which Hodges emerged, the public conversation and consciousness around queer theory, gender studies, and identity politics were at a fever pitch, with critical voices often radically polarized. Perhaps an unintended consequence was a pronounced tendency on the part of many critics to associate the sometimes difficult and discursive nature of Hodges's work with an agenda that could be easily articulated. Occasionally, odd passages appeared that sometimes bordered on the misogynistic or homophobic, as when one critic observed that "Hodges employs materials with the kind of unabashed sentimentality that is usually classified as 'feminine,'" [31] or when another remarked that Hodges was "pushing daintiness to the point where it becomes strangely unsettling." [32]

39. Robert Rauschenberg *Untitled (Hoarfrost)* 1974 solvent transfer on fabric with paper bag, fabric collage 83 ⁷/₈ x 48 ⁷/₈ (213 x 124 cm) Art © Robert Rauschenberg Foundation/Licensed by VAGA, New York

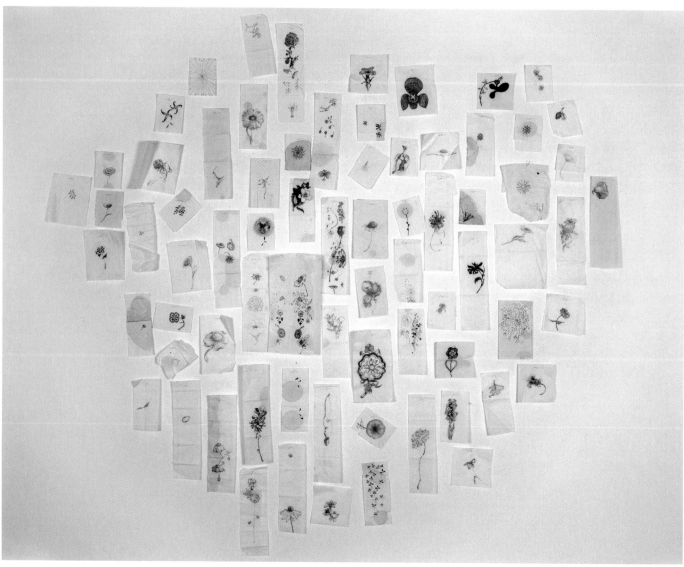

40

40. Jim Hodges *A Diary of Flowers (When We Met)* 1994 ink on paper napkins in seventy-two parts 70 x 74 in. (177.8 x 188 cm) overall Collection Barbara and Michael Gamson

41. Jim Hodges *A Far Away Corner* 1997 white brass chain dimensions variable Collection John and Amy Phelan Photo: courtesy Sotheby's

42. Jim Hodges *Untitled (Happy Valentine's Day)* 1996 ballpoint pen, gouache on paper 8 x 14 ¹/₂ in. (20.3 x 36.8 cm) Collection the artist Photo: Ronald Amstutz

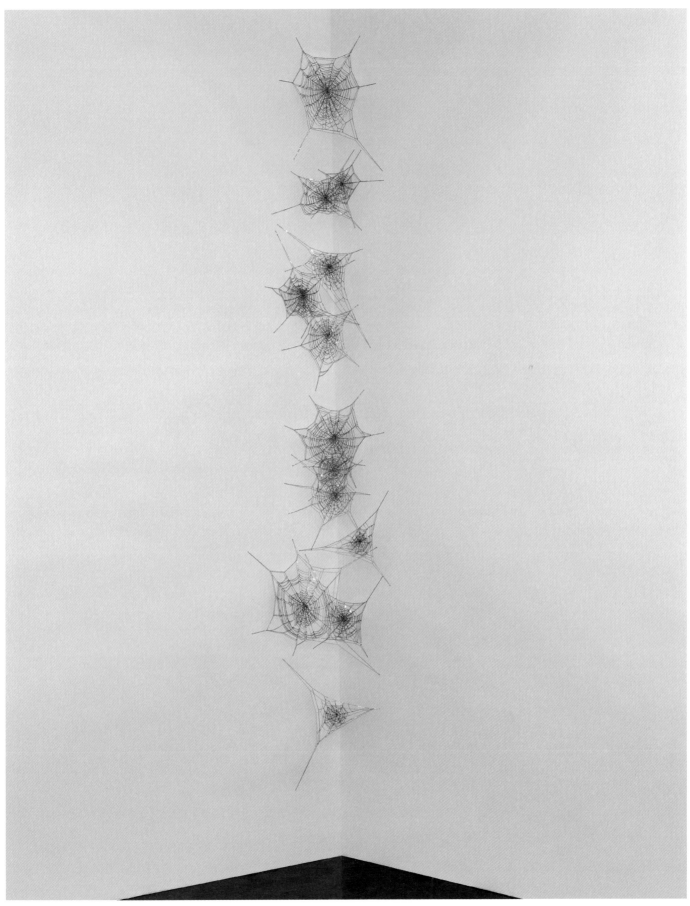

43

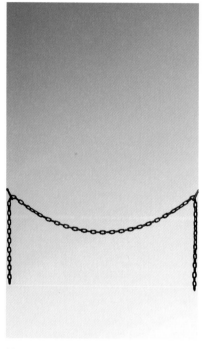

44

As the AIDS pandemic ground on, writers grappling to pin down the thread of intentionality running through Hodges's disparate bodies of work often focused undue attention on his identity as a gay man. It came to be accepted as a truism, for example, that his curtains of flowers serve as a "reminder of both our own inevitable mortality and of a different concept of life or, rather, interrupted life, in an era of AIDS." [33] And the assumption that Hodges's art "almost inevitably resonates with the devastation of the AIDS crisis, of too many friends and lovers who have died" became a maxim. [34] Unfortunately, such readings of Hodges's work came at the expense of more nuanced inquiry.

The mid-1990s witnessed a pronounced facility and renewed sense of discovery informing Hodges's work as he simultaneously produced spiderwebs, the ongoing *A Diary of Flowers*, flower curtains, pinned-flower wall pieces, assemblages, works with silk scarves, and drawings. Drawing remained a constant, and Hodges occasionally produced the surprising anomaly, such as the charming *Untitled (Happy Valentine's Day)* (1996; No. 42). Unparalleled in his oeuvre, this gentle and amusing drawing (note the junkyard along the way to the bucolic woods) strikingly evokes one of Currier and Ives's comforting etchings of country life, such as *Early Winter* (circa 1869; No. 43), an idealization of the pastoral that became a standard of American kitsch, its image emblazoned on dinnerware and hanging as reproductions in the living rooms of countless American homes from the 1950s onward. Hodges's drawing may seem anomalous in his practice, but it reveals a playfulness and lightness often present, yet overlooked, in his work.

This period also brought personal tragedy and professional self-examination. His close friend Felix Gonzalez-Torres died in January 1996, leaving Hodges feeling "tired." And despite the favorable attention his work was now attracting, he was frustrated with his art, sensing "a profound need to make the next step" and not wanting to repeat himself or to "stay in a state of continual sadness and loss and grief." [35] As he had done before, Hodges again devoted himself to a process of reflection and introspection, evaluating where his work had taken him and, equally, where it had left him. On a plane returning from a trip to Los Angeles, Hodges determined that he would break a mirror when he arrived back in New York.

The resulting work, *No Dust* (1996; No. 45), was made by gluing a commercially produced mirror onto an unprimed canvas, turning it mirror-side down on a table, and breaking it with a hammer. For an artist so firmly established in the discourse as a practitioner of "delicate" and "wistful" aesthetics, it took a powerful gesture to instigate the change he was seeking. Perhaps consciously, perhaps subconsciously, in this one decisive moment Hodges began to shatter his persona as an artist obsessed with beauty, memory, and nostalgia. Characteristically aware of the social, symbolic, and art historical significance of mirrors, from Jan van Eyck's *The Arnolfini Portrait* (1434) to Michelangelo Pistoletto's "mirror paintings" of the 1960s and 1970s (No. 44), Hodges welcomed the new dimension this material might suggest.

In this singular, intense, potentially Freudian act, Hodges aligned himself not only with the forceful gestures of American Abstract Expressionists such as Jackson Pollock and Franz Kline, who tried in their painting to reify time, but also with Italian and Japanese postwar artists such as Alberto Burri, Lucio Fontana, and Shizo Shimamoto, who literally "attacked" their canvases by slicing,

43. Currier and Ives *Early Winter* circa 1869

44. Michelangelo Pistoletto *Catena (Chain)* 1971 painted tissue paper on polished stainless steel 90 ⁹/₁₆ x 47 ¹/₄ in. (230 x 120 cm) Private collection Photo: courtesy the artist; Luhring Augustine, New York; Galleria Christian Stein, Milan; and Simon Lee Gallery, London

45. Jim Hodges *No Dust* 1996 mirror on canvas 28 x 22 in. (71.1 x 55.9 cm) Collection Sheila and Bill Lambert; courtesy Neal Meltzer Fine Art, New York Photo: Ronald Amstutz

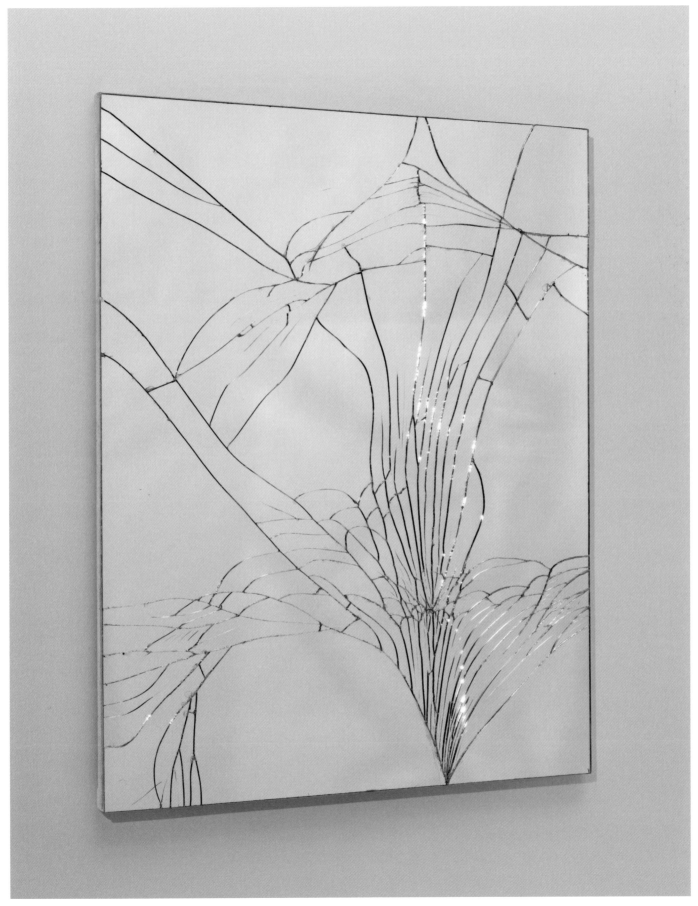

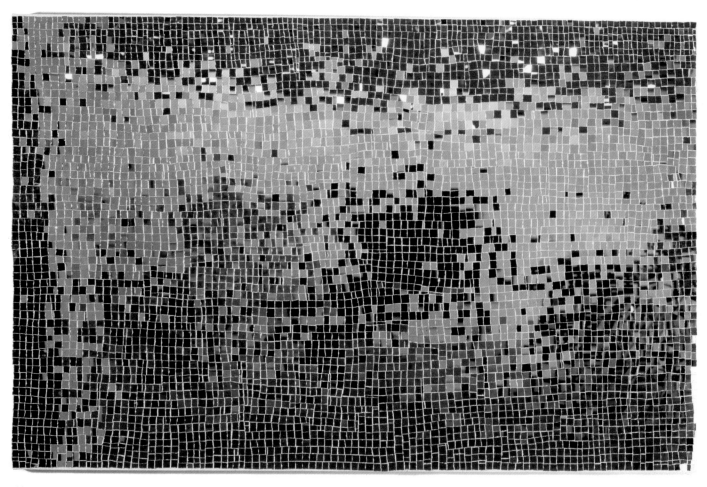

46

46. Jim Hodges *On Earth* 1998 mirror on
canvas 40 x 60 in. (101.6 x 152.4 cm) Pizzuti
Collection

47

47. Jim Hodges *As close as I can get* 1998
Pantone color chips with adhesive tape
81 x 81 in. (205.7 x 205.7 cm) Collection Eileen
Harris Norton

48

burning, and abrading them. The transcendent potential of mirrors to both reflect and distort reality as well as suggest altered states, while serving as both concrete substance and vaporous metaphor, also attracted Hodges. Discussing the material, he noted, "A mirror is always awake; it is permanently in a state of non-permanence…. Mirrors offer more questions than answers." [36] In this unassuming material and through an intentional act—the breaking of a mirror, which in most of our experiences is done by accident—Hodges not only tackled myth, superstition, and the history of art, but also began to initiate a process of dismantling perceived notions that were attaching to his identity as an artist.

Shortly after disassembling that first mirror, he began a process of reassembly that clearly articulated his long-held interest in issues of formalism and Minimalism, tendencies expressed in the work of artists such as Sol LeWitt and Ellsworth Kelly, both of whom Hodges greatly admires. Hodges began by creating a series of mosaics in which pieces of mirror, rather than being broken, were cut into approximately one-inch squares, sanded irregularly at the edges to reduce their cubic perfection, and affixed to canvases in shimmering grids (No. 46). Two of the largest, produced in 1998, are diptychs made of six-by-four-foot panels: *Folding (into a greater world)*, joined along its longest side, and *View*, abutted on the shorter side to create an expansive twelve-foot field of space that Hodges once likened to "a flattened disco ball." [37] Just as the sparkling shards of light that refract off the spinning surface of a disco ball are intended to heighten the sense of dislocation from reality one can experience through dancing, encountering the splintered grids of Hodges's mirrors can induce a similar sense of both euphoria and dysphoria, as they reflect only a fractured vestige of the reality they mirror.

Hodges began creating another body of work in 1998 that appears a logical extension of the mosaics, but here using the vivid color and concrete structure of small blocks of Pantone color chips (No. 47). These dazzling works in collage, assembled through a process of random selection, recall Kelly's luminous paintings from the early 1950s, such as *Spectrum Colors Arranged by Chance* (1951–1953; No. 48), a work whose title explains its making. [38] Hodges soon moved from these brilliantly colored cut-paper works to using lightbulbs to create a series of exuberant, at times eccentric, sculptures (No. 49). In the late 1980s, when he was still working in a restricted palette of black and white, he had incorporated mirrors into his work as a way to direct light into it. Now, a decade later and following his more protracted involvement working with mirrors, he was considering light itself as a source of experience. His endlessly surprising variations on this theme—he produced twenty-one iterations from 1999 to 2003—capture an inventive and playful inventory of painterly gestures through a dazzling variety of bulbs in different sizes, shapes, and colors. The palette of Hodges's sculptures ranges from lush Baroque overloads of riotous color, configured in cartoonish, nearly erotic entanglements, to severely restrained groupings that are carefully composed in calibrated progressions of tonalities and arranged in rigid Minimalist grids (No. 50).

Hodges joins numerous other artists who have investigated the properties of light as the critical element of their art, perhaps none more effectively than Keith Sonnier, James Turrell, Robert Irwin, and Dan Flavin. Countless others, notably Joseph Beuys and Jasper Johns, have addressed the lightbulb

48. Ellsworth Kelly *Spectrum Colors Arranged by Chance* 1951–1953 oil on wood 60 x 60 in. (152.4 x 152.4 cm) San Francisco Museum of Modern Art, the Doris and Donald Fisher Collection, and the Helen and Charles Schwab Collection © Ellsworth Kelly

49. Jim Hodges *Coming Through 2* 2002 wood, metal, ceramic sockets, lightbulbs 22 1/2 x 26 x 15 in. (57.2 x 66 x 38.1 cm) Collection Daryl Gerber Stokols and Jeffery M. Stokols, Chicago/Miami Beach

50. Jim Hodges *Another Turn* 1999 wood, metal, ceramic sockets, lightbulbs in four parts 31 1/2 x 31 1/2 in. (80 x 80 cm) each Pérez Art Museum Miami; promised gift of Mimi and Bud Floback Photo: Peter Harholdt

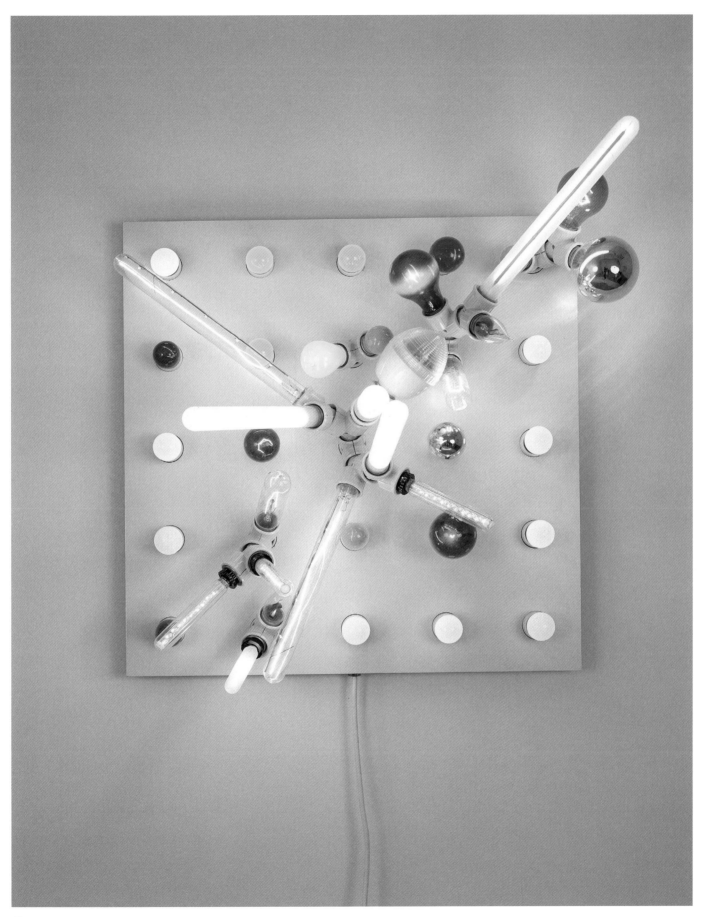

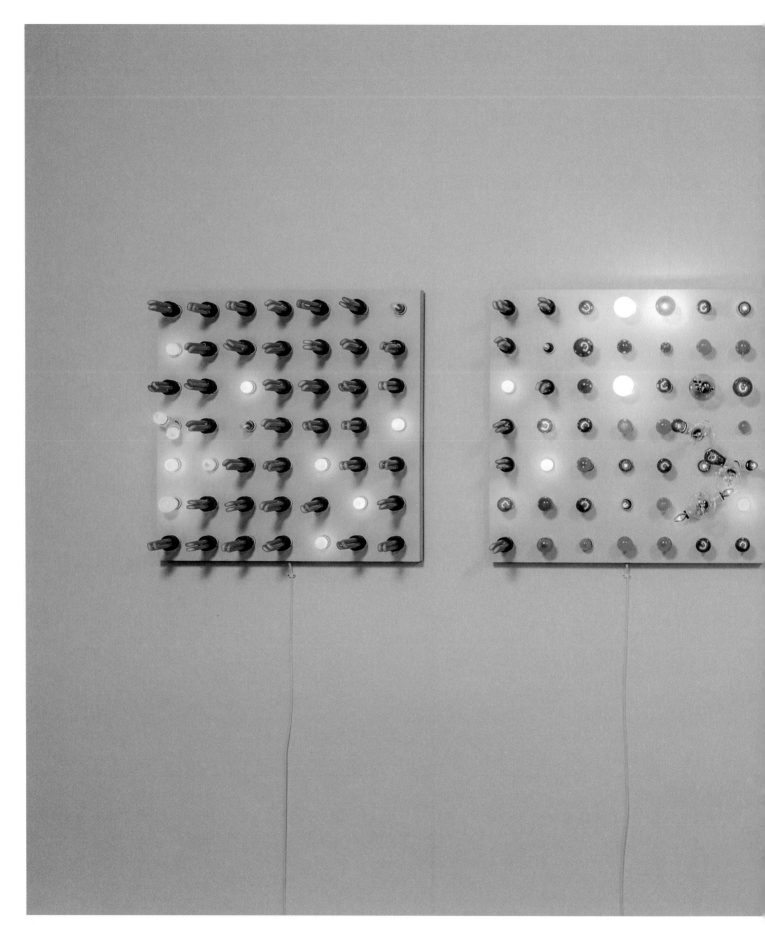

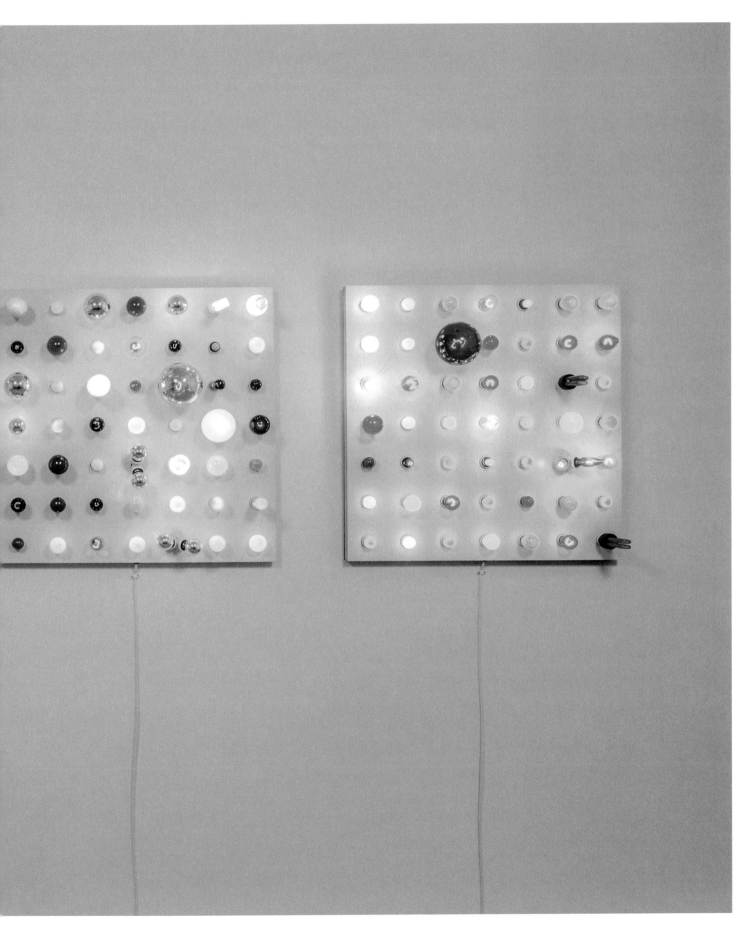

51

as subject. Indeed, Johns's first sculpture, from 1958, was a lightbulb rendered in sculpt metal, and he continued to explore the subject in sculpture, drawing, and printmaking for some twenty years. [39] One is also reminded of the many works Gonzalez-Torres produced in the late 1980s and early 1990s using simple strands of lightbulbs configured in various ways. But it is Flavin who had a particular influence on Hodges's thinking in this instance, and he recalls the impact of encountering an early sculpture by Flavin, *one of May 27, 1963* (No. 51), in the Chicago home of collectors Howard and Donna Stone when he was creating a wall-drawing portrait of the couple in 1998. This work is from Flavin's lesser-known early period, in which he incorporated incandescent lights as well as fluorescent tubes into his work, creating sculptures more expressive and eclectic than his signature pieces composed solely of fluorescent fixtures.

IV.

Around 2000 Hodges began using sheet music as an inventive tool to bridge his ongoing interest in how synesthetic experiences are expressed among various forms. Music, which has always been a background influence and daily inspiration for the artist, became a subject of visual inquiry, reflecting an increasing desire to unify the purely representational with the purely emotional. As Hodges describes it, "Music for me is a way of looking at the body that is not quickly analyzed for its conceptual or intellectual quality." [40] Hodges had previously investigated the properties of sound in two outdoor works that relied on nature—specifically the chance force of wind—to activate them. *Here We Are* (1995) was a "wall of sound" produced by a dizzying assortment of wind chimes hung like a curtain in a garden during the Venice Biennale that year. Three years later, he installed wind chimes again, this time hung high in a sequence of trees in a courtyard next to Old North Church in Boston (No. 52). These chimes, which Hodges once referred to as "spirits, memories called forth from a historic site, the voices of the missing," [41] reflected his attempt to "affect collective memory, to create an association with sound and a particular space." [42]

In an even more ambitious amplification of his desire to relocate the effect of music from one sensory realm to another, Hodges used video to capture sound in *Subway Music Box* (2000). A large-scale installation of seven video projections operating simultaneously, it rotates films Hodges made of twenty-four "buskers," the singing, dancing, often acrobatic entertainers who give life to the underground stations of New York's subway system. Hodges focuses on the musicians in this fraternity, capturing their sometimes irritating, occasionally inspiring performances and presenting them as a disjointed symphony, giving equal time and attention to each character, without regard for the "quality" of their production. Made up of real-time recordings of actual events—there was no attempt to manipulate the material through filmic flourishes—Hodges's work proposes a level field for interpreting and processing the various sonic emissions produced by the rag-tag group he documented. Although the project was, in Hodges's estimation, not entirely successful, it did expand his already established interest in a more participatory public practice outside of the studio.

Hodges continued to explore sound in a number of works from 2000 to 2003 that focused on musical and color notation systems. One multifaceted

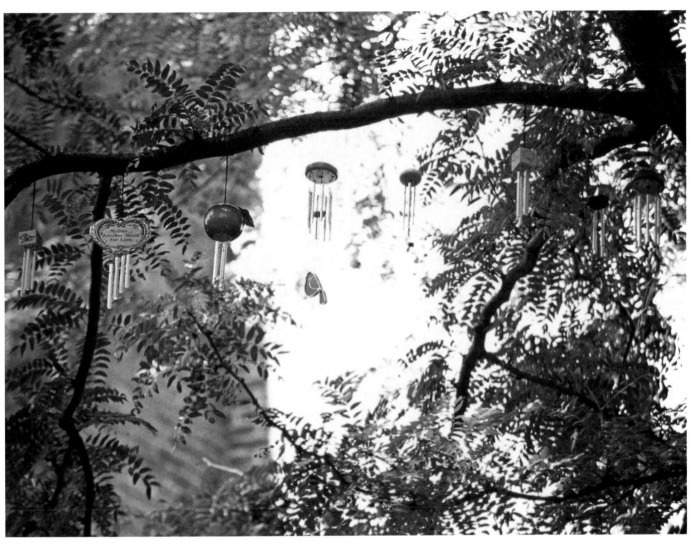

52

52. Jim Hodges *Here We Are* (detail) 1998
wind chimes dimensions variable Collection
the artist Installation view, Old North Church,
Boston, on the occcasion of *Vita Brevis: Let
Freedom Ring*, Institute of Contemporary Art,
Boston, 1998 Photo: Suara Welitoff

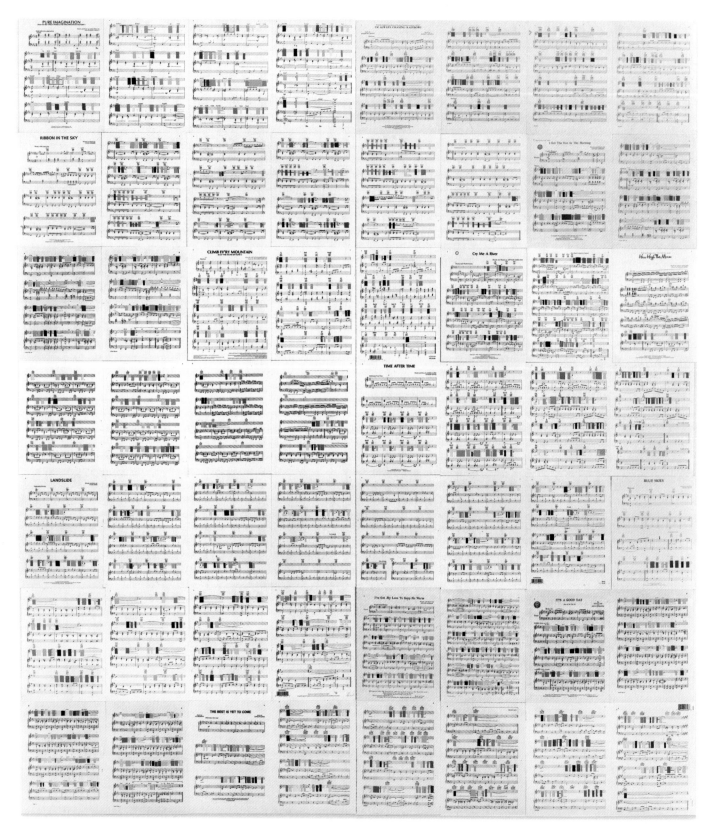

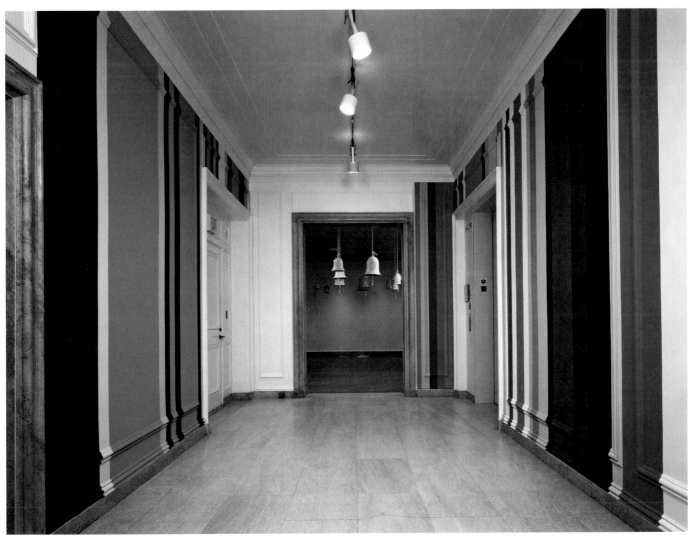

54

53. Jim Hodges *Picturing That Day* 2002
sheet music, Color-aid paper on nylon in two
parts 84 x 72 in. (213.4 x 182.9 cm) overall
The Art Institute of Chicago; Ada S. Garrett
Prize Fund Photography © The Art Institute
of Chicago

54. Jim Hodges *Corridor* 2003 latex paint on
wall dimensions variable Rennie Collection,
Vancouver Installation view of *Jim Hodges:
colorsound*, Addison Gallery of American Art,
Phillips Academy, Andover, Massachusetts,
2003

55. Jim Hodges *Untitled (bells)* (detail) 2002
blown glass in eighteen parts dimensions vari-
able Pizzuti Collection Installation view of
Jim Hodges: this line to you, Centro Galego de
Arte Contemporánea, Santiago de Compostela,
Spain, 2005 Photo: Mark Ritchie

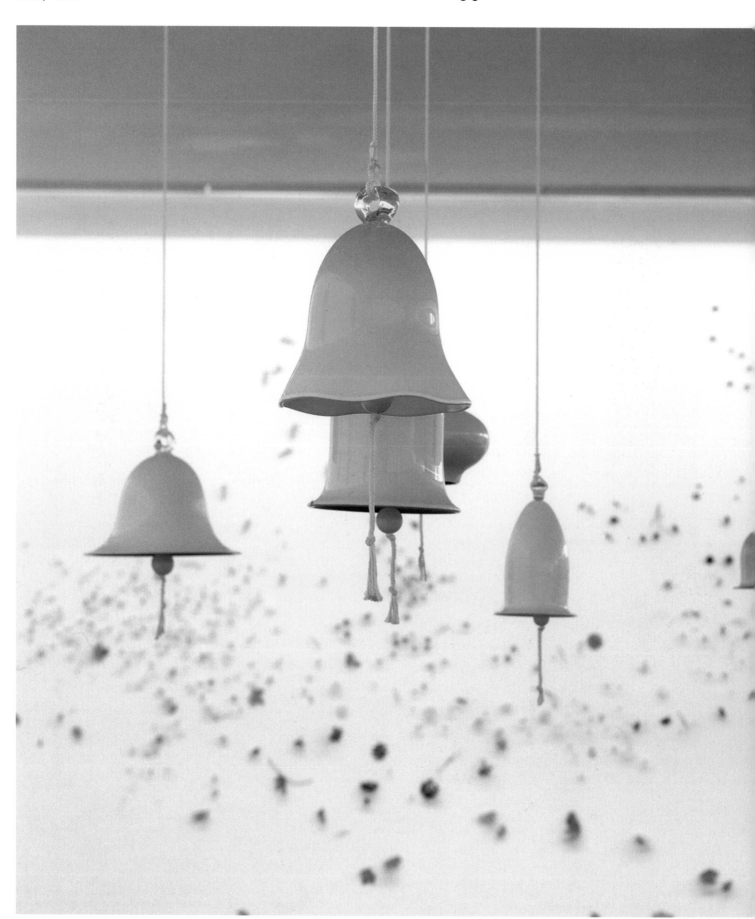

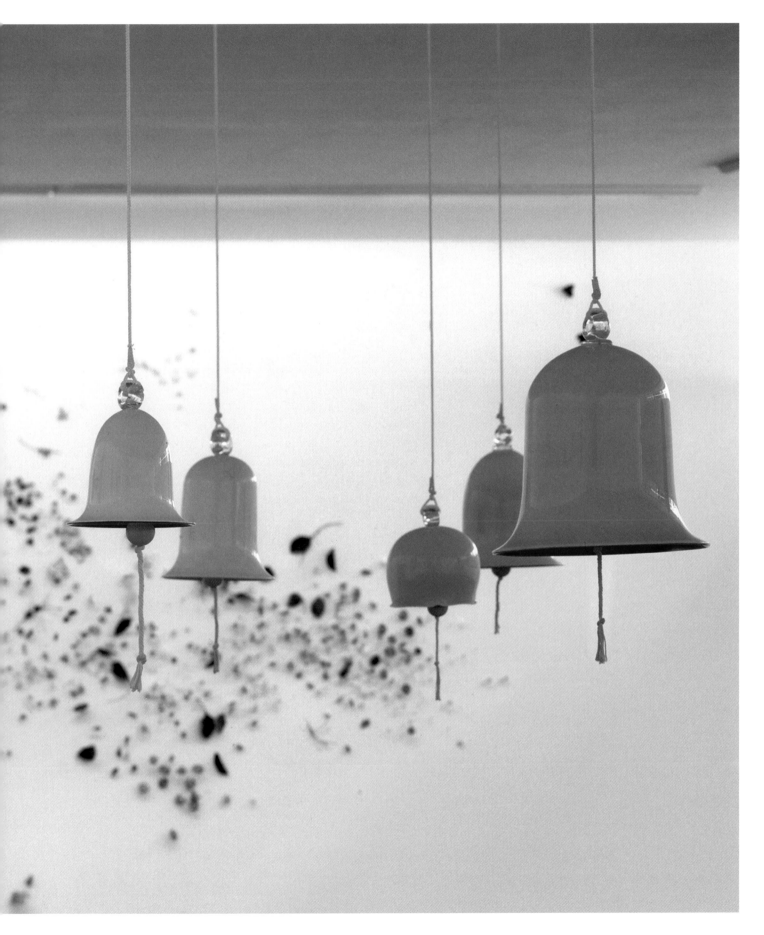

installation at the Addison Gallery of American Art in Andover, Massachusetts, called *colorsound* (2003), included a collaged musical score that determined links between specific notes and colors, which were then expressed as a painted corridor (No. 54). Individual bands of color were painted in widths determined by their placement as notes in musical notation. The piece also included collaboration with students from Phillips Academy; Hodges created a mix tape originating from textual rather than sonic associations by cutting apart musical scores at the point in a stanza where a color, be it blue, green, or red, was named. The fragments were then realigned, creating an abstract score based not on rhythm or logic but on pure chance, and performed by the students. Drawing these different experiences together was *Untitled (bells)* (2002; No. 55), a group of eighteen working bells, spun from glass, each with a differently hued interior, and unified by their milky white exteriors, which visitors were encouraged to ring. In a related work, *Picturing That Day* (2002; No. 53), Hodges excised words from pages of sheet music and replaced each void with a brilliantly colored Pantone chip. In others, he sliced scores of music vertically, isolating a single word such as "love" from different songs, and then perfectly aligned those words to create a visually syncopated score from the staid sheets of music (No. 81).

During this robust period of productivity, Hodges was experimenting with various commercially produced materials ranging from sheet music, Pantone chips, Color-aid paper, and Prismacolor pencils to lightbulbs and mirrors. The syncopation of tone that Hodges realized through such diverse media deepened his interest in a broader understanding of the myriad ways one could harmonize a spectrum of experiences defined separately by text, image, color, and even sound. A sophisticated and elegiac expression of this synthesis was realized in *Slower than this* (2001; No. 56), a collage of letters Hodges cut from photographs and attached to six separate sheets of paper. The moving text, which he originally had composed in 1996, reads as an inventory of memories that never concludes. Both soliloquy and declaration, Hodges's text approximates the structure of a sonnet, creating sentences that envelop the reader in a seductive imaginary landscape even as the actual landscape described in the isolated letters excised from colorful photographs pictures a vibrant reality that transcends the plaintive tone of the poem.

Around this time, overt references to nature seemed less dominant in Hodges's narrative; nonetheless, he continued to keep nature close by. In 2002 he made the first study for *Oh Great Terrain*, which was realized on a grand scale that year as a wall painting in his New York gallery (No. 57). *Oh Great Terrain* is a mural-sized amplification of a human-scale camouflage design rendered in an urban palette of black, white, and gray. A torquing variation on the familiar pattern, it implodes or explodes into a swirling vortex that seems capable of endlessly consuming itself. The camouflage becomes animate and anthropomorphic, as if it were transmogrifying into the living subject it was intended to conceal. Hodges's engagement of aggressive metaphors is not without provocation; he began to sketch ideas for *Oh Great Terrain* shortly after September 11, 2001.

Hodges's interest in this motif stemmed not only from personal signification—he wore camouflage pants constantly at the time—but also from his fascination with the story of Abbott Handerson Thayer, the "father" of camouflage. An American artist, naturalist, and teacher, Thayer was a painter of

56. Jim Hodges *Slower than this* 2001 cut photograph on paper in six parts 22 x 30 in. (55.9 x 76.2 cm) each; 66 x 60 in. (167.6 x 152.4 cm) overall Collection Adrienne and Peter Biberstein

57. Jim Hodges *Oh Great Terrain* 2002 latex paint on wall dimensions variable Collection Glenn and Amanda Fuhrman, New York; courtesy The FLAG Art Foundation

IT WAS A RAINY NIGHT.
IT WAS A WARM WIND
MORNING IN SPRING.
IT WAS A MOUNTAIN TOP
THE SNOW WAS BEGINNING
TO MELT.
IT WAS A SLOW SUNSET.
IT WAS L.A.
IT WAS EARLY AFTERNOON.
IT WAS RAINING.
IT HAD STARTED TO RAIN.
IT WAS A LONG TIME AGO.
IT WAS QUIET AND DARK.
IT WAS HAPPENING
ALL AROUND US.
IT HAD STARTED EARLIER
THAT DAY.
IT HAD DEVELOPED
OVER TIME.
IT HAD BEGUN LIKE ANY
OTHER DAY.

IT WAS WITH THE PASSING
OF A SINGLE BIRD
FROM TREE TO WIRE.
IT WAS SO WARM.
IT WAS LONG AGO.
IT WAS BUILDING AND
COULDN'T BE KEPT DOWN.
IT HAD STARTED A LONG
TIME AGO.
IT HAD TO HAPPEN.
IT COULDN'T BE STOPPED.
IT WAS AS IF IT WASN'T
HAPPENING.
IT WAS A BLANK SPACE,
A BLACK OUT- THE SEA-
THE SOUND OF WAVES-
ENDLESS MOTION. IT WAS
THE EARTH BREATHING,
THE SOUND OF AIR-
THE PASSING CAR-
THE TRAFFIC.
IT HAD STARTED
LIKE ANY OTHER DAY.

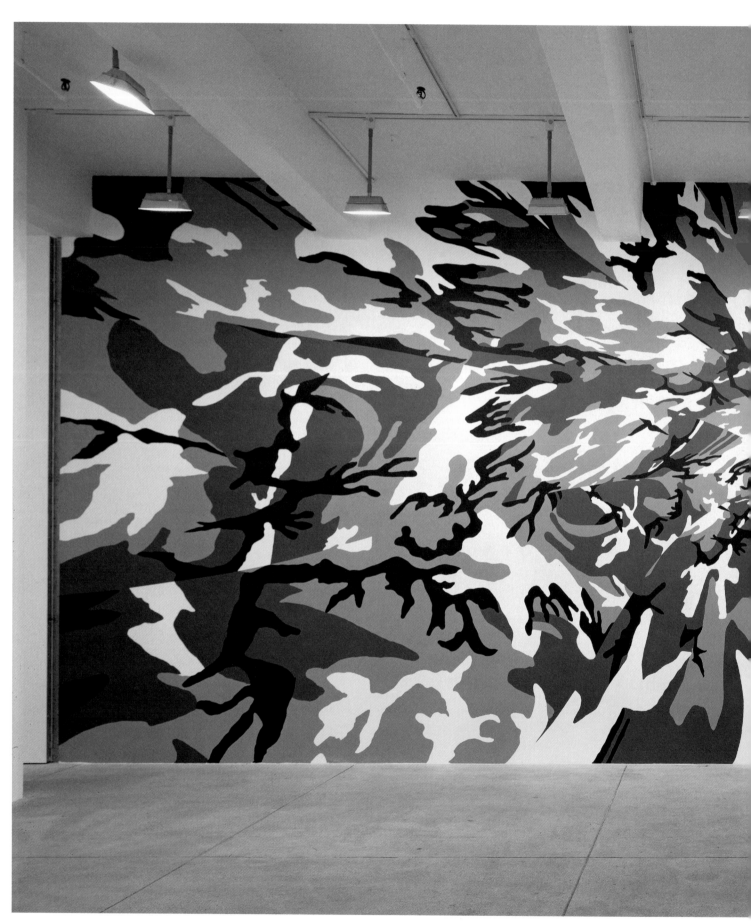

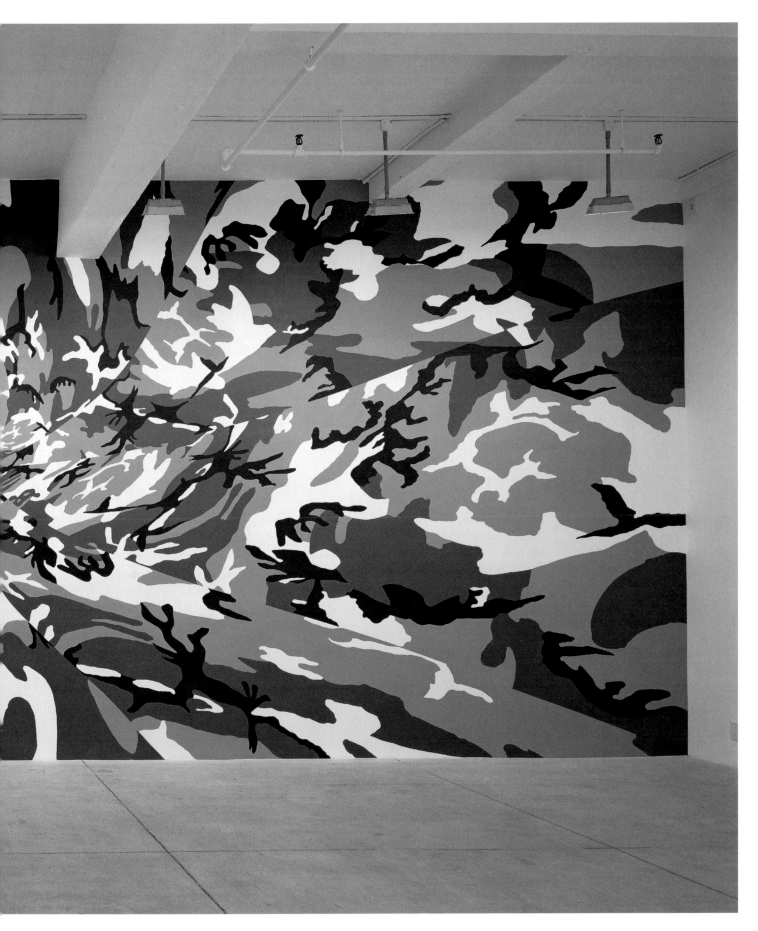

58

59

portraits, figures, animals, and landscapes. His influential 1909 study *Concealing-Coloration in the Animal Kingdom*, describing phenomena endemic to the natural world, became the source of information leading to the development of military camouflage first used during World War I.

Hodges was conscious that he was walking around with this "landscape" on his body—a motif originally articulated as another artist's creation, co-opted as a tool of intimidation and then marketed as a fashion statement. He was equally aware of what he considers to be a certain misrepresentation and ownership of the pattern by the military, and after 9/11 he decided to recoup Thayer's original intentions and return camouflage to its natural place. With this in mind, he set about thinking of ways to articulate camouflage as art. He was certainly aware of the status it had attained as a fine art material, as represented by Alighiero Boetti's influential camouflage paintings of the 1960s (No. 58) and Andy Warhol's articulation of the pattern in countless paintings and prints from the 1980s, one of which Hodges had incorporated into his own work in 1988 (No. 59). He revisited this motif in a number of large outdoor sculptures, including *look and see* (2005; No. 60), and, more intimately, in the embroidered tapestry *all in the field* (2003; No. 61). The latter, a stunning and staggeringly time-consuming object to produce—everything is embroidered by hand—returned the pattern to its familiar material, cloth, and also harked back to Thayer's camouflage paintings. The tapestry embellished the urban palette with lushly colored leaves, vibrant flowers, twisting tree limbs, and delicate pinecones to create a beautiful reconciliation of the artificial and the natural.

Camouflage also served as the transitory material Hodges engaged to conclude the typology he refers to as "a curtain gesture." Through a final act of disassembly and recomposition, in 2007 and 2008 Hodges took black-and-white camouflage fabric, cut the individual patterns apart, and regrouped them according to shade—white, light gray, gray, and black. These sections were then stitched back together to create four monochrome panel paintings, each named *end of time* (No. 62). By destroying and reconfiguring the original pattern, which had become a popular signifier of polarities ranging from warfare to street wear, Hodges transformed an overly familiar pattern into an abstraction. No longer specific in meaning—now newly symbolic—these panels take on the mien of a sublime space for reflection and contemplation.

V.

This strategy of reanimation is one Hodges has used repeatedly in his work, quietly coaxing quotidian objects such as artificial flowers, discarded jeans, sheet music, and Pantone chips into new states of being. His ongoing interest in the power of slight transformational gestures to alter meaning was perhaps most poetically explored in a series of cut photographs he produced from 2002 to 2010. An early example, *where the sky fills in* (2002; No. 63), is a photograph of a rural roadside in autumn, dominated by a lone tree. Not simply a straightforward depiction of nature, the image has been gently yet decisively altered by meticulously incising each leaf in the tree so that it falls away from the surface, revealing the white photo paper on which it was printed. Through a relatively

58. Alighiero Boetti *Mimetico (Camouflage)* 1967 military camouflage cloth 55 1/8 x 57 1/16 in. (140 x 145 cm) Private collection; courtesy Tornabuoni Arte, Florence © 2013 Artists Rights Society (ARS), New York/SIAE, Rome; courtesy Fondazione Alighiero e Boetti—Archivio Alighiero Boetti, Rome

59. Jim Hodges *Untitled* 1988 mixed media dimensions variable work destroyed

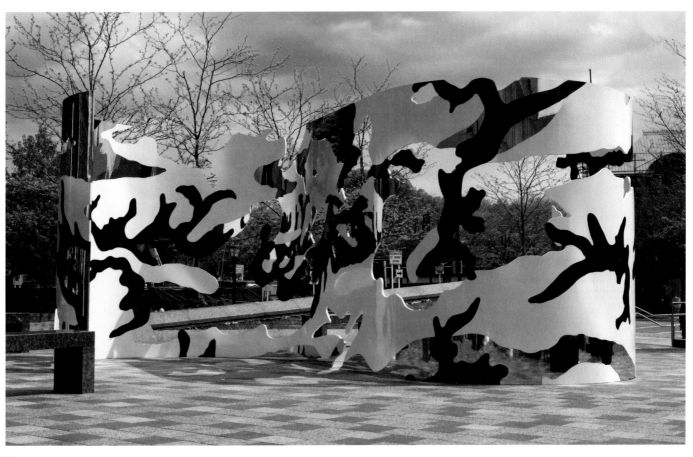

60

60. Jim Hodges *look and see* 2005 enamel
on stainless steel 300 x 138 x 144 in. (762 x
350.5 x 365.8 cm) Albright-Knox Art Gallery;
Sarah Norton Goodyear, George B. and Jenny
R. Mathews and Charles Clifton Funds, 2006

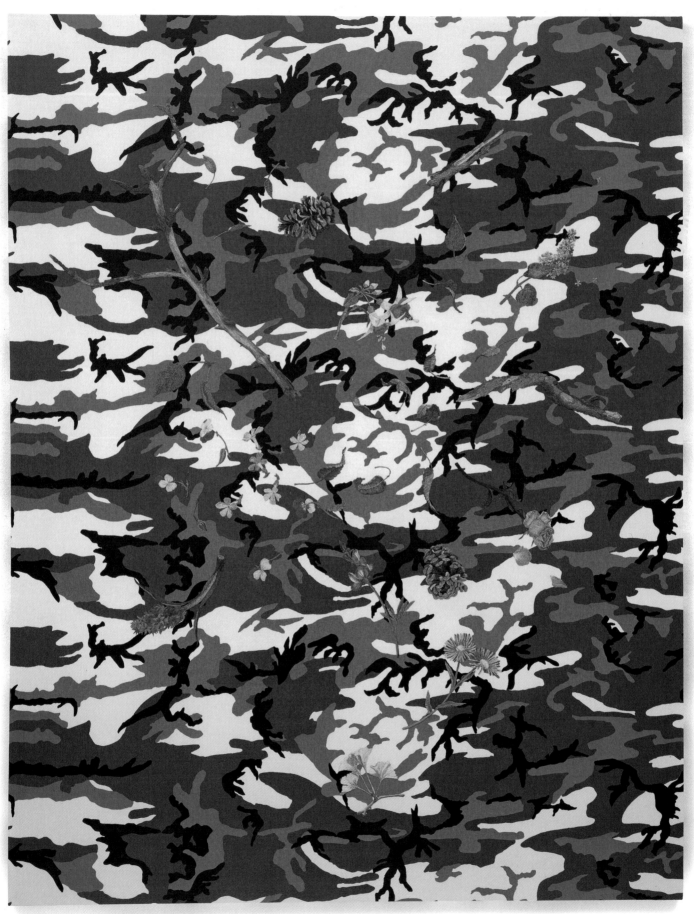

62

61. Jim Hodges *all in the field* 2003
embroidered fabric 72 x 48 in. (182.9 x 121.9 cm)
Cranford Collection, London

62. Jim Hodges *end of time (light gray)* 2008
cotton, polyester 89 ³/₄ x 173 ¹/₄ in. (228 x 440 cm)
Private collection Photo: Stephen White;
courtesy Stephen Friedman Gallery, London

simple if laborious act of transmutation, the two-dimensional plane of the photograph is transformed into a three-dimensional, sculptural object. This subtle shift confirms the artificial nature of the tree — it is only a photograph, after all — and simultaneously provokes a change in one's perception.

In his influential text *Camera Lucida*, French critic Roland Barthes writes movingly of how photographs confer mortality on their subjects. [43] When Hodges photographed this tree, he figuratively imposed a death sentence on a living thing. When he cut away the surface to expose the nature of this artifice, he effectively reanimated the photograph, investing it with new life as an art object. Like the traditional theme of *vanitas*, with its reflection on mortality and the folly of life, which appears periodically throughout Hodges's oeuvre, the metamorphosis enacted in *where the sky fills in* encourages one to consider the physical and emotional barriers separating the natural and constructed worlds. [44]

These same processes of disassembling and reassembling, fracturing and engraving, distilling and abstracting, amplifying and secluding were realized on an operatic scale in one of the most complex and ambitious works Hodges has created in his twenty-five years as a mature artist: *and still this* (2005–2008; Nos. 64, 111–120). Produced over a period of five years, with two of them devoted almost exclusively to its fabrication, *and still this* is an architectural installation made up of ten large panels of gold leaf on gessoed linen. Increasing in both height and width incrementally by one inch per panel, the individual sections are joined together in a gently coiling arc echoing the spiral of the Golden Mean. Each of the ten panels is a singular composition (Hodges refers to the panels as paintings, but recognizes the work as a single sculpture) that forms one chapter in a multipartite narrative. The work is positioned in a room so that as the viewer approaches it, he or she encounters the backside of these panels and is forced to walk partially around the sculpture before entering into it. One transitions from the minimal, architectonic structure of exposed stretcher bars and raw canvas into a dazzling wonderland of gold, intricate patterns, and complex imagery. The effect is startling, similar to entering the interior of an elaborately decorated Islamic shrine, in which every inch of surface is covered in shimmering silver and gold.

Read sequentially, the ten panels illuminating *and still this* narrate a modern-day creation myth born entirely of Hodges's fertile and febrile imagination. In this work, he revisits his development as an artist, at times comically rewriting his own signature moves and casting a retrospective eye on themes and motifs that track throughout his career. He regards *and still this* as "a once-in-a-lifetime experience," and it does indeed synthesize a lifetime of experiences into a spiritual reckoning with the very possibilities they initiated.

Panel one (No. 111) begins the journey. Its surface is almost entirely laminated with sheets of gold leaf except for the pattern in white linen suggesting a vortex. Gathering centripetal force, this swirling composition calls to mind Hodges's *Oh Great Terrain*, the stars of the Milky Way, and even the invisible "primordial soup" proposed to be the beginning of all life forms. Panel two (No. 112) continues the generative proposition of the first. Protean matter seems to have quickly undergone the process of mitosis, splitting into mirror images of fecundity. This Rorschach image of semiabstracted flora creates a framework recalling Hodges's

63. Jim Hodges *where the sky fills in* 2002 cut chromogenic print 76 x 50 in. (193 x 127 cm) The Museum of Modern Art, New York; fractional and promised gift of Agnes Gund in honor of Elaine Dannheisser

64. Jim Hodges *and still this* 2005–2008 23.5k and 24k gold with Beva adhesive on gessoed linen 89 x 200 x 185 in. (226.1 x 508 x 469.9 cm) overall The Rachofsky Collection and the Dallas Museum of Art through the DMA/amfAR Benefit Auction Fund Photo: Brad Flowers; courtesy Dallas Museum of Art

earlier *Untitled (Threshold)*. Inside the space of panel three (No. 113), one recognizes a convergence of the two preceding panels. Natural elements and unbound forces harmonize, coalescing into a powerful field of energy defined by shardlike sunbeams. The fourth panel (No. 114) shifts in tone, as the elements that appeared to reconcile in parallel synchronicity in the previous two panels now splinter into individual fractals, sending harlequin patterns dancing across its surface. The potential of this harnessed energy and light is apparent in panel five (No. 115), which depicts clouds in the sky being shot through by sunbeams, an image recalling a pervasive, if tacky, genre of imagery in which God is alluded to by the shafts of light breaking through a cloudy sky. [45]

Panel six (No. 116) moves from the heavenly realm to the earthly, as the rays of light from the previous panel shoot through a dense forest. Details from the preceding panel appear as a cinematic sequence of close-up views in panels seven, eight, and nine (Nos. 117–119). This sequence also recalls the visual effect of the nineteenth-century zoetrope, a device that creates the illusion of movement through the rapid succession of still images. Panel ten (No. 120) concludes this magnum opus in a gesture of openness and eternal return. A shining light emanates from the center of the canvas as if the viewer were looking up from below, through the limbs and leaves of an overhead tree. Recalling the central force of energy in panel one, it offers illumination, acquiescence, and tranquility in the wake of tumult.

Although the progression in *and still this* would provide a neat conclusion to a discussion of Hodges's career thus far—artist moves from darkness to light, proceeding from denial to acceptance to achieve enlightenment—such a tidy analogy will not hold. Fortuitously and productively, in the act of creating *and still this*, a work one critic compared to "Renaissance woodcut illustrations for the Book of Genesis," [46] Hodges found that such sustained immersion in luminosity provoked in him a need to connect with something he describes as "darker." What followed were the installations *the dark gate* (2008) and *generator* (2009), the former a dark chamber that one must enter, and the latter an unfinished sculpture that continues to mutate: expanding, contracting, and consuming the architecture in which it is installed.

The central chamber of *the dark gate*, which comprises a room within a room, is a boxlike structure made of wood planks, like a crate (No. 65). One enters the space through a set of swinging doors, which, Hodges acknowledges, are his own romantic reimagining of the archetypal saloon doors of the Wild West. But here the physical invitation to enter is immediately rebuffed. Crossing the threshold, one is confronted by a menacing oculus of sharpened steel spikes that focus one's view onto a single illuminated lightbulb suspended from the ceiling. Fragrance—a mixture of the Shalimar perfume his mother always wore and another scent Hodges was wearing at the time of her death—fills the air, emanating from the razor-sharp tips of the spikes, which frame a forbidding and violent opening one dare not transgress. The lone bulb at the center of the aperture is positioned, philosophically, at the opposite end of the emotional spectrum Hodges captured in his previous sculptures using light. Here there is nothing but abject loneliness, terror, and isolation; this could be a prison cell, an interrogation room, or a torture chamber.

The work had its genesis during a site visit Hodges made to the Aspen Art Museum in preparation for an exhibition there in 2009 that would be the first

65. Jim Hodges *the dark gate* (detail) 2008 wood, steel, electric light, perfume, paint, flooring 96 x 96 x 96 in. (243.8 x 243.8 x 243.8 cm) structure; overall dimensions variable Private collection Installation view, CRG Gallery, New York, 2008

(and to this date only) public presentation of *generator* (No. 66), *the dark gate*'s conceptual twin. It consists of a simple system of interlocking wood components measuring two by two feet, with each square hinged together and locked or unlocked by latches made from bars of wood pinioned on a single nail. The primitive, mechanical, do-it-yourself quality of *generator* at first suggests childhood memories of building forts or tree houses. But its elements are painted black, nullifying such carefree associations with innocent times. Solid yet easily disassembled, *generator* is an endless well of potential, capable of mutating and morphing into a variety of configurations limited only by the viewer's imagination. The installation is a physical representation of a psychic space Hodges was inhabiting at that time, following the death of his mother. Furthermore, both *the dark gate* and *generator* resulted from the time he spent creating *and still this*; according to Hodges, "*the dark gate* was originally expressed as an escape hatch in *and still this*. Two-thirds of the way through it, I needed to connect with something darker. I put a cellar door in the middle of it, opened up the cellar door, and that's where *generator* was manifested." [47]

Hodges's use of visual metaphor reflects an earnest desire to keep interpretation of his work open, allowing it to serve as a catalyst for what others may bring to it. Nonetheless, his own personal experience continues to shape intention as his work volleys between darkness and light, exquisite color and muted monochromes. As related in the artist's conversation with Olga Viso published in this volume, an extended visit to India that Hodges made in early 2011 profoundly affected his practice, leading him to reconsider the equal viability of the street and the studio as sites for creation and to reconnect with the beauty and vulgarity inhabiting every material he touches. These tendencies are reflected and mediated in Hodges's most recent work, as he continues to create both theatrical and complex installations and more subtle works on paper.

As part of his 2011 exhibition at Gladstone Gallery in New York, Hodges created two separate rooms, both *Untitled*, that exploited the dichotomies of lightness versus darkness and color opposed to its absence. One installation consisted of a brightly lit room opened to the audience on one side, like a stage set. Composed of white canvas walls, the sculpture could be activated by anyone: viewers were free to enter the space if they chose and become participants in an ongoing performance. This three-dimensional painting-in-process created itself throughout the run of the exhibition. As visitors stepped onto and walked around the "stage," they were forced to frantically dodge and run from douses of vibrant tempera paint that dropped methodically from apertures in the ceiling overhead (Nos. 69–71). Laughing, shrieking, cringing, and celebrating, participants reacted in wildly different ways to the experience based on their own emotional response to the chaos and color.

The other room was similarly animated and performative, though its emotional tone resided at the opposite end of the spectrum. Riveting, meditative, and conducive to private thoughts, this space was dominated by an enormous disco ball suspended from the ceiling that descended deliberately, submerging into a pool of inky black water recessed into the gallery's concrete floor (Nos. 168–171). Ascending, descending, and reascending in a continuous cycle, the ball spun slowly as it moved up and down with four computer-controlled lights projected onto it, casting magical cascades of fractured light across every surface

66. Jim Hodges *generator* 2009 plywood, wood, latex paint, hinges, steel bolts, screws dimensions variable Collection the artist Installation view, *Jim Hodges: you will see these things*, Aspen Art Museum, 2009

67. Jim Hodges *nothing named 4* 2012 charcoal, duct tape, 24k gold with Beva adhesive on paper 30 x 22 ½ in. (76.2 x 57.2 cm) Collection Melissa Balbach and John Bace Photo: Jason Dewey

68. Jim Hodges *nothing named 7* 2012 charcoal, Japanese silver leaf with Beva adhesive on paper 30 x 22 ½ in. (76.2 x 57.2 cm) Collection John and Debra Scott Photo: Jason Dewey

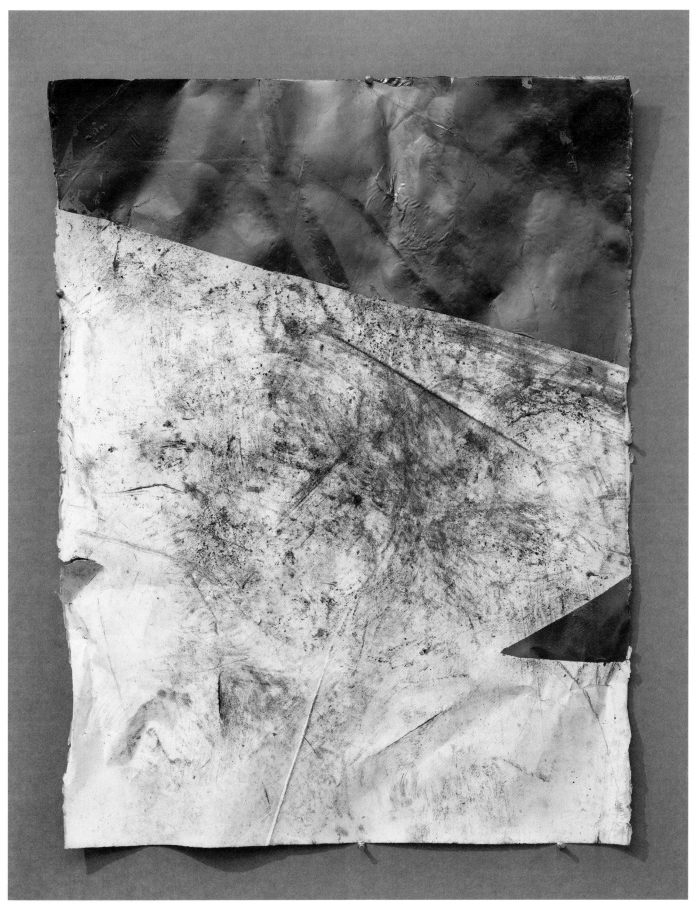

of the room and the bodies of viewers. Despite their high degree of theatricality and the complex mechanical requirements of each work, both demonstrated— as did the scratched sky photographs he also included in the show—a series of straightforward and simple gestures reflecting Hodges's renewed, perhaps continuing interest in the messier, scruffier, process-based approach to making art that he first engaged in his underground lair in the late 1980s.

In 2000 Charles LaBelle wrote a compelling review of Hodges's exhibition at the Capp Street Project in San Francisco, in which he referred to the artist as "a poet of the street." [48] And in recent years, Hodges has increasingly harnessed and rehoned this sensibility, recovering the elemental processes he forged as an artist more than a quarter-century ago, while moving them productively forward into new territory. Nowhere is this spirit more evident than in a group of drawings, some of which might be considered sculptures, that Hodges produced between 2011 and 2012 (Nos. 67–68). These works grew, quite literally, out of the streets of New York. Rendered primarily in the black-and-white palette that defines much of his early work, most are also shot with brilliant color accents derived from foil papers, gold leaf, and chunks of accumulated tempera paint Hodges harvested from his 2011 paint-machine sculpture.

Hodges began this body of work by leaving papers in the street near his studio after a heavy storm, where they were exposed to the elements, kicked around, driven over, sullied, and generally abused by pedestrians and traffic. He then reclaimed these freshly patinated papers, transporting them back to the studio where he then began to domesticate them, intuitively taming the material by shaping, cutting, folding, and coloring. Allowing nature, chance, and intention to commingle in the studio, Hodges recast and revitalized the processes of time, assemblage, and dispersal that were so essential to his first experiences as an artist. This notion of an eternal return—the present ingesting the past— winds itself through the arc of his career. Investigating a spectrum of experience through varied yet synchronic materials, Jim Hodges continually proposes new conceptions for his art, suggesting an enduring realm of endless possibilities. *

ENDNOTES

1. Jim Hodges, e-mail message to author, November 26, 2012.

2. Jim Hodges, e-mail message to author, March 18, 2013.

3. Jim Hodges, conversation with author, June 21, 2012.

4. Jim Hodges, e-mail message to author, November 12, 2012.

5. Jim Hodges, e-mail message to author, November 11, 2012.

6. Though the two artists never met, Hodges's studio was next door to Warhol's printer, and as a habitual diver of dumpsters, Hodges once fished some rejected Warhol camouflage prints out of the neighbor's trash and incorporated them in his work, notably in an untitled early lost sculpture from 1988 (No. 59).

7. Cornelia Butler has described Tuttle's ability to produce conventionally conceived drawings alongside his *Wire Pieces* (essentially drawing gestures rendered in wire) as relying on a "sort of conceptual performativity." Cornelia H. Butler, "Kinesthetic Drawing," in *The Art of Richard Tuttle*, ed. Madeleine Grynsztejn (San Francisco: San Francisco Museum of Modern Art, 2005), 172.

8. Jim Hodges, conversation with author, November 8, 2010.

9. Jim Hodges, conversation with author, June 21, 2012.

10. One of Stelarc's performances, *Street Suspension*, took place in New York City on July 21, 1984, above the street outside the Mo David Gallery. Whether or not Hodges was aware of this event, Stelarc's actions were reported widely in popular arts coverage at the time.

11. As Paul Schimmel notes, the painting's title may refer to a camp outside of Tishomingo, Oklahoma, where German prisoners-of-war were held during World War II. See "The Void as a Space for Potentiality: Paul Schimmel on *Destroy the Picture*," *The Curve*, October 10, 2012, http://www.moca.org/audio /blog/?p=3659.

12. Another work by Hodges, the sequence of drawings from 1993 called *A year of love* (No. 167), also appears linked to Thek's influence, particularly his *Earth Drawings*, a series of ink and watercolor drawings on newspaper. These numerous works depict the earth in white and blue—either on single or multipartite sheets—from outer space, against a black background. Hodges's potential inversion of the earth drawings in *A year of love* may be his homage to Thek.

13. Jim Hodges, e-mail message to author, November 11, 2012.

14. *Untitled (Gate)* was on view for just over three weeks, from September 11 to October 4, 1991; its inclusion in the current exhibition represents the first showing of the work since that time.

15. Stuart Horodner, "Jim Hodges," *Bomb*, no. 79 (Spring 2002): 101. Hodges had flirted with the form for several years, making drawings using transparent tape that took on a weblike appearance but lacked the graphic symbolism of an orb-weaver's web.

16. Hodges recalls a sequence of events that led him to create the first "web": "Spending time in Seattle visiting my brother, I sat on his deck one morning drinking coffee and watched a spider make a web. Upon my return to New York City I went to a concert at Jones Beach to see Erasure; part of their stage set incorporated a large web made of ropes.... There was an additional occurrence … I was convinced that it was time I made one myself." Jim Hodges, e-mail message to author, November 12, 2012.

17. Other examples include *stay close* (1995), a monolithic "non-room" that one could walk into if not exactly enter; *and still this* (2005–2008), an assemblage of ten intricately patterned panels in gold leaf that creates an immersive environment; and *the dark gate* (2008), a sinister chamber that forms a coda to *Untitled (Gate)* (1991) and *generator* (2009). Each of these works expresses a formidable ambition to declare space in a way that is perceptually at odds with the supposed delicacy many have detected in Hodges's body of work.

18. Jim Hodges, conversation with author, July 11, 2012.

19. Ibid.

20. Ibid.

21. This ancient philosophical concept or theory suggests that the sun, the moon, and all the planets emit their own unique sounds based on their orbital revolution, and that conditions of life on earth reflect the tenor of these celestials sounds—their unity or dissonance—though they remain imperceptible to the human ear.

22. An interesting and related connection is found in lyrics to "All the Trees of the Field Will Clap Their Hands," a song by Sufjan Stevens, one of Hodges's favorite musicians. No doubt inspired directly by the biblical verse, Stevens wrote:

And I heard from the trees a great parade.
And I heard from the hills a band was made.
And will I be invited to the sound?
And will I be a part of what you've made?
And I am throwing all my thoughts away.
And I'm destroying every bet I've made.
And I am joining all my thoughts to you.
And I'm preparing every part for you.

23. Jerry Saltz, "Mystic, Cryptic Revelations," *Village Voice*, December 13, 2005.

24. Burchfield is believed to have been afflicted by synesthesia, the phenomenal joining of senses that occurs when stimulus of one type, such as color, registers a simultaneous response in another modality, for example sound, so that one actually sees color when hearing sound.

25. In 1992, using money provided by a grant, Hodges rented a cabin on Vachon Island, one of the largest islands in Puget Sound off the coast of Washington State, where he produced four plein-air drawings.

26. "You Ornament the Earth: A Dialogue with Jim Hodges and Ian Berry," in Ian Berry and Ron Platt, eds., *Jim Hodges* (Saratoga Springs, NY: Frances Young Tang Teaching Museum and Art Gallery, 2003), 14.

27. Roberta Smith, "Jim Hodges" *New York Times*, February 11, 1994.

28. Susan Harris, "Jim Hodges: CRG," *Art News* 93, no. 4 (April 1994): 173.

29. Reagan Upshaw, "Jim Hodges at CRG Art," *Art in America* 82, no. 5 (May 1994): 109. Upshaw also proposed that "Flowers have traditionally been symbolic of precarious beauty," and they "also have a feminine or gay connotation in this culture."

30. Matthew Weinstein, "Jim Hodges," *Artforum* 32, no. 9 (May 1994): 102. "With his appropriation of the kind of femininity any sophisticated female (over the age of 12) would shun, Hodges produces a melancholic reflection of an outcast sensibility. His poetry belongs to another gender's mythology; his self-imposed alienation from the male master-narrative is, for me at least, warm in its familiarity."

31. Lynn Gumpert, "Material Meditations," in *Material Dreams* (New York: Gallery at Takashimaya with the cooperation of the Fabric Workshop and Museum, 1995), 17.

32. Joshua Decter, "Jim Hodges: Marc Foxx," *Artforum* 35, no. 3 (November 1996): 104.

33. Gumpert, "Material Meditations," 18.

34. Gary Garrels, *Present Tense: Nine Artists in the Nineties* (San Francisco: San Francisco Museum of Modern Art, 1997), 22.

35. Jim Hodges, e-mail message to author, December 2, 2012.

36. Dana Friis-Hansen, "Jim Hodges," in *Abstract Painting, Once Removed* (Houston: Contemporary Arts Museum, 1998), 62.

37. Jim Hodges, telephone conversation with Dana Friis-Hansen, July 7, 1998, cited in *Abstract Painting, Once Removed*, 62.

38. Kelly abandoned the use of descriptive titles later in his career, a practice that Hodges now emulates, preferring to leave most works untitled. It is useful, however, to consider the precision with which Hodges once titled his work. For instance, the evocative title of each collage in the series *Another Moon, Satellite*, and *On Earth, Every Color* (all 1998) suggests another dimension or intergalactic distance, perhaps a connection back to one of Hodges's childhood fantasies, a time when he "thought it was more interesting to pretend I was from another planet." Jim Hodges, conversation with author, August 28, 2012.

39. *Burning, Bright: A Short History of the Light Bulb*, a group exhibition focusing on the incandescent lightbulb as subject and material in twentieth-century art was presented at Pace Gallery, New York, October 28–November 26, 2011. The show featured work by Arman, Francis Bacon, Joseph Beuys, Alexander Calder, Pier Paolo Calzolari, Brian Clarke, Jim Dine, Adrian Ghenie, Felix Gonzalez-Torres, Loris Gréaud, Philip Guston, David Hammons, Jasper Johns, Matt Johnson, Ilya and Emilia Kabakov, Lee Ufan, Roy Lichtenstein, Man Ray, Robert Morris, Tim Noble and Sue Webster, Claes Oldenburg and Coosje van Bruggen, Pablo Picasso, Michelangelo Pistoletto, Robert Rauschenberg, Ugo Rondinone, James Rosenquist, Jeanne Silverthorne, Kiki Smith, Keith Sonnier, Hiroshi Sugimoto, Robert Whitman, and Zhang Xiaogang.

40. Jim Hodges, conversation with author, August 28, 2012.

41. Christine Temin, "His Sound Art Echoes in the Mind," *Boston Globe*, July 9, 2003.

42. Jill Medvedow and Carole Anne Meehan, eds., *Vita Brevis: History, Landscape, and Art, 1998–2003* (Boston: Institute of Contemporary Art; Göttingen: Steidl, 2004), 33.

43. Roland Barthes, *Camera Lucida: Reflections on Photography* (New York: Farrar, Straus and Giroux, 1981).

44. A version of this passage of text on *where the sky fills in* first appeared in Carter Foster and Jeffrey Grove, *Drawing Modern: Works from the Agnes Gund Collection* (Cleveland: Cleveland Museum of Art, 2003).

45. Critic Saul Ostrow wrote insightfully about this work, citing comparisons to the painters of the Hudson River School as well as to Warhol's camouflage paintings. Saul Ostrow, "Jim Hodges: CRG," *Art in America* 96, no. 8 (September 2008): 159–160.

46. Ken Johnson, "Jim Hodges," *New York Times*, March 28, 2008.

47. Jim Hodges, conversation with author, June 21, 2012.

48. Charles LaBelle, "Jim Hodges," *Frieze*, no. 54 (September–October 2000): 120.

69–71. Jim Hodges *Untitled* 2011 wood, canvas, tempera, mechanics dimensions variable Installation view and details, Gladstone Gallery, New York, 2011 Courtesy the artist and Gladstone Gallery, New York and Brussels Photos: David Regen; courtesy Gladstone Gallery

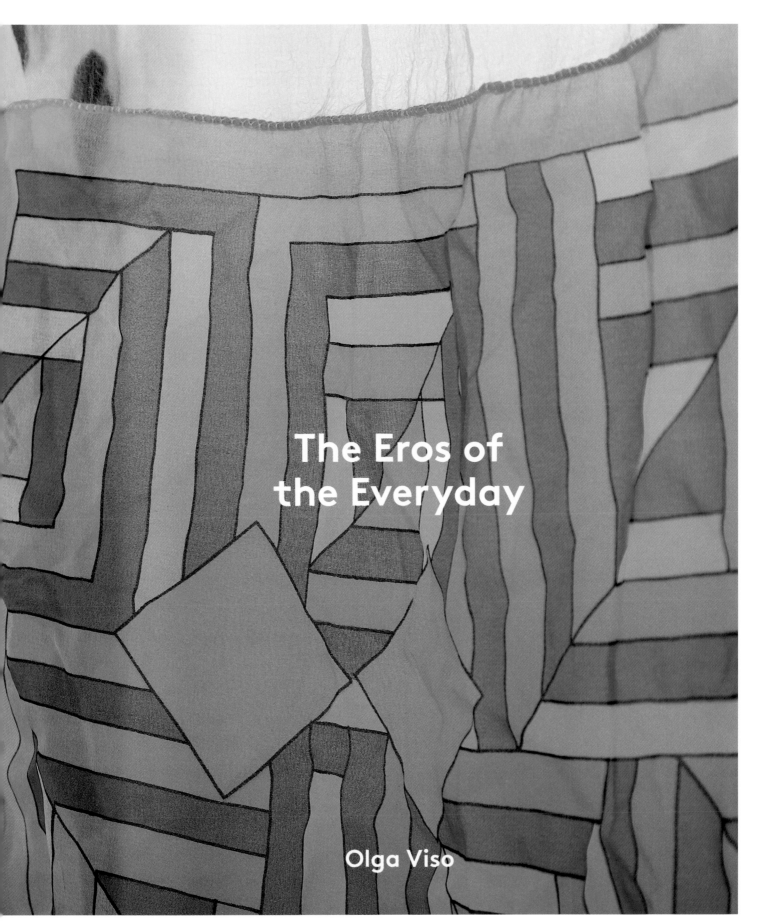

The Eros of the Everyday

Olga Viso

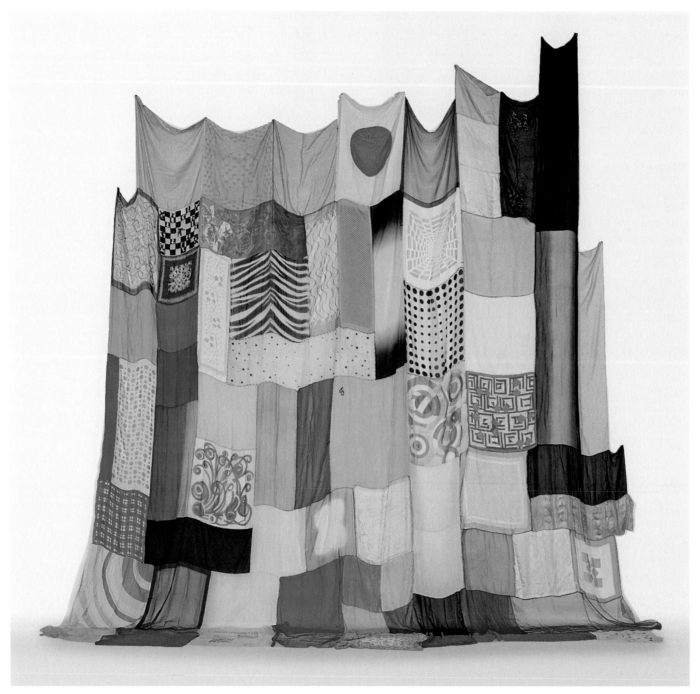

"Certain acts dazzle us and light up blurred surfaces if our eyes are keen enough to see them in a flash, for the beauty of a living thing can be grasped only fleetingly. To pursue it during its changes leads us inevitably to the moment when it ceases, for it cannot last a lifetime. And to analyze it, that is, to pursue it in a time with the sight and imagination, is to view it in its decline, for after the thrilling moment in which it reveals itself it diminishes with intensity." —Jean Genet, *Miracle of the Rose* (1946)

When I first encountered the work of Jim Hodges in 1995, in a small art space in Los Angeles, [1] it was a visceral experience, characterized by heightened awareness and nostalgia. It was spring, and the sun that day was especially bright. My eyes adjusted as I passed through the front door, which had been left propped open to invite a casual wind. Upon entering, I was transfixed by a translucent blanket of fabric billowing above the floor—a patchwork grid of sheer silk scarves in a plenitude of colors tacked on the wall. I was instantly assaulted by a flood of childhood memories, transported to carefree afternoons when I would come home from grade school and frolic blithely around the house, rifling through my mother's bedroom drawers, pulling out a seemingly endless array of scarves, tying them together, and wrapping my hair in front of the mirror. Now, standing before Hodges's piece, I could almost smell my mother's perfume wafting from the silken mesh. Each of the graphic patterns in this unlikely quilt evoked its own specific recollections of childhood and its promises. I felt an inexorable familiarity and identification with these materials, as well as a palpable sensation of rupture and loss. Hodges's wall sculpture, aptly titled *Here's where we will stay* (1995; No. 72–73), did invoke a feeling in me that time had been arrested. There was a slowing down, a delay in my perception that is difficult to describe and, perhaps, was more akin to the experience of reading a moving piece of poetry, watching fireworks, or having a deep connection with music. All the elements were present that I associate with these kinds of transitory events: anticipation, discovery, elation, lament, euphoria, and, ultimately, catharsis.

Taking stock of temporal, fleeting moments of everyday life and experience, Hodges approaches art making from a decidedly humanist perspective. Inspired by nature and the potency of memory, his practice is guided by a keen sensitivity to materials and a process that mines quotidian forms and objects for their emotive potential. His art is also shaped by a strong political conscience and a personal ethic devoted to freedom and social justice. The result is a mesmerizingly diverse body of work that has both eluded and confounded art critics since the 1990s for its refreshing authenticity, its embrace of notions such as beauty, generosity, and craft, and its slippery resistance to polemic. Indeed, throughout his career, Hodges has been less concerned than many of his peers with engaging in art historical theory or in debates around institutional and cultural critique. He was never consumed by the legacies of painting or the histories of Conceptual art and Minimalism that shaped the trajectories of many artists of his generation. His art, by contrast, finds more meaningful reference in the history of American literature, from Walt Whitman to William Carlos Williams and T. S. Eliot, than it does in the history of art. Indeed, some of the most insightful writing on the artist to date has been penned by literary authors, most notably Colm Tóibín and Lynne Tillman. These individuals come closest to capturing Hodges's singular practice.

72–73. Jim Hodges *Here's where we will stay* 1995 printed nylon, painted chiffon and silk head scarves with thread, embroidery, sequins 216 x 204 in. (548.6 x 518.2 cm) overall Courtesy the artist and Stephen Friedman Gallery Photos: Mark Blower, courtesy Stephen Friedman Gallery, London (72); and Christie's Images/Bridgeman Art Library (73)

It is thus not surprising that the terms employed by literary critics to describe an author's methods and style—narrative, character, metaphor, allegory, elegy, allusion, and metonymy—seem more apt in framing a deeper, more critical understanding of both Hodges's art, in all its nuances, and its reception. Traditional corollaries around the interpretation of art—with their focus on artistic biography and creative process, critical theory and philosophy, a work's place within the history of art, and the sociopolitical context of its making—are useful, but they are limited in their ability to convincingly articulate the significance of a practice that is layered, poetic, and equivocal. Hodges's own use of language in his titles serves to introduce and suggest potential meanings as he seeks to foreground the dualities of our existence and to manifest the threshold spaces in between. Titles such as *Here's where we will stay*, *here it comes*, and *On We Go* all reinforce the notion of slowing down, of stopping and discovering, or of passing through disjunctive moments that lead to deeper consciousness and heightened awareness.

Hodges achieves this result through a subtlety of means and a modesty of gesture. His art involves quite simple acts: assembly, disassembly, folding, unfolding, repositioning, recontextualizing, and establishing striking juxtaposition. These gestures effectively "freeze," diagram, extend, or expose complex human feelings associated with and/or embedded in objects and materials. Whether the artist is creating a monumental outdoor sculpture using stone and steel or making a piece of delicate visual poetry like that shimmering scrim of fabric fluttering on the wall, his alchemy profoundly transforms rather ordinary materials and temporal artifacts of culture into extraordinary objects of reflection and contemplation. In his hands, they become poetic ruminations on life and the fragile nature of our existence. As Tillman notes, Hodges's work "revels in and unearths the significance of pastness, of what's gone, lost, what's left, discarded literally, or stuck in memory; then, through a work, he claims it—for now." [2]

As I would come to learn many years after my first encounter with *Here's where we will stay*, scarves conjured similar childhood associations for the artist. The work was a paean to his mother and his great-grandmother, who taught him to sew and cultivated in him a certain sensitivity to space, to the slow and methodical nature of process in craft, and to materials—a sensibility that has distinguished his practice from the beginning. Since the late 1980s, Hodges has transformed an array of commonplace materials and objects—napkins, silk flowers, mirrors, shopping bags, chains, decals, sheet music, lightbulbs, boulders, and words—to make a diverse, expansive body of work that is not easily classifiable. He considers himself both a draftsman and a maker of objects, and these two modalities are perhaps best described, as the artist has done, as forms of record-making and notation.

Some of Hodges's earliest works of the late 1980s and early 1990s consist of "un-monumental" objects that are, for him, monuments of a different order: poignant markers of time that address varying issues of identity, its masking and unmasking, and a growing sense of tragedy and loss. At the same time, their loose assembly and configuration in space allow them to retain the immediacy of a sketch or line drawing. In *Good Luck* (1987; No. 10), for example, he unraveled the threads from the edges of a ski mask and then stretched and pinned it across the corner of a room to reconfigure its inherent facial features. Similarly, in *Deformed* (1989; No. 11), he cut open a floral-print Bonwit Teller shopping bag and flattened it to reveal its

74. Jim Hodges *what's left* 1992 white brass chain, clothing dimensions variable Private collection

75. Jim Hodges *Arranged* 1996 book, metal paperclips 13 x 6 1/2 x 10 1/4 in. (33 x 16.5 x 26 cm) overall Collection Heidi L. Steiger Photo: Ronald Amstutz

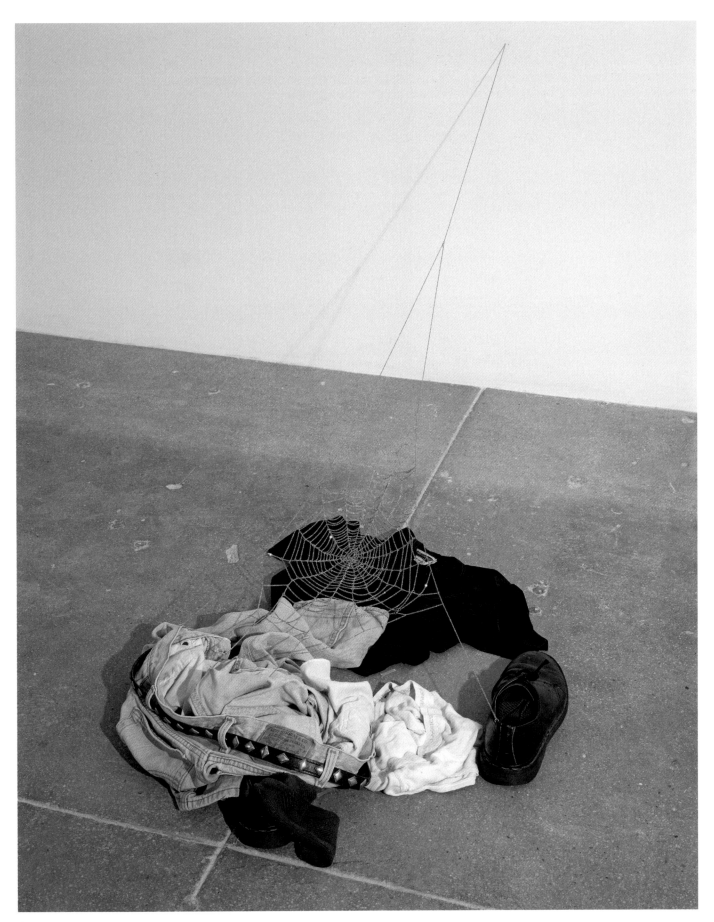

Step 5: Delicate, white tuberoses subtly fill out the design. Th

s design is fill
um orchids e
buquet, b eps from
s beyond s and w

90

ning and elegance from the centers of artichokes. This array
and the graciousness of a hospitable host.

133

design structure and composition. In *Arranged* (1996; No. 75), he curled over the pages of a book to project a two-dimensional arrangement of flowers (on the printed page) into a three-dimensional standing object. In an ongoing series from the early 1990s, he extended these gestures into more literal "drawings" in space by linking metal chains into intricate networks of cobwebs, which he arrayed in clusters on walls or draped in doorways, closets, and passageways. At times he would commingle these man-made webs with personal effects, including his shoes and jeans, as in *what's left* (1992; No. 74), conjuring an array of possible narratives through their simple juxtaposition. Tillman describes how *what's left* inspires a need in her to figure out the story: "I could write a short story. I want to know: where's the body? who wore those jeans? A person, a man, must have hurriedly undressed—for sex, for a shower, he was late, had to change fast, for a party, a tryst, or a funeral. No, he committed suicide—but this happened a while ago, because the web is elaborate, woven over time.... It's like the brain, whose cells renew and whose neurons generate startling and complex links and relationships." [3]

77

In *A Diary of Flowers*, a series from the early 1990s that brought the artist his first critical acclaim, Hodges's adoption of literary forms, such as elegy and metaphor, found even greater expression. These works were born of straightforward, ritualistic acts of drawing each day on coffeehouse napkins. Over time, the artist's accumulated "doodles" would be assembled into cloudlike clusters or groupings, ranging from 8 to 576, which served as elegiac markers, memorializing friends and other individuals, many of whom were lost during the height of the AIDS crisis (Nos. 40, 76). In a related series of "saliva drawings," Hodges transferred small ballpoint-pen drawings of flowers onto other sheets of paper using his saliva (No. 77). This bodily act of transfer and agency was a response to cultural attitudes about AIDS and its transmission in the early years of the pandemic. And though the artist generally resists such narrow, identity-oriented readings of his art, preferring to emphasize its broader communicative potential, Hodges's works of this period were no doubt informed by these stark realities, which he transcribed through subtle, evocative gestures of mourning and memorial.

Transcribing aspects of life experience and giving sculptural or graphic form to shared human emotions became central to Hodges's art throughout the 1990s. In *He and I* (1998; No. 78), he captured the poetry of a powerful romantic union by rendering two large intersecting circles of lines on a wall; each was drawn in a different color selected by the person in question. Metaphor continued to be another potent tool as his expressions took more direct sculptural form. In *Landscape* (1998; No. 80), he nested successive sizes of fifteen men's and boys' shirts, one into the other, and laid the assembled "body" with its arms extended on a simple wooden table. A self-portrait of sorts, the handmade object conjures myriad associations related to time, daily acts of ritual, aging and maturing, familial legacy, and generational continuity.

Even as the scale and construction methods of his works became more ambitious throughout the 2000s, the subtlety of gesture that has always distinguished his art never diminished. To make *Untitled (Love)* (2000–2001; No. 81), he took apart and then recollaged a musical score. *Picturing That Day* (2002; No. 53) also uses sheet music, but here the large-scale collage creates a synesthetic association between sound and color. Through such gesture-laden processes, Hodges loads complex human nuance and content into spare, poetic objects that he has imbued with mystery

76. Jim Hodges *A Diary of Flowers (In Love)* 1996 ink on paper napkins in twenty-four parts 50 x 33 in. (127 x 83.8 cm) overall Walker Art Center; T. B. Walker Acquisition Fund, 2011 Photo: Gene Pittman

77. Jim Hodges *Untitled* 1992 saliva-transferred ink on paper 12 x 9 in. (30.5 x 22.9 cm) Walker Art Center; Miriam and Erwin Kelen Acquisition Fund for Drawings, 2007

78

78. Jim Hodges *He and I* 1998 Prismacolor
pencil on wall 70 ¹/₄ x 102 ¹/₂ in. (178.4 x
260.4 cm) Collection the artist
Photo: Ronald Amstutz

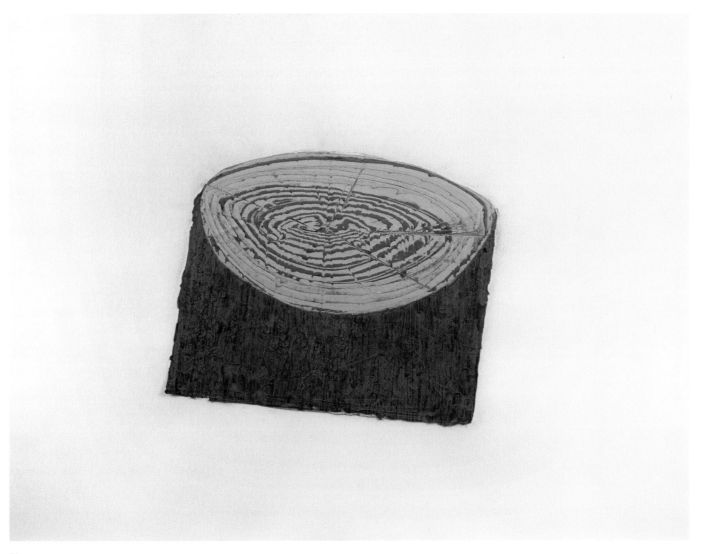

79

79. Jim Hodges *Untitled (Study for One with
the other)* 1997 contact paper on paper
38 ¹/₂ x 50 in. (97.8 x 127 cm) Cejas Art, Ltd.

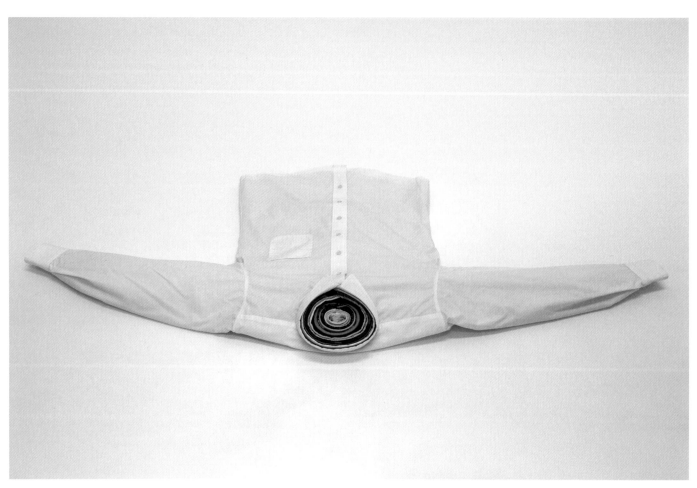

80

80. Jim Hodges *Landscape* 1998 cotton, silk,
polyester, vinyl, wool, plastic 5 x 63 ³/₄ x
32 ¹/₂ in. (12.7 x 161.9 x 82.6 cm) overall
Courtesy the artist and Stephen Friedman
Gallery Photo: Mark Blower; courtesy Stephen
Friedman Gallery, London

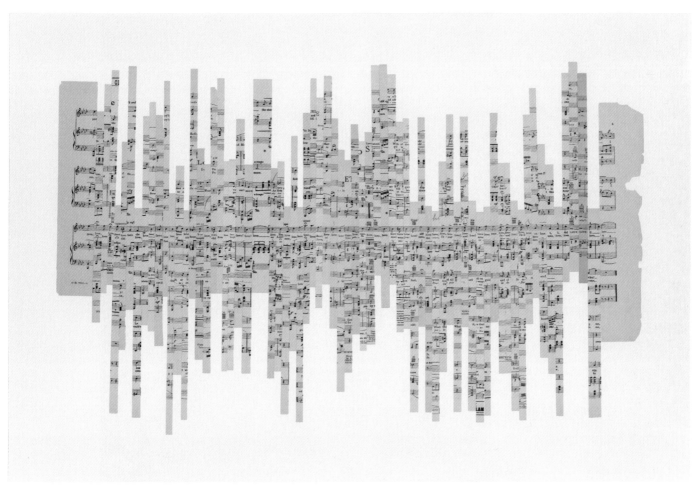

81

81. Jim Hodges *Untitled (Love)* 2000–2001
sheet music collage 21 x 33 ¹/₂ in. (53.3 x
85.1 cm) Whitney Museum of American Art,
New York; purchase, with funds from Faith
Golding Linden, 2002.199 Digital Image ©
Whitney Museum of American Art

82. Jim Hodges *Untitled (It's already hap-
pened)* 2004 cut chromogenic print 102 ¹/₄ x
70 ³/₄ in. (259.7 x 179.7 cm) Collection Andrea
and Jim Gordon

83. Jim Hodges *Just this (the end)* 2010 cut
chromogenic print 98 ³/₈ x 65 ³/₄ in. (249.9 x
167 cm) Collection James Van Damme,
Brussels Photo: David Regen; courtesy
Gladstone Gallery

84

and metaphor. In *Untitled (It's already happened)* (2004; No. 82) and *Just this (the end)* (2010; No. 83), for example, he evokes the seasonal effects of nature through the most modest of means. In these two photographic prints of trees, the paper is cut and alternatively loosened from the front, in the former, and from behind, in the latter, to suggest the cascading effect of falling leaves and their ultimate disintegration.

A modest wall sculpture rendered fully in glass, *a view from in here* (2003; No. 85), depicts a tree branch with a fragile bird's nest. As one ponders the hovering form, which protrudes directly from the wall in three dimensions, one focuses first on the craft and mastery involved in making this delicate glass object with its painstakingly articulated leaves and twigs. The saccharine tones of the greens and pinks that adorn the branch and the blue of the tiny robin's egg located at the nest's center are surprising. Hodges's sentimental image of childhood innocence, redolent with familiar platitudes and "cuteness," is, however, quickly shattered by the sight of the ominous legs of a black widow spider looming at the base of the nest. Here Hodges has given quite literal form to an array of childhood fears and monsters, and to the potent dualities that his works often foreground: beauty and ugliness, fragility and permanence, elegance and kitsch.

The subtle gestures that Hodges enacts privilege human intimacy and the natural world, and often seek to find what is epic in the most mundane. In *Untitled* (2011; Nos. 86–87), now sited on the campus of the Walker Art Center, he transformed four massive granite boulders into striking contemporary objects by applying a sheen of molten, colored stainless steel to their surfaces, literally fusing metal and rock through a complex process of casting and inlaying. Displaced from a forest in western Massachusetts, the boulders had been deposited there by ancient glacial movements. By placing them in a circle, with their finish-fetish metal surfaces in high-key colors facing in, Hodges orchestrated a dynamic interplay of reflection and light. The arrangement also suggests ancient monuments such as Stonehenge and other markers of civilization that attest to humanity's persistence and insistence. The boulders carry another, personal, meaning for the artist related to his 2011 travels in India, where he observed the ritualistic uses of color in Hindu rites and meditation. One is afforded a secular version of this experience by standing in the center of Hodges's boulder circle, amid the intense cacophony of hues afforded by the natural light. In this regard, the boulders operate in a similar fashion to James Turrell's sky spaces, which reference Buddhist as well as American Quaker ritual traditions and are situated in nature and subject to the contingencies of light and time's passage.

Hodges's monoliths harness both epic, timeless themes and a contemporary sensibility, and in this way the artist does not resist the range of human emotion and sentiment that his materials and his gestures upon them might elicit. Indeed, he makes use of all the attendant personal and cultural meanings that materials may possess or that viewers may bring from their own contexts and histories. Throughout his career he has worked with all manner of objects associated with sentimentality and craft, including scarves, silk flowers, and love songs, and taken on loaded subjects such as beauty, romance, and mortality. This approach may seem surprising in the context of contemporary art, particularly the art world of the 1980s and 1990s, when many artists were fixated on questions of identity, multiculturalism, and appropriation. This was a time in which art making privileged social and political commentary over aesthetic, poetic, and formal concerns. [4]

84. Jim Hodges *"When I get there I'll tell them about you"* 2005 Prismacolor pencil on inkjet on paper 14 x 11 in. (35.6 x 27.9 cm) Linda Pace Foundation, San Antonio

85. Jim Hodges *a view from in here* 2003 glass 15 ³/₄ x 11 ³/₄ x 22 in. (40 x 29.8 x 55.9 cm) overall The Rachofsky Collection

86–87. Jim Hodges *Untitled* 2011 granite, stainless steel, lacquer 75 x 248 x 301 in. (190.5 x 629.9 x 764.5 cm) overall Walker Art Center; gift of the Prospect Creek Foundation and a commissioning fund established at the Walker by the Frederick R. Weisman Collection of Art, 2012 Installation views, Gladstone Gallery, New York, 2011 Photos: Ronald Amstutz (86); and David Regen, courtesy Gladstone Gallery (87)

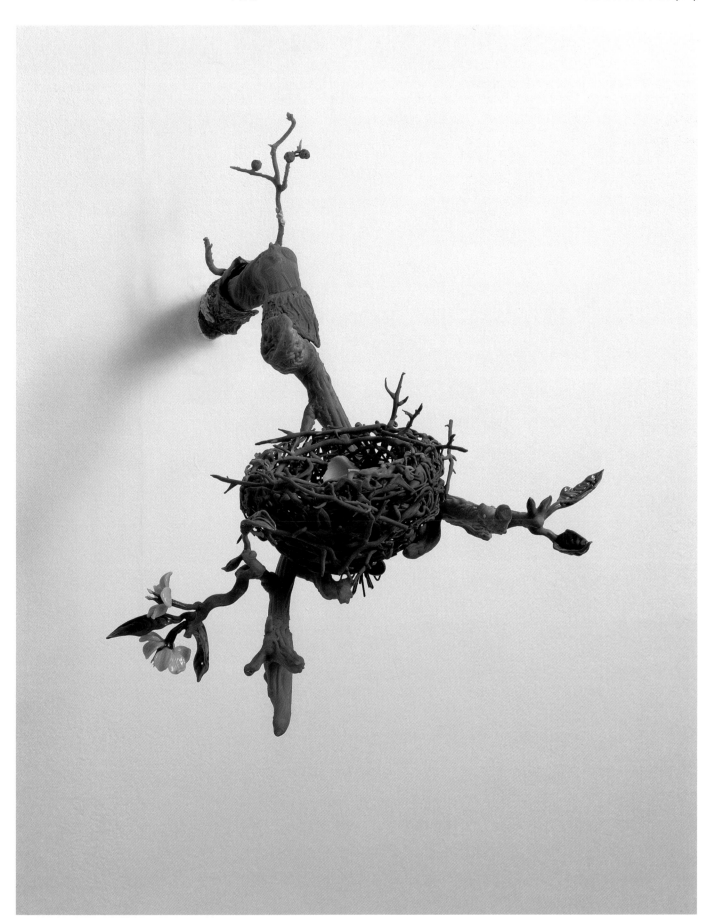

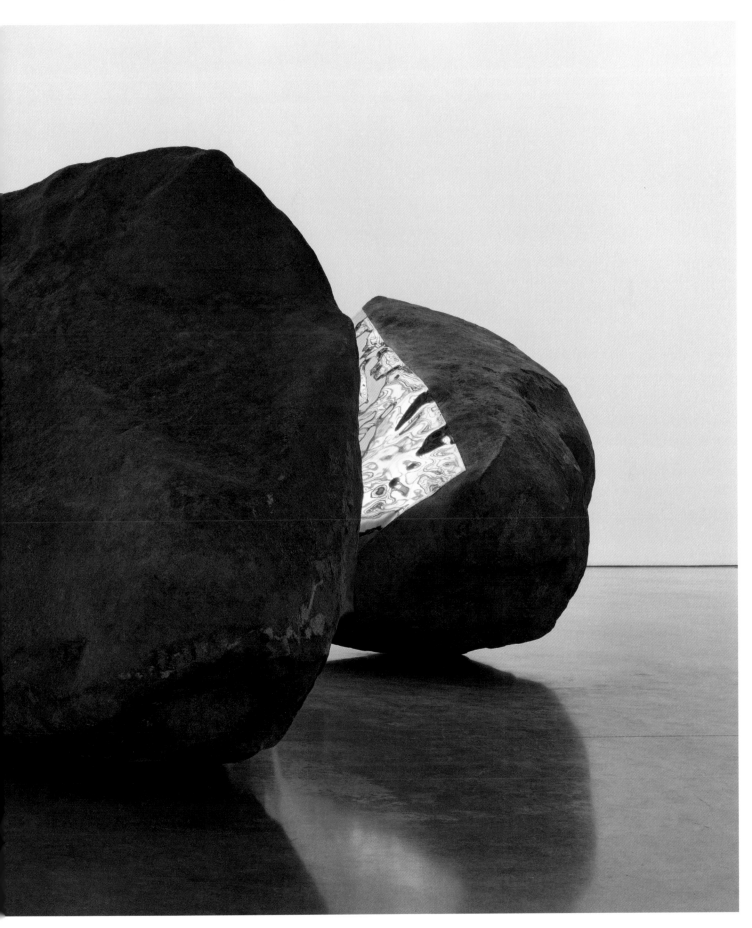

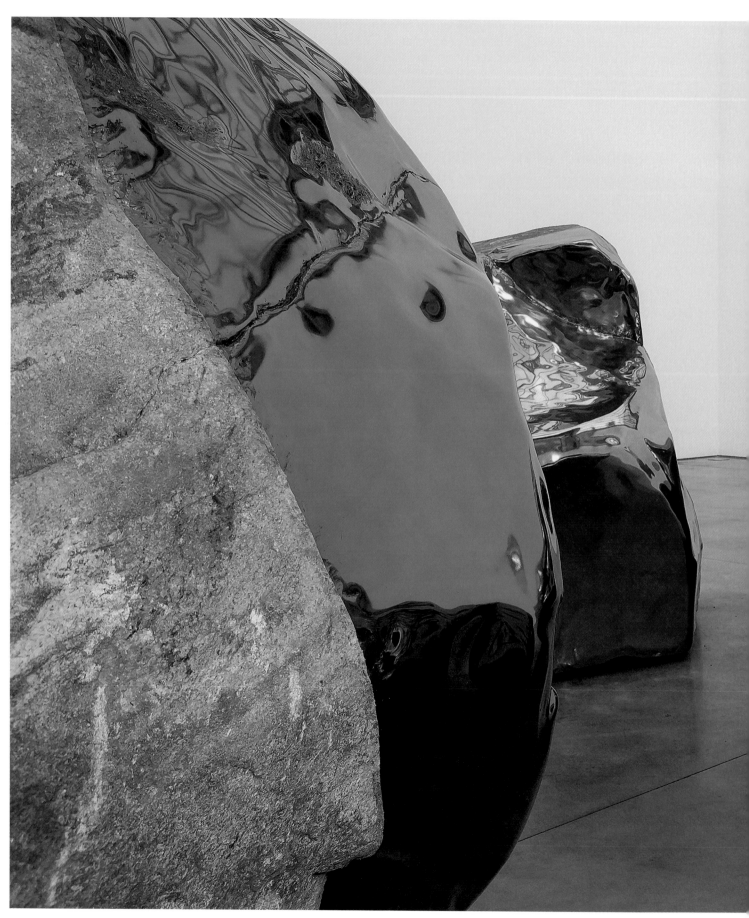

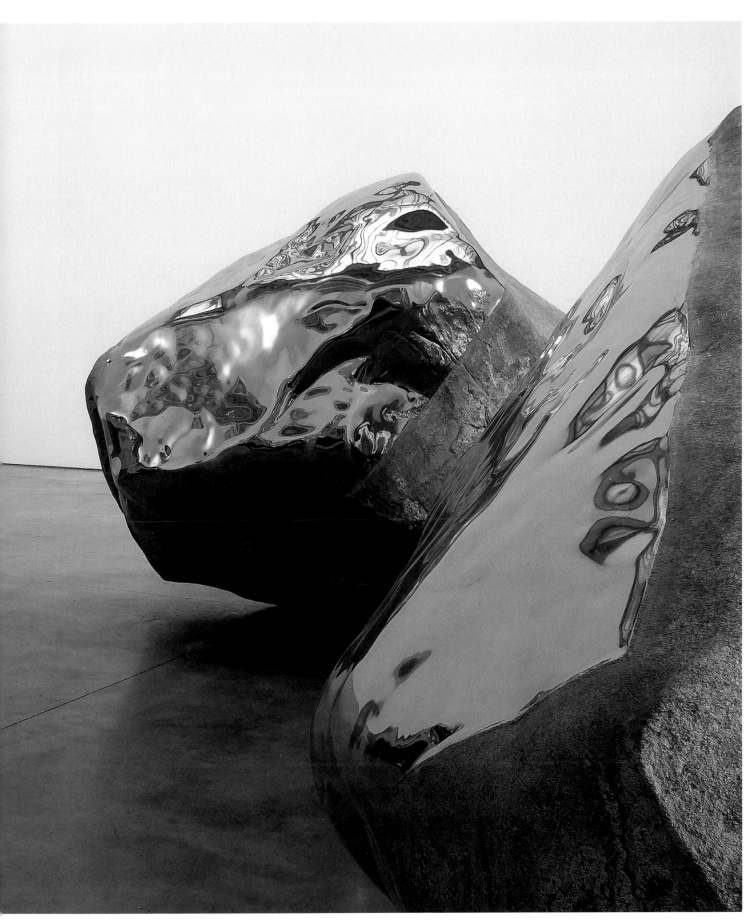

88

88. Robert Gober *Untitled* 1992 dimensions
variable Installation view, Dia Center for the
Arts, New York, 1992 © Robert Gober; courtesy
Matthew Marks Gallery

Hodges's strategies, subjects, and materials, in fact, have their origins in feminist art practice of the 1970s and in the works of artists such as Lynda Benglis, Hannah Wilke, and Louise Bourgeois. In terms of the work produced by other artists active in the late 1980s and 1990s, one might think of Jeff Koons's kitschy porcelain interpretations of banal genre scenes from the history of painting, Haim Steinbach's appliance-covered shelves, Mike Kelley's hand-stitched agglomerations of childhood toys and stuffed animals, and Robert Gober's early dollhouses and fantastical wallpaper tableaux (No. 88). These last artists developed diverse sculptural practices distinguished by mining and recontextualizing everyday materials and objects; their works are imbued with the social and political ethos of their time, emanate from a fascination with material culture, and seek to transcribe the personal into the political. Hodges, on the other hand, unlike his peers, does not appropriate cultural kitsch or quotidian objects as a form of critique. He does not demonize the commodification of culture or cultural excess as Steinbach and Koons do, nor does he delve into the uncanny, abject qualities of these objects in the manner of Kelley and Gober, who alternatively ponder the darker sides of the human psyche. Hodges is perhaps more aligned with certain female sculptors of his generation, including Roni Horn, Katharina Fritsch, and Kiki Smith, whose works manifest a greater connection to nature and express the poetry and politics of the human body in more literary veins.

Addressing broad themes of love, loss, and connections we all share, Hodges was among a small number of artists, including Smith, Horn, and Gober, whose works of the 1990s marked a decided shift in the contemporary artistic landscape and proposed a more quiet and poetic mode of expression in which form and content, beauty and politics, might at once find potent balance and nourishing friction. Perhaps more than any of his colleagues, Hodges takes his cues first and foremost from his chosen materials and harnesses the full range of emotional associations and resonances they carry in a manner that holds poetry and sentiment on a par with social and political content.

Among Hodges's closest friends and colleagues during his early artistic development was the late Felix Gonzalez-Torres. Before his untimely death in 1996, Gonzalez-Torres likewise embraced themes of beauty, generosity, and participation at a time when such subjects were highly contested and politicized in the US art world, particularly as it was shaped by the tragedy of the AIDS crisis, artistic censorship, and political extremism. Hodges's series *A Diary of Flowers* was created concurrently with Gonzalez-Torres's elegiac lightbulb strands (No. 89) and Gober's pierced waxen male torsos. Mexican artist Gabriel Orozco, an artist fascinated by the poetics of the commonplace, also deserves to be mentioned in this context, as do many younger artists who would emerge later in the 1990s, including Olafur Eliasson (No. 90), Wolfgang Tillmans, and Douglas Gordon. And yet, among the many artists who have contributed significantly to the dialogue around beauty, none have tackled the notion as forthrightly as Hodges, harnessing all its delights and discomforts with such audacity and integrity. [5]

As I have struggled to find the appropriate language to describe the depths and potentialities of Hodges's art, as well as to capture its more transcendent and transcendental qualities, I have come to realize that what the work offers beyond poetry, literary expression, and beauty is devotion to what Susan Griffin has referred to as the "eros of everyday life." In her compendium of essays on

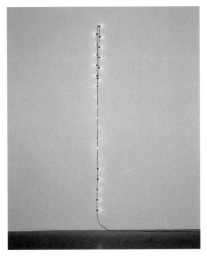

89

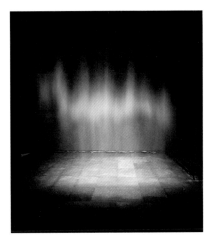

90

89. Felix Gonzalez-Torres *"Untitled" (Last Light)* 1993 lightbulbs, plastic light sockets, extension cord, dimmer switch; edition of 24 + 6 APs overall dimensions vary with installation © The Felix Gonzalez-Torres Foundation; courtesy Andrea Rosen Gallery, New York

90. Olafur Eliasson *Beauty* 1993 spotlight, water, nozzles, wood, hose, pump dimensions variable Installation view, *minding the world*, ARoS Aarhus Kunstmuseum, 2004 Photo: Poul Pedersen; courtesy the artist; neugerriemschneider, Berlin; and Tanya Bonakdar Gallery, New York © 2013 Olafur Eliasson

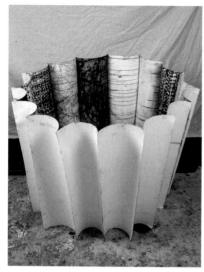

91

ecology, gender, and society, first published in 1995, Griffin eloquently traced what she perceived to be an emergent shift in Western thought in the face of growing global ecological disaster. In her view, society was navigating a crisis of survival and meaning by seeking greater "communion" between science and nature and slowly migrating toward the *eros* embedded in daily and practical life. As she argues:

> If human consciousness can be rejoined not only with the human body but with the body of earth, what seems incipient in the reunion is the recovery of meaning within existence that will infuse every kind of meeting between self and the universe, even in the most daily acts, with an eros, a palpable love, that is also sacred. [6]

It is in this return to nature and intimacy, which privileges the mundane aspects of life and positions the "experience of knowledge as intimacy rather than power," that a "just society" may be found. [7] Griffin's writings, which have been an inspiration to Hodges through the years, seem relevant to developing a deeper understanding of an artistic practice that is rooted in modesty, intimacy, and integrity—one that seeks to find the epic in the most mundane as well as the quotidian in the epic.

Hodges's art, at its core, is about our humanity. It is work about a body moving through life, through experiences, marking life's moments with simple acts of devotion and *eros*—a palpable love—that help us see familiar things in the world differently. Although Hodges would not describe himself as a poet or a philosopher, aspects of both are manifest in his art. As he reveals in the conversation that follows, his art emanates from a complex personal history and an ongoing quest of liberation and undoing. While the work may sometimes be about beauty, sometimes it is not. Sometimes it is dark. Sometimes it is about loss. Sometimes it is about pain and death. *Eros* and *Thanatos*. Sometimes it is ecstatic and euphoric. And, at other times, it is base, honest, and raw.

*

In March and July of 2011, the artist and I recorded several conversations, which we revisited in November 2012 and April 2013. Edited excerpts from these exchanges appear below, in which we touch upon many of the subjects introduced above: love, rejection, mortality, language, color, faith, and making.

ON FIRST ENCOUNTERS

Olga Viso: You've heard me tell the story before, of the first time I saw your work [*Here's where we will stay* (1995)] and how I was transported by that wall sculpture made of silk scarves to an intimate moment from my childhood. One of the things that struck me most about that experience was having such a private moment within the public context of a gallery.

Jim Hodges: Making that work had childhood references for me too. When I was a kid, my brothers and I would put two card tables together and drape them

91. Jim Hodges *One* 1988 charcoal, tempera on paper 36 x 48 x 48 in. (91.4 x 121.9 x 121.9 cm) overall work destroyed

with sheets to construct forts in the living room. These caves of soft cotton made perfect hiding places and spaces of fantasy in which to conjure imagined scenes, where we could become pirates or cowboys and Indians. I find that memories are transmitted through materials, especially when one is engaged in slow, constant contact with them.

When I started sewing the silk scarves together, I became lost in their softness and their color, choosing shades that I might find in the changing skies. At this time, I had also been giving the paintings of Sigmar Polke a lot of consideration. Elaine Dannheisser, who had given me a basement studio space in which to work at her art foundation [in New York], had begun to more aggressively collect Polke, so I was brought into close proximity with a few of his paintings. Some of them were made of disparate fabrics that had been sewn together. I would look at the paintings and think, "Why the paint? Isn't the fabric enough?" And at the time, for me, the fabric was enough.

I had been sewing for some time when I started making *Here's where we will stay*. It was something I learned from watching my great-grandmother and my mom sew when I was a kid. My first boyfriend, Robert Valenciano, whom I met in 1986, was a designer/tailor and an incredibly inspiring, adventurous guy. His sewing also influenced me and reminded me of the potential that lay in that process. Making *Here's where we will stay* was a very slow process because I did not want to use a sewing machine. I wanted to sew it by hand to extend the process and slow the experience for myself. So I sat for a long time, sewing, taking the scarves out to a bench along the Hudson River in Tribeca close to my Dannheisser Foundation studio.

It's nice to hear you recount your visceral reaction to seeing the piece for the first time in the gallery, and how it was being animated by the wind that blew through the big doors. This animation of the materials heightened your experience and triggered your memories, which transported you, just as the making of it had transported me.

I was after a queer expression when I set out to make the piece—choosing the scarves, sewing them together, and even all the decisions that went into how the work would be constructed, installed, and titled. In all those choices, and then in the specific installation in which I utilized and exploited the natural "materials" of the space itself, it all added up to that moment when you arrived. You describe a very personal experience that erupted from you, initiated by what was present there. That moment contained the actual "art," and it was located in you. You unfolded internally the private in the public … that's the function and the mechanism that we think of as art, right?

OV: Indeed. Did the scarves belong to family members, or did you collect them? They are so specific to the era of each of our childhoods.

JH: I was on a hunt for scarves, although I did have some that came from my mom and grandmothers. I had the experience as a kid, like you, of going through my grandmother's drawers and finding them. My mom wore scarves, and the smell of Shalimar perfume would always linger on them. I'm lost to the romance and sensuality that fuse onto these materials. Most of the scarves in the piece were found at thrift stores or flea markets; I collected hundreds of

92

92. Jim Hodges *A slow sunset* 1995 silk scarf 24 x 15 in. (61 x 38.1 cm) overall edition produced by the Fabric Workshop and Museum, Philadelphia Private collection

93

93. Jim Hodges *Happy—A World in the World*
2001 Prismacolor pencil on paper 47 ³/₈ x
34 ¹⁵/₁₆ in. (120.3 x 88.7 cm) Collection Jeff,
Mary, and Martha Rathmanner

them and still have a few of my favorites. I used to wear them and give them away to friends.

OV: But to make a sculpture out of them is something else.

JH: I was making what I thought of as a "painting." I had been in a slow process of what I would call now, in retrospect, "coming out," while simultaneously finding my voice through materials and process. This simultaneous process of developing language and identity marked this period in my life. Moving from making pieces in which I had been using black and gray felt to colored fabrics was part of that process. Color itself was something that was very slow to return to my work after putting the paints away. The fabric and then the scarves brought me back to color.

OV: You moved away from painting fairly early in your career. For your generation, painting was a weighty subject, especially in art school where your teachers must have been steeped in the Abstract Expressionist tradition.

JH: I received my MFA degree in painting from Pratt Institute [in Brooklyn], and my favorite teacher there, Phoebe Helman, was an old-school New York abstract painter—a "no bullshit" kind of a person. She was tough, and I got the most from her when I was at Pratt. Painting was all I knew then, really. Although I was slowly beginning to think about making objects, I was mostly thrashing about while in art school, lost in the hugeness of painting. The medium ended up being too complicated for me. There were too many variables, too much history, and too many choices. It was overwhelming. I also felt I was underserving the medium. I could mimic stylistically a number of art historical references in painting, but I was not able to find a way to my "self" through the material. At the height of my struggle, I got important advice from my friend and teacher from undergrad studies [at Gonzaga University in Spokane] Scott Patnode, who told me: "Do what makes you happy."

Drawing was always a favorite thing to do, so I put the paints away and picked up the most basic materials I knew: charcoal and paper. That simple choice was a definitive moment for me. Scott's instruction to look for my pleasure was an important fundamental direction. This turn initiated what I now call my "practice" and started me on my way.

ON LIBERATION

OV: Could you speak more about how pleasure factors into your practice?

JH: In this moment I just described, I began to pay attention to pleasure as an indicator and instructive function of my body; I tried to be sensitive to my gut as a way to zero in on things, on materials, and how they could be brought together and manipulated. It was the very beginning of identifying a personal symbolic iconography and inventing methods for making. It was a rich period of questioning and growth in which I sought to understand my personal relationship to the history of art and its authority, which I had, up until then, simply taken for granted, with a kind of submissive acceptance coming out of my education.

In the basement of the Dannheisser Foundation, I began to take it all apart. I literally utilized a kind of destructive and reductive method to get into things I was interested in or that caught my eye. I came to realize that I'm a destroyer as much as I'm a maker. I find the disassembly (or the taking apart or breaking) of something as important in my practice as constructing things. It's been almost my default mode, to destroy. I have a soft, destructive nature.

OV: What was the next liberation?

JH: I think I've always strived for freedom in my life, at least for as long as I can remember. Perhaps it is a reaction to feeling repressed and isolated as a kid. I was a very introverted child, living my life primarily inside a fantasy that I maintained, or used, to make being here bearable. It sounds far more dramatic than it probably was, but I was a seriously interior guy who projected a friendly, easy façade. Liberation came to me slowly, and perhaps the liberation from painting to drawing led to further liberations. Breaking free of the notion of some outside authority was the major breakthrough and the start of a mature practice, which has consisted of letting myself do whatever, not saying "no" to myself. "YES!" was what art said to me.

OV: Much of what you say resonates with me as someone who also grew up Catholic, indoctrinated in ritual, in tradition, in particular values and beliefs defined by limits.

JH: I think that so much of my liberation has been slow because I was the good Catholic boy, an altar boy who thought he wanted to be a priest when he was in grade school. I was twenty-seven years old when I said, "I am no longer identifying or presenting myself as a straight man."

I have been through a process of shedding skins, breaking through boundaries—imposed, self-imposed, learned, whatever—and the funny thing is, there's always another wall that I go crashing into, another layer of crap to shed, another blossom that reveals more complexity and challenges. Thankfully this process doesn't stop.

ON LANGUAGE AND TRANSLATION

OV: Would you describe yourself as a sculptor?

JH: I love sculpture. I think of things sculpturally in regard to spaces and contexts. Fundamentally, though, I am a "drawer." But I love spatial relationships and dimensionality. I'm interested in theatrical moments and choreographing experiences in space. I think as a drawer and make as a sculptor. Or maybe I have that reversed?

OV: In scanning the critical writing on your work, I'm struck by the dearth of significant art historical texts. Poets and literary authors seem to come closer to grasping the essence of your practice. Do you think of it as a poetic or literary practice?

94

94. Jim Hodges *"I am building a wall of brilliant color"* 2005 Color-aid paper with Beva adhesive on paper 15 x 11 ³/₄ in (38.1 x 29.8 cm) Collection Annabel Fuhrman, New York

95–96. Jim Hodges *When I Believed, What I Believed* 2008 stained glass, steel 81 ¹/₂ x 56 x 56 in. (207 x 142.2 x 142.2 cm) Courtesy the artist, Gladstone Gallery, Stephen Friedman Gallery, and Anthony Meier Fine Arts Photos: Ronald Amstutz

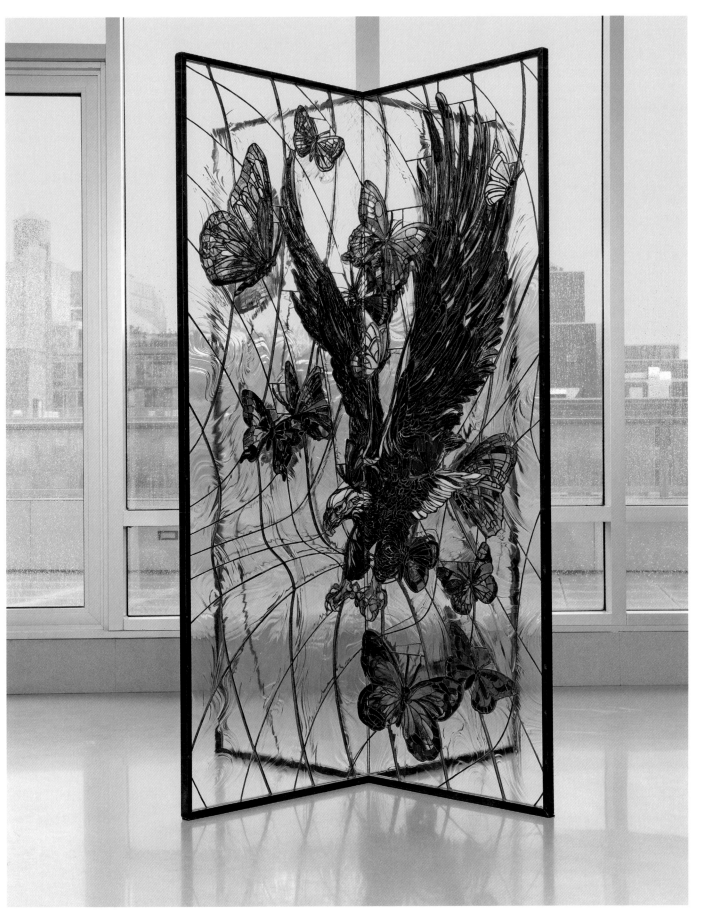

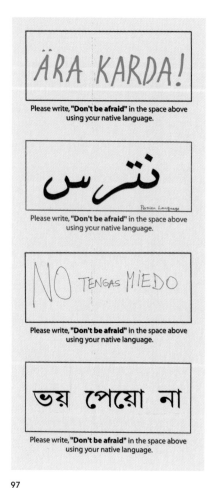

97. Handwriting samples by United Nations members for Jim Hodges's mural *Don't be afraid*

JH: In regard to what has been written about my work, or even how to approach writing about art, I might ask: What is to be accomplished through writing? Is what's written meant to act as a stand-in for experience? Is the burden of the writer to feel that he or she must in some way illustrate or re-create a particular reality, re-create or invent a verbal equivalent? I'm not a writer, and I don't envy the person who has the challenge of writing about art.

Writing, like any creative form, is a challenge, and it fails or succeeds at the hand of the artist. Writing about art is like singing about a book or dancing a poem; sometimes translations overlap and forms meld. Written language is the most specific and detailed, and therefore I think it poses the greatest amount of challenges when it comes to talking about visual art—especially with work such as mine, which innately resists being pinned down, or won't stand still, or lacks even the body to insert the pin through. That's a problem. If one has to invent the body to insert the pin, so that it can be held down, then that's where things start falling apart. It's the problem with interpretation and translation from one form to another, when in fact the form of the original is set and specific. Translating it changes it and can leave it behind.

OV: Our discussion around the limits of language and the transmission of equivalent content in alternate forms makes me think about a piece you made in the years following the tragedy of September 11, 2001. It began with words—a simple written phrase, "don't be afraid." First a drawing, then a bumper sticker, the work ultimately evolved into a major public project that brought more than one hundred international voices together. It was presented as a wall mural at the Worcester Art Museum [in Massachusetts] in 2004 (No. 98) and wrapped the façade of the Hirshhorn Museum and Sculpture Garden on the National Mall in Washington, DC, in 2005–2006. In many ways, this project was born of an amazing act of translation and communication. Your approach, which was a simple invitation to participate, seems to have unmoored that delimiting "pin" you just described.

JH: I made a small drawing titled "don't be afraid," as a kind of personal reminder. It was the year 2000, and I had recently moved with my partner at the time [Craig Ducote] from Brooklyn to the San Francisco Bay area to take part in an artist residency program at Capp Street Project. The move disrupted my rhythm and set me off into a whirl of insecurity, in which I found myself displaced and struggling to stay connected and committed to my practice. Upon their rendering, the words "don't be afraid" became a kind of mantra for me that I incorporated into my routine. I'm a creature of habit and ritual, so this action was not anything new for me. I'm also a creature of emotional sensitivity and insecurity, and mantras are something that I have utilized for a long time but never directly in a piece of art.

Once the expression was made physical, I found other opportunities in which it could become manifest. In 2004 I was invited by Susan Stoops, a curator at the Worcester Art Museum, to respond to a large wall in the museum rotunda. It was during the years of the George W. Bush administration, and a hyperpropagandized period in America in which the government was instilling a huge amount of fear in its citizens. It was a dangerous and traumatic moment, when the official message of the US government was that to be safe one had to be on alert,

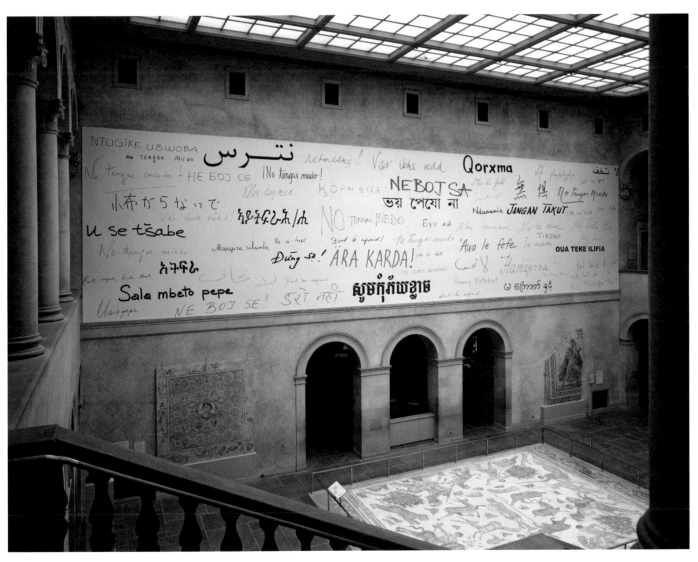

98

98. Jim Hodges *Don't be afraid* 2004–2005
inkjet on vinyl dimensions variable Collection
the artist Installation view of *Jim Hodges:
Don't be afraid*, Worcester Art Museum,
Massachusetts, 2004

99

99. Jim Hodges *See II* 2003 mirror on canvas
in two parts 60 x 40 in. (152.4 x 101.6 cm)
each Collection Sharon and Michael Young
Photo: Brad Flowers

implying that somehow we were not "safe" at all. I felt that the destruction of the World Trade Center had been utilized in the most monstrous and aggressive way to make us all victims of government, in which our own political leaders were behaving like terrorists. When pondering the huge blank wall of the museum rotunda at this moment, I asked myself, "What would I like to say to everyone walking into the museum, especially every small child?" The phrase "don't be afraid" seemed the most direct and efficient way of expressing and offering some comfort and support. I then asked myself, "How can I reach every individual? How could I 'speak in tongues'"?

I realized I needed a "world translator," so it occurred to me that my neighbors in New York City, the United Nations, might be willing to help. I wrote a letter of invitation to all the UN delegates at the time and asked each person to write, in his or her own hand, the words "don't be afraid." The invitation revealed my intent, which was for each individual piece of handwriting to unfold in a field of unique "voices." Each hand would offer its own individual gesture, touch, and intonation of feeling and, together, they would create a global chorus of voices conveying a collective message of love. I received numerous responses to my invitation, and over time more than one hundred translations in over seventy languages arrived (No. 97). Most countries were very enthusiastic about participating, save for one; the only country to formally refuse to participate was the United States. I twice appealed to the US delegate and both times I was refused. I was shocked at first by this reaction, but then understood. What other kind of response would one receive from a government in which the official message is to be afraid? Thankfully, Great Britain and Australia replied to the invitation and therefore English is "spoken" in the piece.

OV: The subsequent realization of the project in Washington—within view of the US Capitol and across the street from the Federal Aviation Administration—was especially potent. As deputy director of the Hirshhorn at the time, I recall getting a call from an FAA administrator, who was immensely grateful to have your project visible from the FAA conference room. The silent chorus of international voices became a mantra of sorts for him and numerous staff, contractors, and government officials who regularly utilized the space during the many months the mural was installed on the museum's façade. Who knows what plans and policies were shaped (or altered) by the presence and generosity of your global mantra!

JH: As often happens when making work, one rarely knows where it will end up or who the audience will ultimately be—or if there will even be an audience for that matter. The fact that you brought the work to the National Mall provided the opportunity for the work to "respond" in a direct way to the very government that provoked its inception. It is a high point of my working life to have had this piece installed in Washington during the time when the Bush administration was causing so much horror and instilling fear in the American populace. That all of our combined efforts—yours, mine, the UN collaborators—ultimately resulted in this work's visible placement and presence on the Mall and that it may have led to the potential positive effects you suggest ... what could be better?

ON KINSHIP

100

OV: Who are some artists you admire or that were early inspirations?

JH: I admire Paul Thek.

OV: Thek is a surprising revelation.

JH: What I found groundbreaking and mind-blowing about Thek's work, when I first saw it in a show at Brooke Alexander Gallery in the late 1980s or early 1990s, was the incredible scope of his practice. It physically manifested itself in such a wide variety of forms and materials. That, to me, was radical. I also identified a kind of kinship in spirit with Thek.

OV: Who are some of your other kin?

JH: I am a huge fan of James Lee Byars and of Richard Tuttle. I first saw Tuttle's work while in graduate school in the early 1980s. There is an immediacy to his practice, a "now-ness" that is held within the objects and that is never, ever not present. There is a purity in the work, I guess. I don't know if purity is the right word, but the directness and closeness you experience with the artist are pro-found to me.

I also admire Bruce Nauman (No. 100) for, I believe, the same reasons—the complexity in the work and yet the immediate, direct way it was made, especial-ly his early sculptures, which I was introduced to by Elaine at the Dannheisser Foundation. Ad Reinhardt is another reference. He had a profound influence on me when I saw his first black painting at the Whitney. I loved it because I didn't get it. I had never seen anything like that before. I loved it because of its auster-ity, monumentality, singularity, insistence, and strength, as well as the subtlety of the painting—how it could be so bold and strong and, at the same time, a "whispering" thing. The complexity and structure appealed to me.

OV: You once told me that Picasso was an important early reference.

JH: Talk about an artist who was always restless, always putting challenges in front of himself: doing and undoing, building and destroying. I see Picasso, as I guess many others do, as someone who was phenomenally gifted and never satisfied. Because he had the facility to immediately achieve whatever he was after, it re-quired a continual stepping beyond, and stepping beyond.

OV: What impact, if any, did Minimalism have on your early development? Were you working with it or against it?

JH: I think a little of both. I saw a Robert Morris retrospective at the Guggenheim in the early 1990s that was a big influence. I thought the work was quite confron-tational and intentionally flat and repellent. There was also something that I liked, something really good about the artist's choice of the color gray and the odd di-mensions of his forms. There was a repulsion that I found very attractive.

100. Bruce Nauman *Model for Triangular Depression* 1977 plaster, burlap, expanded steel mesh, steel beams 21 x 121 x 103 in. (53.3 x 307.3 x 261.6 cm) The Museum of Modern Art, New York; gift of Werner and Elaine Dannheisser © 2013 Bruce Nauman/ Artists Rights Society (ARS), New York

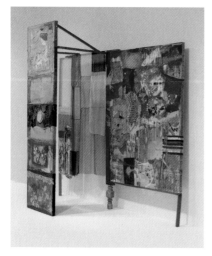

101

OV: What about Robert Rauschenberg?

JH: Yeah, of course, he did everything. I think these are all artists that one works through as a young person. One is attracted to certain aspects of the work for different reasons. For me, with Rauschenberg, it was the white paintings, the black paintings, the cardboards, the combines, and the way he made so many great things in succession (No. 101).

OV: He comes closest to Picasso in that perpetual cycle of invention and reinvention.

JH: He's kind of your American Picasso, really, because it feels very American to me.

OV: Does your work feel American to you?

JH: I've thought of it as American. I know that seems a funny thing to say. I'm not a patriot and don't really like nationalism. But I guess that I'm …

OV: … a product of your time and your experience.

JH: I'm a country bumpkin from Spokane, of which my therapist always reminds me.

ON INDIA

OV: After you traveled to India for the first time, in early 2011, you shared how affirming it was to be in a place where many of your own perspectives—in terms of how you look at the world, the lens through which you see and experience life, and make art—were echoed.

JH: I felt so supported there, as if I had been in India all my life. I came to realize that I have been involved with and engaged in a kind of sensitivity, in a kind of attention to my world that felt parallel to what I experienced in India. Being there allowed me to reconnect with my thoughts and my practice, from which I had become detached. In New York I didn't have that place of remove, that ability to step back from myself, that I had in India. There, I was thrown into the midst of a complex reality that I had never experienced, and my ways of thinking were being questioned. I liked this complexity and these questions that the place relentlessly raised.

OV: What, specifically, was called into question?

JH: The mirror that India held up to me demanded me to reevaluate so many things, starting from very simple things like crossing the street to more complicated issues, such as my relationship to currency and money and power. Deeper still were reflections on permanence and impermanence, creation, death and life, and fundamental beliefs and spirituality. There is this spectrum of experience there, from the mundane to the very heavy.

101. Robert Rauschenberg décor for *Minutiae* 1954/1976 oil, paper, fabric, newsprint, wood, metal, plastic with mirror and string, on wood 84 1/2 x 81 x 30 1/2 in. (214.6 x 205.7 x 77.5 cm) overall Walker Art Center; Merce Cunningham Dance Company Collection, gift of Jay F. Ecklund, the Barnett and Annalee Newman Foundation, Agnes Gund, Russell Cowles and Josine Peters, the Hayes Fund of HRK Foundation, Dorothy Lichtenstein, MAHADH Fund of HRK Foundation, Goodale Family Foundation, Marion Stroud Swingle, David Teiger, Kathleen Fluegel, Barbara G. Pine, and the T. B. Walker Acquisition Fund, 2011 Art © Robert Rauschenberg Foundation/Licensed by VAGA, New York Photo: Gene Pittman

OV: What happened when you returned?

JH: If you think of a fan that opens up and moves from one fold to another in three dimensions, this is what India offered. And then it expands again, to reveal even more dimensions. Throw all that into a fun-house mirror and then you're getting an idea of how India, as memory, resonates in me. Because everything there is more complicated than you think. You believe you have grasped it but then, all of a sudden, it all just crumbles, and you find yourself coming to from a daydream next to a cow or a goat that's foraging through garbage lining the street, that's being shared with children playing and digging around in it, just steps from the spot where their mother is stirring a pot of something cooking. This all takes place within feet of a very busy, dusty street with cars, bicycles, and tuctucs buzzing by.

What I found in India was an immediacy that I have always been attracted to—a place where beauty is revealed in a kind of degradation … in proximity to degradation. Beauty is not isolated or contained. Its function and visibility are reliant on a context there that is really "full." What's dictated to me from India is the removal of judgment and hierarchy. Good/bad, right/wrong, and life/death—all of these things start dissolving.

After six weeks of traveling there, I returned to New York and remained in the dream of India for some time. Travel is like that. If you don't resist, you become a place, and that place is with you when you return home.

OV: As I listen to you describe your experience there, I can't help visualizing your artworks. The way you describe the fan as it folds and unfolds and opens up again in surprising ways conjures for me specific drawings that you have made. I can see it all so clearly. On the surface, things appear one way and then another, filled with myriad layers and nuances.

JH: I thought about Vincent van Gogh a lot when I was in India. I thought he would have been in absolute heaven there, in a place where color is so profoundly celebrated. I was especially drawn to the flags that fly in temples. I asked a driver as we traveled through Rajasthan, "What do those colored flags mean over the temples?" His response was, "God loves color!" "Of course," I thought. He explained how different aspects of God, and different gods, were expressed through different colors. How red, for instance, was the color of Hanuman, the monkey god, and that when people petitioned a god for help, they would fly a colored flag in thanks to the god for prayers answered.

OV: Has the use of color in your work been a source of empowerment?

JH: I don't know that it is that specific. I don't think so. Growing up a Catholic kid out in Spokane, I do remember the symbolic use of purple, for instance, and its association with Easter. I recall the power of black and white and growing up with certain ideas of blue and pink in that irritating binary in which we were reared. These are things I thought about when I was first starting to make art: thinking about the conventions of color, embracing some of those conventions, and also playing with them, challenging them in myself, and denying them too.

102

102. Varanasi, India Photo: Jim Hodges

103. Jim Hodges *picturing: tracing form* 2004 cast crystal 5 3/4 x 5 5/8 x 7 3/4 in. (14.6 x 14.3 x 19.7 cm) Collection Marilyn and Larry Fields

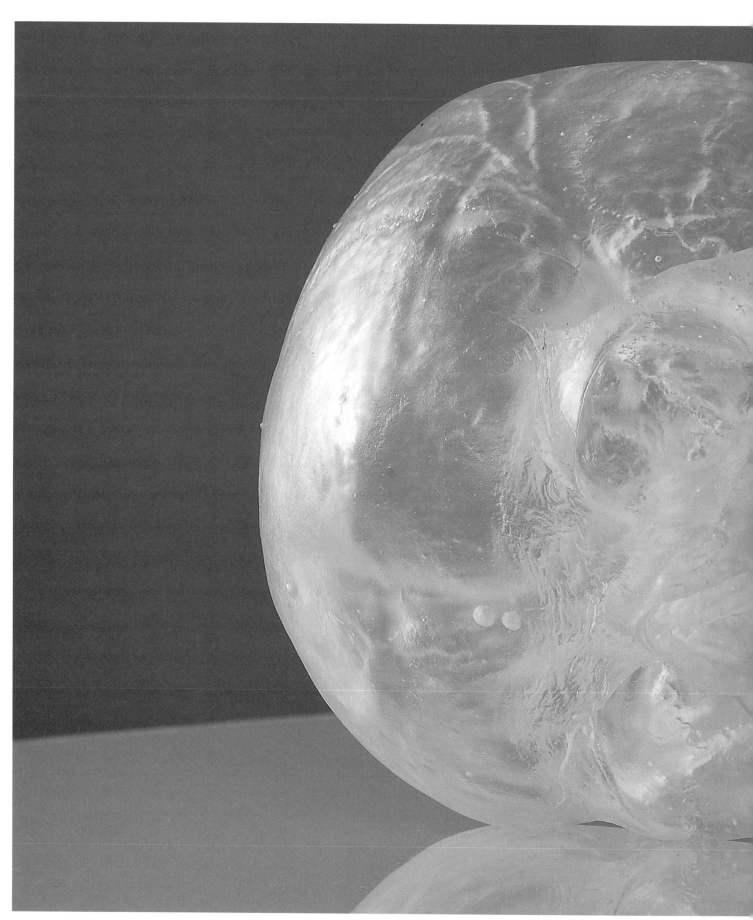

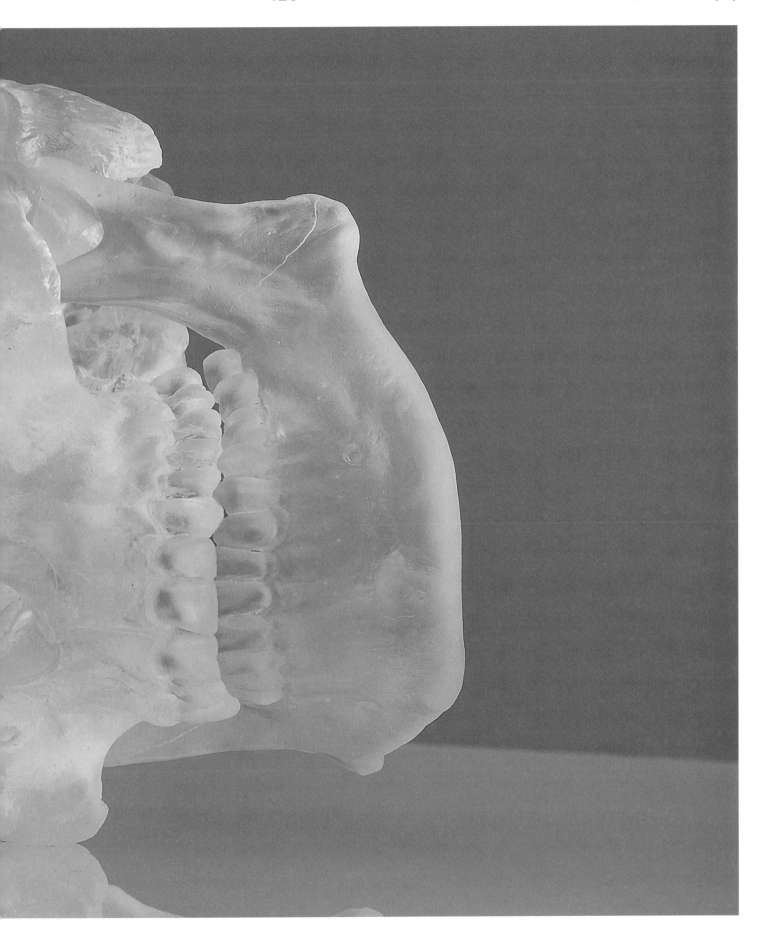

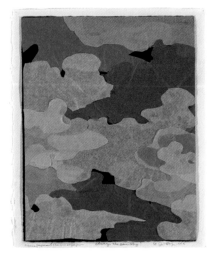

104

But I also knew that there is a tradition that is older than my understanding of things. Before there was language to describe what we see, we experienced it. Slowly, from experience, we began to name things. "Blue," for example, takes on something that I believe is so very old in us.

When I was in India, I was struck by the flexibility and expansiveness of imagination there. To this day, Hindus are still inventing gods. There's still the possibility for a new god to be found somewhere. That, in and of itself, was wonderful for me to observe and experience. It has helped me in my own life, in my daily life, to recognize God in all of it, and not just in the nice parts.

OV: This may be a dangerous question, but you have introduced the notion of God several times in our conversation. Is God, or the manifestation of a god, or however anyone defines God, important to you? Is God manifest in your work?

JH: As a topic for conversation, I think it's interesting. My relationship to the idea of God has been an ongoing evolution. At times, it has felt natural and a part of what I am engaged in, but I don't engage it specifically as a subject in my work. I have, for a number of years, wondered about creativity, about ideas and philosophy, and what it means to "name" things and where ideas come from. I do have a natural faith and a belief that art is a powerful energy for social change, having potential for creating an opportunity for radical social change. And I attribute this awesome power to a functioning system and expression of human inventiveness that is always restless and longing for something beyond itself … this, for me, comes close to spiritual ideas that I could associate with my fluid concept of "god." But I am not attracted to formal dogmatic systems that prescribe definitions and impose rules for belief in or worship of something I think of as boundlessly unknowable and beyond actually understanding; so in this way, because the ideas generate imaginative thought, it, the notion of god itself, becomes creative and mirrors an art process, completing a circle. My hesitation in sharing these thoughts is a complicated response and repulsion to "religion" and so I have a hard time locating the context to cast these ideas. I suppose I think of the experience that I call "art" as a condition I associate with the "divine."

As a little kid, as an altar boy, I was attracted to the rituals of the Mass, the entire theater and drama of the Catholic ceremonies, and to all the mythologies and stories. I was raised in that and found myself there naturally. It sparked my imagination and allowed me a place to deposit my ideas and fantasies, and it gave rise to my earliest erotic thoughts. And my ideas developed from there. I think that I have always had some relationship to God, either as a concept or as something out there or something in here. What I found exciting in India was being in a place where it was very natural to comment on God in a way that felt free of judgment … simply and in a matter-of-fact way. Here I tend to keep these thoughts to myself and I don't feel the availability of a context that would encourage such dialogue, though clearly there are the thoughts.

OV: It's a natural part of people's consciousness and day-to-day existence in India?

JH: So much so. Everywhere. I think there have been times when I have looked for what I might call a spiritual entry point into my art making … or I have looked

104. Jim Hodges *always the same sky !* 1999 tissue paper, charcoal on paper 11 ³/₄ x 9 ¹/₂ in. (29.8 x 24.1 cm) Collection Dar and Geri Reedy, Dellwood, Minnesota

105. Jim Hodges *in a brighter light* 2002 mirror on metal and wood in twenty-five parts 85 x 75 in. (215.9 x 190.5 cm) overall Carlos and Rosa de la Cruz Collection

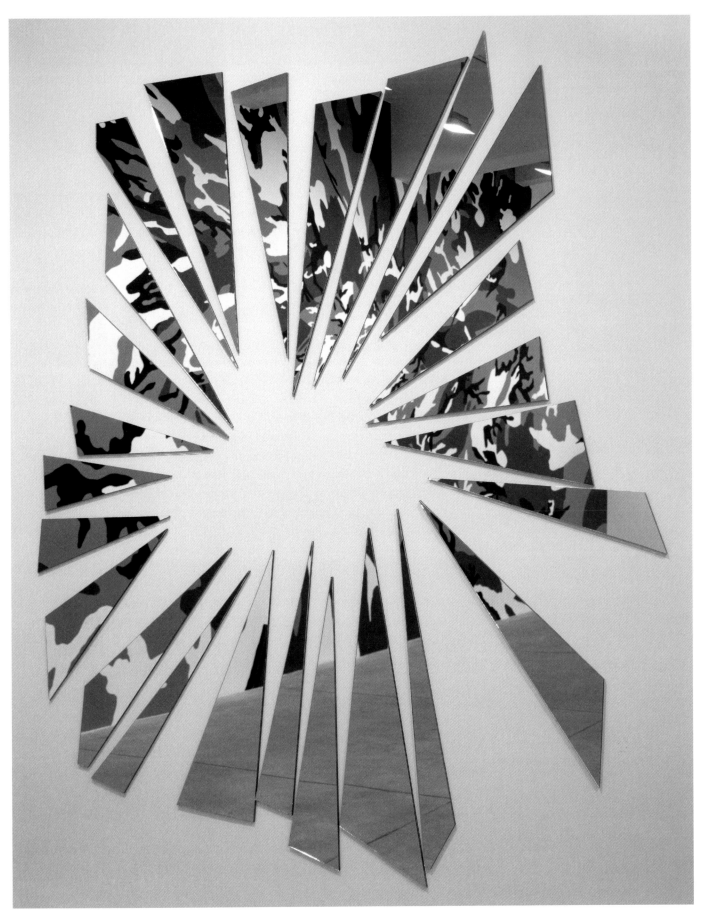

106

107

for a spiritual solution to a difficult personal problem. Or I've looked for some kind of spiritual something, or philosophy in my life as a way to keep me moving or as a place to rest. So I think it's always been a part of my practice, though, like the tide, ebbing and flowing. I certainly don't single out spiritual aspects of my dimensional practice nor do I ever want to limit what I do to single concepts or defining attributes … I don't want to "conclude."

ON REVOLUTION

OV: I know that one of your favorite authors is Susan Griffin, who wrote *The Eros of Everyday Life*, *Pornography and Silence*, and *Woman and Nature*. All these books were of great interest to you at different moments in your career. Griffin's essay "Sometimes It Is Named," in *The Eros of Everyday Life*, resonates profoundly for me in regard to your practice, which, as we have discussed, resists the act of naming. I wonder if what she describes there might shed light on your quest as an artist? Do you seek to disrupt societal strictures and dissolve delimiting boundaries?

JH: I think at times I have attempted to disrupt or challenge a societal norm or convention, or to project a shift of paradigm—at least I hoped to. I aim more, I suppose, to have a radical revolution within myself, as much as I may dream of radical changes in society at large. I want to experience freedom and liberation in myself. So if I recognize differences or variations from my norm and find that there is something exciting and interesting there for me, and usually there is, then I will move toward it. In the same way, if I find myself repelled, then something is pushing me away. It still might end up being attractive to me, and maybe even more so than the initial thing that attracted me. Teaching helps me exercise and maintain flexibility in seeing and looking and remaining open … it helps me expand and locate my thoughts.

OV: But when you explore something in your practice, and take on something that either attracts or repels you, how does that begin? Does it come from reading?

JH: I read a lot and often, but I also take time to think, and I sit with things for a long time. I am a very slow maker, and that exploration takes a long, long time. I want to be curious and stay attentive.

OV: What role does drawing play?

JH: It plays a big role, but recently, it hasn't been a consistent tool for me. I take notes to record and acknowledge ideas or observations. Maybe I'll snap a picture with my phone or send a text to myself. And I always have a sketchbook in my backpack.

Today, for example, I saw a piece of garbage on the street that was purple. There was something significant about it—not the fact that it was garbage, but that purple was being presented in this filthy way. That somehow resonated for me very strongly.

OV: Does it usually start with an image?

106. Jim Hodges *Even Here (Horizon)* 2008 archival pigment print on Crane portfolio rag paper with varnish overlay; ed. 1/5 16 x 21 in. (40.6 x 53.3 cm) Collection the artist Photo: Ronald Amstutz

107. Jim Hodges *Eyes (For Traveling)* 1993 ink on paper 13 x 10 in. (33 x 25.4 cm) Collection the artist Photo: Ronald Amstutz

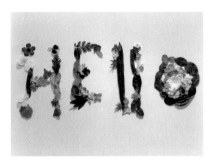

108

JH: Most things, I would say, do. A lot of my ideas come with some image. Sometimes ideas happen in a flash, from a specific observation, and appear fully realized as a complete, succinct concept. The denim pieces I am working on now happened that way (Nos. 172–174). While driving in upstate New York, I looked into the sky and the idea arrived. I could see the entire thing all at once. I would say that I am image-oriented, but not exclusively so. I'm a "picturer" who works in spaces.

OV: And does the image usually emerge from a dichotomy, something that is beautiful but presented in a base form?

JH: There is no "usual." I'm inspired by, and work toward, complicated problems. My work tends to manifest in simple, singular forms. I am continually working for complexity simply expressed.

ON NAMING

OV: The fragile proximities between life and death, beauty and degradation, that you experienced in India have always been potent themes in your art. In *a view from in here* (No. 85) they take surprisingly literal form in the presence of the black widow spider.

JH: The presence of literal (or symbolic) death is something that has always been part of my work, although perhaps not as overt, or maybe as literary, as it is here, with the depiction of the bird's nest and the spider. That was an important gesture for me because I am effectively "naming it." Naming it *is* what was important to me in this particular piece, although I am never usually that transparent. In my practice I move close to articulation and then far away from it. I move from what could be blindness to precision and back to blindness again.

OV: Was it liberating for you to name death so specifically in this instance?

JH: I think the literal inclusion—the naming and the depiction of implied death in the form of the black widow—was important for me at that time. But it is not just death that is present there. There's also disappearance and emptiness that point to other conclusions or suggest other possibilities. There's a whole other thing going on in the outside part of the work. Death is just hanging out while the blank, empty openness of the work expands …

OV: But "death" is not immediately apparent. I remember the first time I saw *a view from in here* and the shock of discovering the spider looming below. I was transported to childhood again. I felt confused and vulnerable. You could have named the sculpture *Death*, but you didn't. The work's title, *a view from in here*, allows for a range of possible meanings. With your titles, you often set up circumstances that allow multiple points of entry.

JH: I have, in the past, loved titling things. I think titles are part of the work. I don't always hit them right, but sometimes I get a title that feels like it is the

108. Jim Hodges *Hello (auto-portrait)* 1997
silk flowers, thread, pins 11 x 26 in. (27.9 x
66 cm) overall Collection Robert Harshorn
Shimshak and Marion Brenner

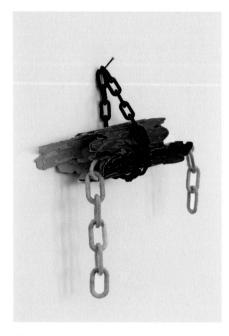

109

109. Jim Hodges *Anymore* 2010 handmade
paper, cast paper with Beva adhesive 28 x 18 x
5 ¹/₂ in. (71.1 x 45.7 x 14 cm) overall Collection
Lillian and Billy Mauer

right entry point or the right jumping-off point, or even the right ending. I know that titles, and the language of a wall text or a label, are part of the route people will take in approaching a work—to see, to understand, to know, and to enter a work. And with sculpture, titles are one more way of rendering; they add one more dimension, hopefully.

This last year, I've entered into a postnaming period. I am not sure how long it's going to last, but titles seem suspicious to me recently. I am reevaluating my relationship and commitment to them.

OV: Your titles are often invitations; they offer "a view from in here" or invite one "this way in," for example.

JH: Yes, they have been that. I guess it's been important to me to recognize the partnering that goes on in the experience of art. It is an engagement between things, between people and something. At times I've wanted to celebrate that engagement with the language that I chose. And other times I've simply wanted to elicit a particular mood or an ambience. Words can be applied as one might put on a scent, such as perfume. Some scents are so wonderful and others are sickening … titles can be the same.

OV: The titles add dimension, create a mood; would you say they heighten the experience?

JH: Not always. Sometimes they just fall flat. Language is also a record of things as they are. Titles are records of thoughts, records of what I am thinking about over time. Works that are failures still hold a record of importance. So even something that no one would ever want to look at, or that I may never want to show people, is still an essential thing.

OV: So you title even those works that you consider unsuccessful?

JH: If I keep something, then I'm committing to it, and if survival is success, then nothing that is kept is unsuccessful.

OV: Do the titles ever come first? Or do they come in the making or even follow?

JH: They come about in all those ways. There is no one path. I'm open to the potential of the possibilities of how things arise in me. Language is associative, as in our conversation. One thing leads to another. Often a title, such as *ghost*, was there from the beginning. The title suggested something I knew I needed to make. The word had an impact on the way the work ultimately manifested itself, and what it became. As a word, "ghost" has complex slipperiness and ambiguity and cartoony cultural implications that I like. It also holds aspects of the possible and impossible. I like it when my work takes me to an edge of my perception or to an edge of my understanding of something. A work usually leaves me far behind, as it comes to completion. It becomes "itself," and an estrangement begins to take over what was, in the beginning, a relationship.

ON MAKING

OV: I know you think of yourself as a maker of objects, but I've always had a relationship with your work that is much more experiential.

JH: I would like to believe this is true. I am interested in experience, *fully*.

OV: You mentioned that you are interested in subtly choreographed experience, in staging or creating a kind of object-based theater. Were you ever involved in theater or dance? Are you interested in choreography?

JH: I worked once with my friends Tom Bogdan and Terry Creach in a piece they were doing at St. Mark's for which I provided a set for them to respond to and work within, but I have never personally been involved in theater or dance. For my most recent exhibition at Gladstone Gallery, I was thinking a lot about the imagined audience who would visit the exhibition and I imagined them as "dancers" moving through the works. Once I arrived at that idea, I began thinking about offering the work to choreographers to respond to and this led to three collaborative performances that took place during the run of the exhibition (No. 110). [8]

 I am interested in choreography, yes, but collaboration ultimately is what I am most interested in, and I look for opportunities to work with others—choreographers, composers, and artists working in a full spectrum of expression and form.

OV: Throughout our conversations, you have spoken repeatedly about what your works "dictate." What are they dictating to you now?

JH: I am a dedicated servant to art, a devoted servant. I will do what art wants. That is part of what art asks of me: to be engaged physically with an experience. This is what I wish to continue to develop. In this way, the work becomes that which you experience too. There is something that is going on, right now, in my work. I am at this new place for myself.

OV: Can you put words on it?

JH: I'd rather make it and show you when it gets here ... ✳

110

ENDNOTES

1. Hodges's work was included in the group exhibition *Late Spring* at Marc Foxx Gallery, Santa Monica, June 7–July 15, 1995.

2. Lynne Tillman, "Absence Makes Art," in *Jim Hodges: this line to you* (Santiago de Compostela, Spain: Centro Galego de Arte Contemporánea, 2005), 177.

3. Ibid.

4. See, for example, Helen Molesworth, ed., *This Will Have Been: Art, Love & Politics in the 1980s* (Chicago: Museum of Contemporary Art Chicago in association with Yale University Press, 2012).

5. For more on this generation of artists and issues of beauty in contemporary art, see Neal Benezra and Olga M. Viso, eds., *Regarding Beauty: A View of the Late Twentieth Century* (Washington, DC: Hirshhorn Museum and Sculpture Garden with Hatje Cantz, 1999).

6. Susan Griffin, "Sometimes It Is Named," in *The Eros of Everyday Life: Essays on Ecology, Gender, and Society* (New York: Anchor Books, 1996), 9.

7. Ibid., 7, 5.

8. *Jim Hodges*, Gladstone Gallery, New York, November 5–December 23, 2011. The series consisted of collaborative performances by David Dawson and Raphaël Coumes-Marquet (November 19); Alexandra Gilbert and Damien Jalet (December 8 and 9); and François Chat (December 16 and 17).

110. Alexandra Gilbert and Damien Jalet (choreography by Damien Jalet) performing in Jim Hodges's *Untitled* (2011), Gladstone Gallery, New York, 2011

111–120. Jim Hodges *and still this* (details) 2005–2008 23.5k and 24k gold with Beva adhesive on gessoed linen 89 x 200 x 185 in. (226.1 x 508 x 469.9 cm) overall The Rachofsky Collection and the Dallas Museum of Art through the DMA/amfAR Benefit Auction Fund Photos: Brad Flowers; courtesy Dallas Museum of Art

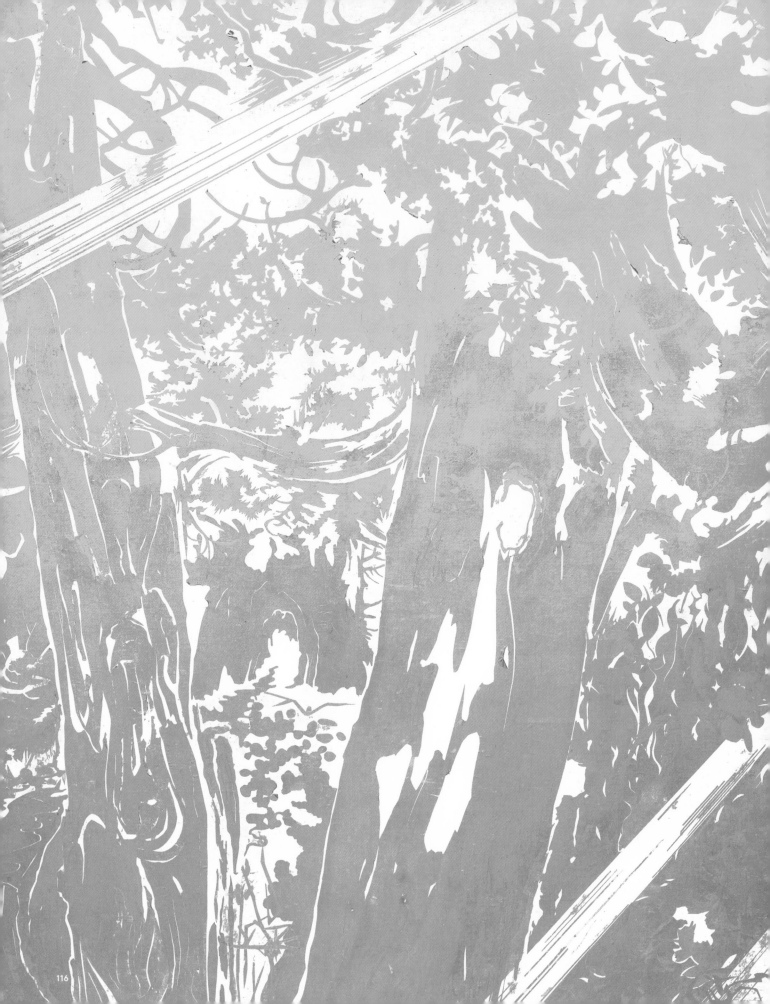

I See It Now

Susan Griffin

NATURE

Oh I see it now, I say to myself. I am gazing at Jim Hodges's *With the Wind*, when suddenly a question I asked over fifty years ago receives an answer. I was just fifteen and gazing then at a tree in the backyard of the suburban house my father and I shared. It was sunset, and the way the intense yellow and orange light glinted off the branches and leaves of the tree seemed astonishingly beautiful to me. So much so that the paint and brushes I was holding seemed inadequate.

It was not a matter of technique. I knew I could draw the likeness of a tree. But the tree, backlit by the descending sun, was so beautiful I was transfixed. How could I ever paint *this*? I wondered.

121. Jim Hodges *Movements (Stage IV)* 2009
mirror on canvas 57 x 96 in. (144.8 x 243.8 cm)
Collection Barbara Zomlefer Herzberg; courtesy
McCabe Fine Art Photo: Ronald Amstutz

WIND

"Who has seen the wind?
 Neither I nor you …"
—Christina Rossetti

You cannot see the wind. Though you detect its presence, coming over the bay, the cold seeping through cracks in the window molding, chilling the air, or, you can see it as it rushes up the hill, in the branches of the tall pine tree next door that move almost violently, or (on another day) you observe how it pushes the broad leaves of that flowering plant whose name you have never learned, so gently they dance. One, two. One, two, three. One, two. And settling into this music, you recognize immediately that it is this last kind of wind you are thinking about. Even if, at the moment, the curtains are still, you swear you are seeing the wind. Or perhaps not seeing, exactly, but *feeling*. Feeling through your eyes.

INSIDE

Feeling through my eyes. This is what I wanted. Not a reproduction of what I saw but the feeling I had then. A kind of rapture. Though the inner and the outer are not separate at all. Not separate in any sense.

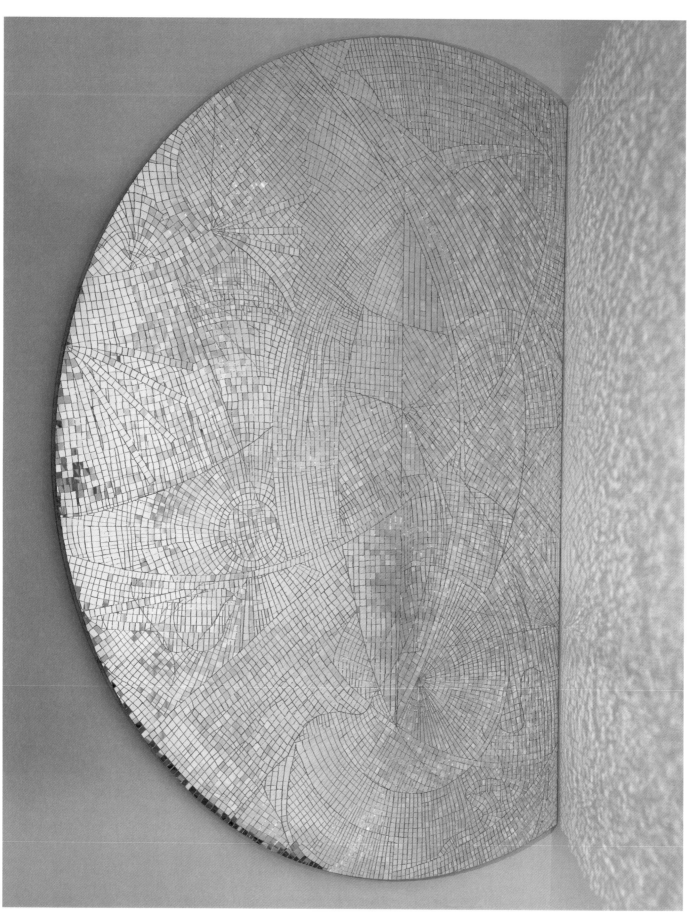

LISTENING

When I begin to unwrap the loaf of bread, the sound of the crackling cellophane gives me pause. Such a beautiful sound. Precise and simple. And this makes me realize that I have been listening all day to a very subtle music. The sound of shirts lying on a table, the sound of mirrors being shattered, the sound that patterns of color make in the mind. I have been hearing the sound that webs, chains, blinking lightbulbs, flowers, petals, leaves, bark, gold leaf, and skulls evoke, the sound of a crumpled pair of jeans, a belt, a nest. Is it because of the intimacy I feel with what I've seen? Is this how I have been coaxed into hearing what I once believed was inaudible?

122. Jim Hodges *Movements (Stage 1)* 2005
mirror on canvas 96 x 66 in. (243.8 x 167.6 cm)
Private collection Photo: Christopher Burke

QUIET

And as I think further *into* this experience, I realize that what I hear (see, taste, smell) has been shaped by a kind of inward quiet. Not silence (silence being simply the back side of sound), but quiet. Like the quiet in a forest, when you can hear the slightest sounds, the wings of a small bird, a pine needle dropping. A quiet allied with quietude. Patience. Small steps. That sort of humility. Though the artist neither is a saint nor needs to be. It's in the attention, in the act of making, the resonance between hands and texture.

MATERIALS

"My soul vibrated back to me from them, from sight, hearing, touch, reason, artic-
ulation, comparison, memory, and the like."
—Walt Whitman, "A Song of Joys," *Leaves of Grass*

The thing itself of course, but also the stuff we are made of. That everything is
made of. *Every atom belonging to me as good belongs to you* (Whitman's words), and
this has become the official conclusion, announced in the first few years of the
last century. It's all atoms, energy and matter alike. (I am thinking now of the little
particle they just found, the one they say gives form to it all. *Every atom.*) We're
all part of the same fabric: bodies, birds, bandages, beetles, butterflies, rocks, rock
music, sidewalks, silverware, tables, trees, freeways, flowers, frogs, oceans, cars,
curtains, stars, big-box stores, thunder and lightning, fire.

 The sharp lines between you and me, human and nature, mind and matter,
form and content (form emerging from a particle), thought and feeling, the work
of art and the material (mater, matter, mother) from which it is made, wavering,
blurred.

MEANING

"'No ideas but in things' is a poetic principle, but I think it is by implication a criticism of the European conquest of North America and its continuing history."
—Wendell Berry, *The Poetry of William Carlos Williams of Rutherford*

Diary: a record of events kept daily. Flowers: the part of a seed plant that bears the reproductive organs. Or: a state of blooming, flourishing. (The puns revealing secrets.) You can touch the *memento mori* here. Sex and death. Day and then day's end. The diary less a depiction than an enactment. Daily ritual. Napkins deteriorating, ink bleeding here and there. *Even as you are charmed, you cannot escape.* Where would you go? You are the drawing and the drawn, the moment and the material. And then there is a subtle sensation, slightly frightening at first, the slow invisible motion into imperfection, the downward slide, the muck, the fed and fevered soil, readied for generation, and finally a strange, bewitching joy.

BLUE

The sound. *Blue*. Thinking it through. Lips pursed. UE, OU. OOOU. Different from O. OH. It's OU. As in BeaucOUp, as in *feeling blue*, that bell-shaped voice, honeyed and sad, *I'll be seeing you*, Billie singing blues. And your teacher said, *blue skies, nothing but*, it was a fallacy to think the sky, rain, sunshine sympathetic with *you, I'll be*, thinking blue mood, *looking at the moon*, still I can't help it, *but I'll be*, not so much logic as meander, *seeing you*, the path water takes down the mountain, thinking through blue, through the valley, up into, synapses winding through my body, up into the clouds, patterns everywhere, how one thing leads to another, that fog bank getting under, how that syllable echoes, makes waves, *under my skin*. Gentian blue. A particular kind of blue, gentian, gen tian, or genie or gen ay, Genet looking out his window, color of the flower but not made from the flower, out from his cell, good for a weeping wound, a honeycomb of cells, across an impossible, (*will the one I love*) the hand leaves a trail (*please come back to me*) of bright, slightly light, blue.

123. Jim Hodges *movements (variation III)*
2008 mirror on canvas 84 x 60 in. (213.4 x
152.4 cm) Collection Glenn and Debbie
August Photo: Ellen Page Wilson

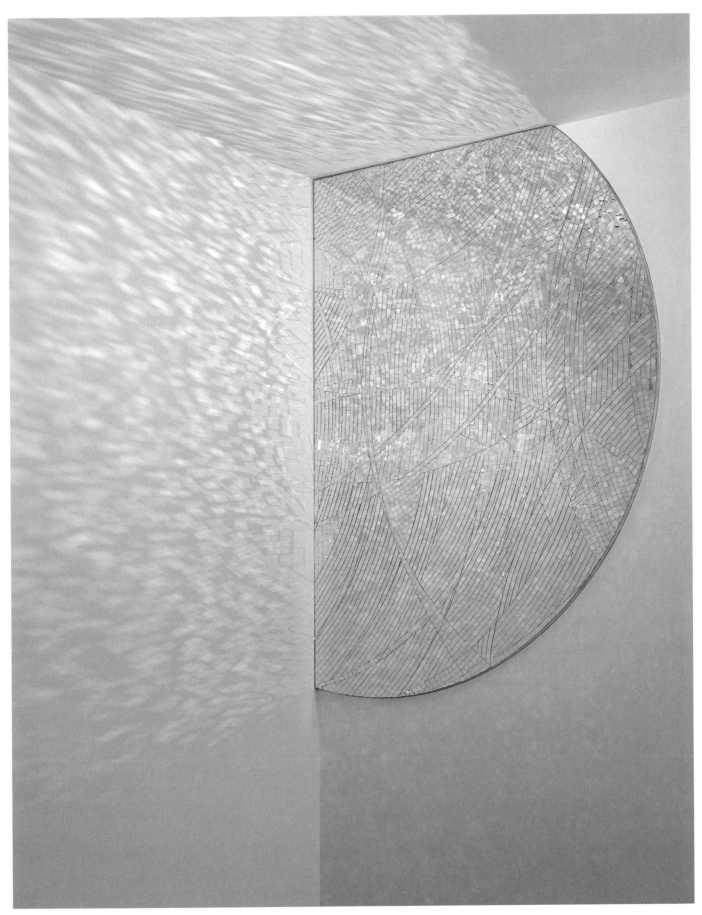

LEAVES AND THE ABSENCE OF LEAVES

"Mais où sont les neiges d'antan?"
—François Villon, "Ballade des dames du temps jadis," from *Testament*

As if even in spring, or at least by late summer, you can see what will happen. How the green will vanish, and all you will see is absence (before the branches are covered with snow, given it snows where you live). Though this absence has to be imagined, that is, it is visible only in anticipation, or if you begin this reckoning in winter, in memory. What was once there is not now. Or what is here now will not always be.

Where are the snows of yesterday? I can still remember the day, years ago, when I was a child and snow fell in the San Fernando Valley, an arid place, where it hardly ever snows. And then there is the snow on the ground in New York City into which Patty and I, both born and bred in California, young and warm with drink, fell laughing. Or the falling snow I watched with my grandchild, Sophie, when she was just two years old, and I held her up to the window, so she could see.

You learn early in life that it will not go on forever. Still, that you can't return remains a perpetual surprise. Every time you try to turn back, you will be awakened by the stark beauty of how things really are.

SPEAKING OF EDGES

"Between the emotion
And the response
Falls the shadow."
—T. S. Eliot, "The Hollow Men"

As I eat my lunch, I listen to the radio as a veteran of the Vietnam War explains patiently and carefully the nature of the dark side we all share. How, threatened with death, he was quick to fire his gun at any motion in the grass, fire before asking or knowing what it was that moved. Because in the few moments it might take to find out, he could easily be killed.

Of course he's right, I realize. It's in us all. That kind of instantaneous ruthlessness, when faced with a violent threat. He follows this confession with other stories, one about the tears he shed years later, thinking about the men he had killed. Then he talks about the need for soldiers to shed these tears, in order to return to normal life and reclaim their souls. If you don't cry, he says, if you keep on pushing these tears away, *you'll become who you are pretending to be*, someone who doesn't care, or even a menace to others.

I am thinking of war stories. How they are told and how they are heard. Sometimes a soldier reveals suffering and regret and in this way begins to heal. But more often, war stories are told along heroic lines. This process of course is not isolated. Someone must listen. And whoever listens has a profound effect on how the story is told.

The young Hemingway talks about how, after he returned from the First World War, people, especially men, wanted to hear only about heroism, not about the real thing (the piss-in-your-pants terror and shame at your failure to live up to an ideal).

The edges of the mask are fraying.

124. Jim Hodges *Movements (Stage II)* 2006
mirror on canvas 84 x 96 in. (213.4 x 243.8 cm)
Collection Glenn and Amanda Fuhrman, New
York; courtesy The FLAG Art Foundation

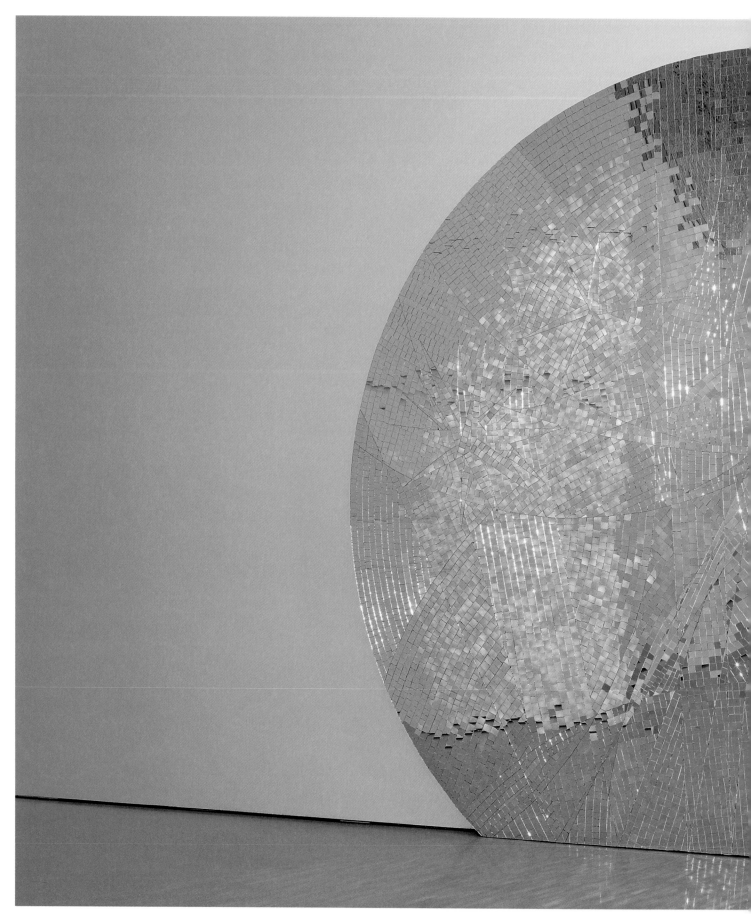

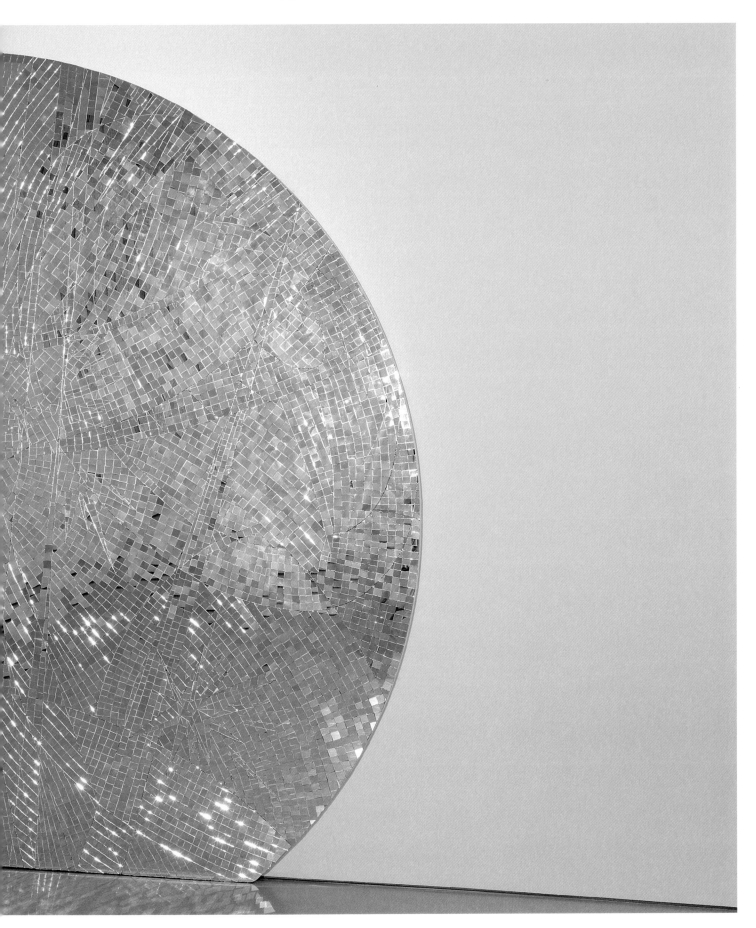

DRAWING

In the late spring of this year I spent some time in Paris. Quite by accident I ran into an old friend in San Francisco in line for the flight that, as it turned out, we would take together. Penniless, yet using miles and staying with friends, we had both managed to make this journey. I told her about the night of museums to take place a day or two after we arrived. All the major museums in Paris were to be open at night and free. We decided we would go together to an exhibit of Degas at the Orsay. We had not seen each other for several years and in the interim, she told me, she had taken up drawing. A writer and scholar, she has no artistic ambitions. Nevertheless, this has become one of her great passions.

Why am I writing all these details? I don't know. They seem irrelevant. Except perhaps not. Perhaps there is some significant detail here or curvature of the narrative line that I have neglected. Something about accidental meetings, serendipity, or even synchronicity. Or passion. The lengths we both went to get to this city, the time we spent in a long line to see this popular exhibition.

We were not disappointed. Though already exhausted from jet lag and hunger (it was after all dinner time), I lingered over every image. I felt fortunate to be there with a friend who was serious about drawing because I could see various lines and shadows through her eyes. The way, for instance, in *Femmes Nues*, Degas's almost casual pastel drawing of prostitutes, one is bent over a basin to wash herself, yet they hold so much, both exhaustion and that state of mind for which there is no single word: the sense of having been beaten down. And in the same line that etches out her nude body from behind, thighs corpulent, ass almost as small as a child's, back curved into a telling slump, hair draping inelegantly but naturally over her shoulder, I could also see a powerful empathy and a tenderness.

It is a kind of ritual, I realize now, one for which my friend and I pushed our own limits so we could join the pilgrimage and partake, one which Degas practiced too as surely as whoever drew images of animals—bulls and lions and deer and horses—so many thousands of years ago on the walls of caves (the first discovered by accident), underground at Lascaux, for instance, or Pech Merle or Chauvet, caves even then to be reached only by the most arduous effort, these drawings too a testament to the astonishing capacity to enter another being, to get inside, and feel *that* life, as if the hand itself knows and wants to tell.

WHAT IT ONCE WAS (WE ONCE WERE)

"Upon the mosaic ceilings of the Church of San Vitale … Jesus Christ … delivers his Sermon on the Mount … within a landscape where lilies and the expanding and intertwining tails of peacocks and dolphins remind us we live within a varied world."
—Terry Tempest Williams, *Finding Beauty in a Broken World*

A sack. The kind they give you at department stores. And there's history in it. (Remembering childhood from a familiar taste: those chocolate drops called "Flicks" you eat in the movies, that orange popsicle with vanilla ice cream inside sold from a truck that drove down your block, the bread my grandfather taught me to dip in the juices from the roast beef my grandmother cooked, those famous cookies dipped in tea.) A sack redolent with memory (what can't be done by machine), the ritual of making art, Warhol still fashioning the window at Bonwit Teller, marking time, not in the sense of measurement, but rather in the sense of *remark*. To note the whole spectrum of the experience, sensual and invisible, even that which is impossible to pin down. (Once the butterfly is dead, the wings will stop fluttering—and how do you describe *that* loss?)

Who we are sometimes appearing, coyly, in disguise, shyly, slyly.

The bag torn at the sides becoming a cross. (Laughter to be inserted here, and then, *Oh!*) Yes, that cross. Not just the Christian one. Or perhaps that too. (*Consider the lilies.*) But underneath (as we descend into the world of the forgotten) we see what the cross once was: the Tree of Life. Is that why this sack is embellished with vines and flowers, a forest canopy? And then, perhaps, we remember that the sack is made from paper; it came from a tree.

BROKEN TO PIECES

Sharp like knives. Shattered. No longer whole. Looking like weapons. Shards from a missile strike. Embedded god-knows-where, willy-nilly, with no distinction between an infant and a soldier. Torn apart ("rent asunder" they used to say). Torn like Inanna after she went down into the underworld. Overstepping the boundaries, her own boundaries are violated. She is hung and dismembered. (*Oh my innards!* she cries.)

Except sometimes brutality can be turned inside out. Re-formed into a new pattern (let's try to make something out of it), a different whole. Beauty.

DE-FORMING OR TEARING APART AND RESHAPING
(to be read aloud or chanted)

Form. This is how it is.
Everything slowly, reshaping
and in its own way.
FO-RM
ATION
The breaking down (leaf become
soil, soil feeding leaf et cetera, et
cetera)
Holy equation
FORMATION
(not exactly so) DE
 -FORMA-TION
(what your hands know)
That old
familiar
rhyme.
ABA (three beats then pause
on the fourth) B
Before and (or pause on the third)
Be fore and af ter (soft on the fifth)
Change. Evo
lution. (Keeping
time)
How she sang as she died.
(This little light of mine)
How I miss .
 That caesura, that pause,
that tear in the
fabric,
(it's the stitches
the mending

that make me
cry)
T M
A F
F E I
S
What does it spell?
(Matisse saying
whenever he felt lost,
he would find
his way)
Mutation
Maturation
Mending
(through the hole
in the pattern)
T M A
E S
What does it mean?
Formation
Does it matter?
MATTER.
(Take one
step to the right)
Change
(and three
to the left)
Creation
(I'm gonna let it shine)
This Is All Hand Made.

AT HAND

"Yet somehow the work does not feel tragic. Instead it is full of life, of eros, even of comedy…. Each piece in the show vibrates with originality and mischief."
—Arthur C. Danto, "All About Eva," reviewing a 2006 retrospective of the work of Eva Hesse

What is made not apart but part. Hesse using latex and fiberglass. (Hesse's phrase, "mark of the hand," haunting me for years.) That leaf I find as I rearrange the plants in the little room off my kitchen. I can't throw it out. I don't know what it's made of. It's an imitation of a leaf; it fell just like a real leaf would, off the stem of an imitation flower. A lush red flower I keep in this strange little room, no doubt intended to be a dining nook. I had the inner window moldings embellished with a thin line of gold paint, after which we began to call it the Versailles dining nook. On a table against one wall I've placed two fake bird's nests, two white bluish eggs made of stone, three fake birds. The table has a faux surface; it looks like green marble, only you can tell right away it's just paint. (A visual joke.) The legs are embellished with painted gold rings. On a small chair, a child's chair, a birdcage with a bird that sings when you wind it up. How would I describe this room? When they were very young, my grandchildren would have told you, it's a playroom.

TESSERAE

"A name is a mirror to catch the soul of a thing …"
— Susan Brind Morrow, *The Names of Things: Life, Language, and Beginnings in the Egyptian Desert*

That thing they do in mosaics. Seeking the odd shape, because each variation in the surface reflects the light differently. Like the play of light over water. The current making waves, the continual motion sparkling, making a kind of magic. You are dazzled, aren't you? Captivated. As if the water were rippling through you. As if you were light. Be-dazzled.

Then, you catch a look at the reflection and see, yes, it *is* you.

THE WEB OR THE CHAIN (THAT BINDS US)

"He did not, for example, abandon the idea of love, but if there was to be love then it would be love for some person, place, or thing particularly known and imagined."
—Wendell Berry, *The Poetry of William Carlos Williams of Rutherford*

Not to abandon love, being loved, but to look. Those faces of the moon. Craggy, flawed, old girl, old tomato, old boy, old goat. Moon. How many faces, with me for all my life. The web, chain, intractable, adorable. The tender trap. And still, and still, we strain to catch even a glimpse. Hiding now behind the pine tree, then behind the buildings lining the hill to the south, in the direction of the house that caught fire last fall, flames visible and frightening in the early hours, and *how often I've been burnt* (she says to herself). Yet coming back from the ashes, again and again, that desire, always desire, taking you out of yourself, past yourself (even to look at that tree, engulfed in the setting sun), into the larger scheme, so you are caught up again, one thread, one link, drawn like a line into all creation.✳

125–131. Jim Hodges *here it comes* 2009 charcoal, 24k gold, pastel, saliva on paper in seven parts 30 1/4 x 179 in. (76.8 x 454.7 cm) overall Collection Meryl Lyn and Charles Moss Photos: Ronald Amstutz

The Whole World Is Watching

Helen Molesworth

It is now an art world commonplace to encounter talk of AIDS and loss, grief and mourning, when reading about the work of the artists, and friends, Jim Hodges and Felix Gonzalez-Torres. Both came of age artistically, and as gay men, during the plague years of the AIDS/HIV epidemic (and Gonzalez-Torres lost his life to the disease in 1996), yet their work eschewed any direct reference to the disease and/or its effects. Nevertheless, the work of both artists seemed to function as elegiac meditations on the structures of feeling and the overwhelming affective sensibility that governed the staggeringly pervasive amount of death in the New York art world and gay male communities of the 1980s and 1990s. Hodges's work—curtains made out of artificial flowers, newspapers covered in gold leaf, delicate snapshots of tender landscapes, large-scale photographs of trees with each individual leaf cut out, drawings of flowers on paper napkins—trafficked in the physically delicate and the psychologically melancholic. This combination has sometimes led to a hum of anxiety about the work's relation to sentimentality. Even among Hodges's stalwart supporters, one can detect a slightly defensive tone, as when curator Susan Cahan said of his work, "[It's] very provocative because it's beautiful, very emotionally expressive, and it comes this close to being sentimental but it never crosses the line." [1]

But what if the work does "cross the line"? What if it *is* sentimental? What is it about sentimentality—both as an emotional state and an aesthetic manifestation—that causes Cahan (and me, to be completely honest) to want to hold it at bay? After all, the delicate nature of the materials—their porosity to the quotidian stuff of the world, their very tenuousness as "high art"—seemed to offer a response to the crisis that was as suffused with tenderness as the contemporaneous activist interventions of ACT UP were structured by rage. And it's not as if activists had an exclusive relation to rage. Artists and collectives such as Donald Moffett, General Idea, Group Material (of which Gonzalez-Torres was a member), Marlon Riggs, and David Wojnarowicz all made deeply acerbic works regarding the AIDS crisis. These tended to be strongly didactic, as they typically deployed a mixture of text and image to address the misinformation and prejudice that dominated coverage of the epidemic by the mass media. Hodges and Gonzalez-Torres (along with Ross Bleckner and Robert Gober) took a different tack. Certainly their work may have been related to the anger being expressed on the streets, but Hodges and Gonzalez-Torres each produced a body of work that registered the surrealistic dimensions of the crisis, work haunted by loss and love and fear.

These antinomies—art and activism, delicacy and rage—are at the heart of a recent work by Hodges, *Untitled* (2010), [2] which resulted from an invitation he received to talk at Artpace in San Antonio about Gonzalez-Torres's work. [3] Rather than deliver a lecture, Hodges found himself assembling a sixty-minute video montage. *Untitled* is a bit surprising, for the sentimentality one typically associates with Hodges's (and Gonzalez-Torres's) work is here held in a tense network of relations that, in addition to recalling Hodges's early spiderwebs, complete with their menacing referent (for what is a spiderweb after all but a trap intended to kill?), helped illuminate for me what is indeed so very powerful about his overall project. In other words, *Untitled* feels simultaneously out of step with the rest of Hodges's oeuvre (it is not at all sentimental) and like a Baedeker to understanding it better (for it is a meditation on why the sentimental is necessary).

Untitled is pieced together from a variety of sources—including television news

132–135. Stills from Jim Hodges, Encke King, and Carlos Marques da Cruz *Untitled* 2010 video (color, sound) 60 minutes

Source footage:
132. *One Nation Under God* (dir. Teodoro Maniaci and Francine Rzeznik, 1993)

133. left: *After Stonewall* (dir. John Scagliotti, 1999) right: *One Nation Under God* (dir. Teodoro Maniaci and Francine Rzeznik, 1993)

134. left: *Lessons of Darkness* (dir. Werner Herzog, 1992) right: *Home* (dir. Yann Arthus-Bertrand, 2009)

135. "Day of Desperation" (dir. James Wentzy for *AIDS Community Television*, 1991)

133

134

135

136

136. Felix Gonzalez-Torres *"Untitled"* 1989
paint on wall dimensions vary with installa-
tion Installation view, *Untitled: An Installation
by Felix Gonzalez-Torres*, Visual Aids Program,
Brooklyn Museum of Art, New York, 1989
© The Felix Gonzalez-Torres Foundation;
courtesy Andrea Rosen Gallery, New York

footage, AIDS activist documentation, and 1950s film reels—that are meticulously spliced together. The imagery is accompanied at times by a lush soundtrack, ranging from opera to The Smiths, and at other times by real-time sound. There is no voice-over narration to suture the disparate images and sounds; instead, the heterogeneous images and voices alternate between moments of contingency, contradiction, and complementarity. Viewers, left to their own narrativizing tendencies, may either fashion a story out of the clips or simply ride in the slipstream of the sometimes random, sometimes pointed juxtapositions. Furthering this splitting—between image and soundtrack, between narrative and chance—is an intermittent use of a bifurcated screen, whereby occasionally an image fills the entire field of vision, edge to edge, like a landscape, or two images run parallel to each other, with the pictures being either radically different or twinlike in their similarity (Nos. 133-135). Hodges's deft use of these editing strategies means that *Untitled* harks back to the heyday of experimental cinema, and, in fact, the film feels a bit like a work from the late 1960s or early 1970s, one that might have been shown in a double feature with a work by Jean-Luc Godard or Stan Brakhage. This is another way of saying that the handmade quality of *Untitled* has no clear relation to the kind of sumptuous, Hollywoodesque, gallery-based video that has become a mainstay of contemporary art, and indeed it is commensurate with the cut-and-paste quality of works by Hodges such as *As close as I can get* (1998; No. 47), a mosaic-like collage fashioned out of Pantone chips, and *Untitled (Love)* (2000-2001; No. 81), a brilliant collage of cut-up sheet music that isolates the word "love" over and over again.

In addition to summoning the handmade logic of both collage and experimental film, *Untitled* echoes Gonzalez-Torres's "portraits," works in which descriptions of seminal events in a person's private life, along with events that happened before the person was born, or that happened in world history to everyone, are painted in nonchronological order around the perimeter of a room, at the edge where wall and ceiling meet (No. 136). The words, like crown molding, delicately ride the line between art and décor. Gonzalez-Torres's portraits intimate that there is no such thing as an individual identity, no selfhood separate from the events that shape us all, and, likewise, the portraits suggest that there is no idea of the social or the public that isn't imbricated in the interior or the private.

As an elegiac portrait of Gonzalez-Torres, *Untitled* is a compilation of the historical world events that shaped his life and death—primarily the homophobia of pre-Stonewall American culture, the emergence of a gay liberation movement, and the political mendacity that fueled the AIDS crisis—combined with the events his premature death caused him to miss, notably the 2001 terrorist attacks on the World Trade Center in New York and the decadelong, unprovoked wars waged by the United States on Iraq and Afghanistan that followed. As a stand-alone film, *Untitled* tumbles historical events, like so many semiprecious stones in a polishing machine, and functions as a collective portrait of the end of the twentieth century. By virtue of this toggling between the highly individual and the generically public, *Untitled* allows for a rigorous meditation on the complex role that sentimentality plays in Hodges's oeuvre.

In her short but deeply informative essay "What Is Sentimentality?" June Howard argues that this particular quality is linked with emotions that are characterized as affected, shallow, and excessive. Sentimentality, she says, is "haunted

by its vulnerability to accusations of banality and inauthenticity," and though it is "not always stigmatized, [it] is always suspect; the appearance of the term marks a site where values are contested." [4] Why should the representation of emotions provoke such a stigmatizing logic, especially when the history of emotions can be seen to be bound up with the articulation of our moral lives, such that, for instance, benevolence is viewed "as a defining human virtue"? [5] Howard's answer is bracing: "'sentiment' and its derivatives indicate a moment when emotion is *recognized* as socially constructed," and the "packaged" quality of emotion "is a distasteful reminder that the partition of the public and private" is indeed impossible. [6] In other words, sentimentality galls us because it makes us aware that we feel as others feel, and that our emotional lives are neither unique nor proof of our exceptionalness. Rather, the sentimental registers our emotions as socially produced and shared. Given the outrageously persuasive and coercive function of mass culture, sentimentality is frequently used to create feelings of consensus when perhaps there is not one, and many have, rightly so, resisted being addressed as an undifferentiated mass in this manipulative manner. Yet the sense that sentimentality, and the anxiety that attends it, flares up at the borders between social values is a compelling matrix through which to examine its role in Hodges's oeuvre, and is something I want to pursue further in discussing *Untitled* and its relation to his earlier work.

Looking back at some of Hodges's earliest (and most sentimental) works we can track a consistent working method across a seemingly diverse range of objects, beginning with the coffee-shop and diner napkins he used as a ground for his drawings, the store-bought fabric flowers and metal chains that were the material for his curtains and webs respectively, and the camouflage pattern that recurs in both wall drawings and mirror mosaics. All these examples point to his playful use of the readymade, harking back to Duchamp's original use of objects culled from the domestic world (hat racks, combs, bottle dryers, and the like). For his part, Hodges amplifies the domesticity of his choices through the acts of doodling, sewing, and fastening, compounding the quotidian nature of his choices even as these activities transform everydayness into the register of the special or the poetic. And yet, Hodges's work was never positioned within the tradition of the avant-garde or neo-avant-garde register of appropriation that governed the critical discourse of the 1980s; instead, it was discussed as part of the return of "beauty" in the 1990s. Even when he made "paintings" out of shattered and mosaic pieces of mirror—works such as *On Earth* (1998; No. 46) that explicitly borrowed the disco ball as their starting point—he still was not seen as an appropriationist.

This is ironic, considering that American gay culture has been involved in the occupation of readymade forms and the appropriation of dominant mass culture to its own ends for most of the last century, whether it is the androgyny of the lesbian scene of the interwar years, the role of camp in the closeted days of the 1950s and 1960s, or the heady days of disco in the late 1970s. [7] With the AIDS crisis, the two most dominant of these formations (the humor of camp and the liberatory excess of disco) withered in the face of the need for an activist, highly mobilized intervention in the absence of medical and governmental response. (Sometimes the humor and pleasure of both camp and disco were utilized to feed the activist movement, but they tended not to appear in the high-art culture of the late 1980s and early 1990s.)

137

137. Jim Hodges *Felix on the Road* 1994
chromogenic print 4 x 6 in. (10.2 x 15.2 cm)
Collection the artist

Hodges crossed the wires of the readymade activities of Duchamp and the neo-avant-garde with a set of activities and practices gleaned from queer subculture, resulting in materials saturated with allusions to other cultural formations, exponentially rich in affect. For instance, his utilization of fabric flowers summons the realms of adornment, costume, and interior décor, provoking associations with artifice, permanence, domesticity, and mourning as readily as they evoke painterly strategies of allover composition (a thing without an end, apocalyptic wallpaper) and the Rauschenbergian desire "to act in the gap between art and life." This mélange of allusions suggested the commonality (as well as the specifically queer or art-world meanings) of these ideas across the culture as a whole.

This desire to be legible to both of these precisely rendered publics (gay, art world) as well as to more generally conceived publics (the consumers of fabric flowers, for example) can perhaps be seen most clearly in a particularly skillful and surprising segue in *Untitled* between footage of a 1992 ACT UP action in which people threw the ashes of their deceased comrades and lovers over the wrought-iron gate and onto the lawn of the White House and the display of the AIDS quilt in Washington, DC, in 1989 (Nos. 138, 139). The dispersal of cremated remains on the White House lawn was one of the most emotionally gut-wrenching of ACT UP's actions, and it engendered a brutal response as mounted police officers used their horses to quell, thwart, crush, and intimidate the rush of activists descending upon the White House gates. In *Untitled*, the video footage of the demonstration is haunted by the ongoing piercing scream of one of the activists. It is the unadulterated sound of human anguish. The protesters' rallying cries alternate between the admonishment "Shame! Shame! Shame!" and the declaration "The Whole World Is Watching," in essence toggling between invectives based, respectively, in private conscience and media publicity. This scene cuts directly to an image of the AIDS quilt unfurled over the National Mall; a solemn voice intones as it reads off the names of the dead while the image depicts individuals in stunned silence moving around the edges of the quilt, at times kneeling down and weeping. I found this juxtaposition to be simultaneously emotionally unbearable and revelatory.

Back in the day, the quilt was seen by many activists to be an overly sentimental rendering of the crisis, meant to appeal to mothers and aunties struggling to accept their gay children. Its handmade quality and patchwork reality seemed an anodyne mode of dramatizing individual losses, when what was needed was a way to galvanize a public toward more generalized political action capable of disrupting and disabling the homophobia and racism at the root of the crisis. The activism of ACT UP was designed precisely to strike deep into the muscle of those agencies—governmental, medical, and mass media—whose inaction in the face of a major national health emergency was responsible for the epidemic. The quilt seemed to say that the losses were private rather than public (each rectangle is dedicated to one person, made by that person's friends and/or relatives). And because one effect of the AIDS crisis had been to demonstrate that the "conditions in which sexuality seems like a property of subjectivity rather than a publicly or counterpublicly accessible culture" [8] was no longer tenable, this meant the "privacy" of the quilt felt out of step with an emergent politics of queerness that was to demand not only *access* to public space, but the *queering* of public space. [9] But *Untitled* refuses the division between private and public, or between acts of personal commemoration and mourning and public and communal activism.

138–140. Stills from Jim Hodges, Encke King, and Carlos Marques da Cruz *Untitled* 2010 video (color, sound) 60 minutes

Source footage:
138. "The Ashes Action" (dir. James Wentzy for *AIDS Community Television*, 1992)

139. *Common Threads: Stories from the Quilt* (dir. Rob Epstein and Jeffrey Friedman, 1989)

140. "Like a Prayer," documentation of the "Stop the Church" action by ACT UP and WHAM!, 1989 (DIVA TV, 1990)

138

139

140

Untitled offers the quilt as a brilliant spatialization of the loss, a literal queering of public space—the National Mall—marked by previous historical assemblies for civil rights that took place there. So too does the film demonstrate the shared communal logic of historical quilt-making circles and the action groups of ACT UP. And the handmade lettering and reparative act of sewing—tactics frequently deployed by Hodges—are seen to straddle amateur and high-art practices. In other words, *Untitled* shows us that both the rage of ACT UP and the sentimentality of the AIDS quilt were doing the work of imagining queer public space—and with twenty-five years of history between then and now, Hodges's film tells us that we don't have to make a choice along an aesthetic axis of agitprop versus sentimentality, for, as his film goes on to argue, we have more pressing problems to face.

In a tour-de-force of cutting and collaging, *Untitled* takes us from the appropriation inherent in the AIDS quilt, complete with its striking and effective deployment of sentimentality, to an activist use of camp, as we watch AIDS activist and artist Ray Navarro, dressed as Jesus, speak to a fake news camera about the 1989 ACT UP "Stop the Church" protest at St. Patrick's Cathedral in New York (No. 140). This segue makes clear the sympathetic relation between camp and sentimentality: both are invested in excess; both are a function of taste; and both use what Susan Sontag called "artifice and exaggeration." [10] That each should be an aesthetic associated with queerness perhaps goes without saying (though I don't want to argue that queerness offers any exceptionality on this front, just a historical propensity). In addition to being historically queer, sentimentality and camp also share the logic of appropriation—and as such both work to create a "counterpublic" of viewers, adept at reading a popular culture that refuses their existence by reading it against the grain. This idea is amplified in *Untitled* through a clip of French philosopher Jacques Derrida's discussion of the story of Echo and Narcissus. Echo, Derrida says, takes the words of another in repetition and through her appropriation makes them her own, such that "she speaks in her own name by just repeating his words."

By establishing an implicit recognition of gay culture's history of appropriation, *Untitled* explicitly refuses to fashion a hierarchy of "correct" or "better" aesthetic responses to the AIDS crisis. Instead, the film proceeds to collage clips of the first Gulf War conducted under the first President Bush in 1990–1991 with those of the Iraq War waged under President George W. Bush, including clips that allude to extradition and acts of torture perpetrated by the US military (Nos. 141-143). Most of these events transpired after Gonzalez-Torres's death, and it is here where *Untitled* makes some of its largest claims. When *Untitled* intercuts images of 9/11, and the United States' warring and vengeful response to it, with those of the AIDS crisis, it does so with utter parity, underscoring that the victims in both cases are equally innocent. The lack of government response to the AIDS crisis and the vindictive response of the same government to the terrorist attacks are both posited as indiscriminate abuses of state power, in which innocent lives have been sacrificed in the name of profit. [11] The pairing is an object lesson in what happens when we exhibit an ethical disregard for others, particularly when we refuse to see others as constituting a public. This juxtaposition insists upon the trauma of both events; indeed, it requires us to think of these events concurrently, seeing in them the same structural logic of state violence and the same inability to properly mourn the dead. [12]

141–143. Stills from Jim Hodges, Encke King, and Carlos Marques da Cruz *Untitled* 2010 video (color, sound) 60 minutes

Source footage:
141. left: *Fahrenheit 9/11* (dir. Michael Moore, 2004) right: Desert Storm coverage (CNN, 1991)

142. *The Road to Guantanamo* (dir. Mat Whitecross and Michael Winterbottom, 2006)

143. left: *Fahrenheit 9/11* (dir. Michael Moore, 2004) right: Desert Storm coverage (CNN, 1991)

141

142

143

If, as so many have felt before me, Hodges's work of the late 1980s and early 1990s can be seen as a response to the devastation and trauma of the AIDS crisis, then what might those objects and gestures have to tell us now about our country's deleterious response to the trauma of 9/11? In using the sentimental as a way to foreground the socially constructed nature of our emotional lives, or in using mirrors to intervene into the space of the museum whereby his work gathers up the reflections of other artists' works and makes them contemporaneous with and coequivalent to our own reflections and images, [13] Hodges has offered us opportunities to engage in moments of intimacy in public. The same is true of *Untitled*. Its recurrent images of the abuse of power are relentless (although it does possess one bright spot as we witness two older lesbians being married in San Francisco, and hence watch the state act, in an uncharacteristic manner, to affirm love and intimacy rather than to destroy souls). One could be forgiven for quickly brushing away the tears and walking away from the film, eager to return to the banality of the everyday. And yet the film suggests that nothing is more everyday than asking how and whom do we mourn? Is there a way to learn from the dead in addition to mourning them? How does a nation come to terms with itself and its violence? How do citizens come to terms with the violence done against them?

Judith Butler has written of the "precariousness" of the body in relation to the violence of the state, asking if we can imagine a way to mourn and grieve that does not include the fantasies of retribution that have come to dominate the post-9/11 landscape of the United States. She asks: "Is there something to be gained from grieving, from tarrying with grief, from remaining exposed to its unbearability and not endeavoring to seek a resolution for grief through violence?" [14] And commensurate with this probing emotional and ethical question is her rumination on how we might ensure that grief does not lead to violence, namely, by not doing what we currently have done, which is to establish groups of people who cannot be grieved, constituencies who are ungrievable publicly: Palestinians murdered by Israeli troops; Afghan citizens killed by US drones; or the more than six hundred thousand who have died of AIDS in the United States and the millions who continue to die in Africa. *Untitled* establishes the shared trauma of AIDS, terrorism, and war, and shows us that part of the trauma of these events is not simply the extraordinary loss of life that attends each of them, but the state's inability or refusal to allow these human losses to be named, to be grievable.

Even as *Untitled* stages this dilemma, it also shows me that Hodges's oeuvre is littered with models of how to grieve for and mourn the dead as well as how to learn from them. *Untitled* is a portrait of Gonzalez-Torres that never announces itself as such. It refuses the contemporary art world's increasingly hagiographic relation to "Felix" as an exceptional individual; instead, Hodges allows his subject's absence to permeate our current understanding of the violence under which we live. Similarly, Hodges's objects do not affirm our radical separateness from one another, but, instead, through the language of sentimentality, they demonstrate the ways in which our emotional lives are constructed and shared, how they are mutually imbricating. The flower curtains are provisional walls, demarcating spaces for intimacy—for sadness and joy. The napkins with flowers drawn on them flutter slightly, altered by the energy of passing bodies. The disco mirrors remind us of the ecstatic utopian nights of sweaty dancing and the preposterous way youth can postpone time, just as the mirrors' fractured surfaces disallow any

144. Jim Hodges *untitled (Eagle and Butterflies)* 1993 plastic decals on paper 16 x 12 in. (40.6 x 30.5 cm) Collection the artist
Photo: Ronald Amstutz

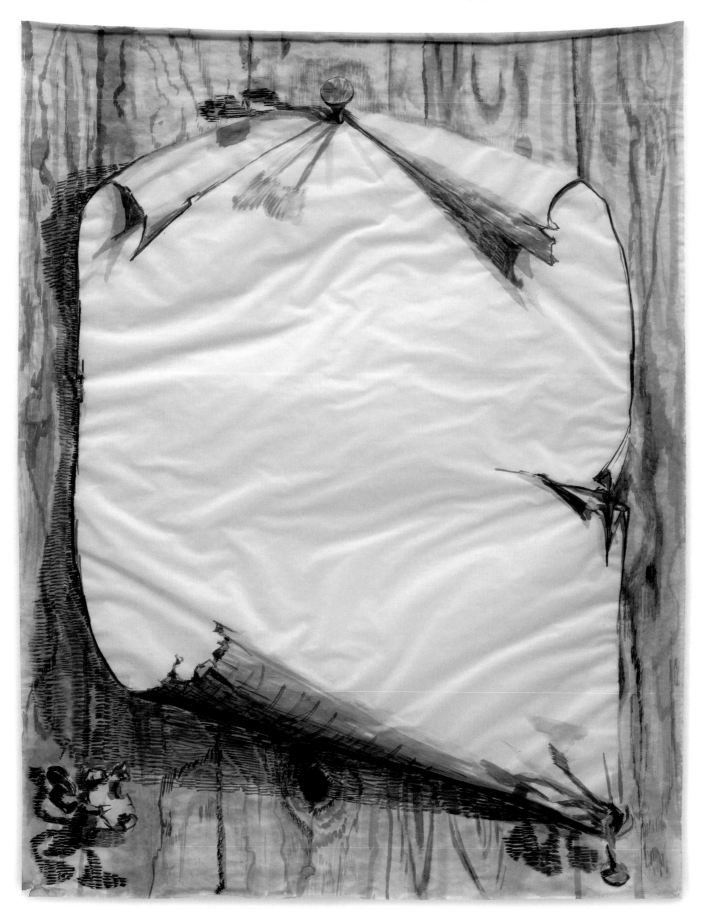

fantasy of wholeness, leaving our image shattered along a thousand fault lines—fault lines of shame, pain, excess, gravity, love, passion, touch, and taste. When I see myself in one of these mirrors, I hear the old ACT UP refrain "The Whole World Is Watching," and I realize that the desire to be seen and to see is potentially as sentimental as it is political.

After watching *Untitled*, I went back to look at the artist's 1991 *Wanted Poster 1* (No. 145), a work that slyly references Duchamp's self-portrait "Wanted" poster of 1923. Hodges's work is a trompe l'oeil drawing of a wanted poster nailed to the wall. Its style evokes the old American West, a kind of spaghetti-western version of criminality, and belongs to an image tradition haunted by the posters used to track down escaped slaves. But Hodges's poster is blank—there is no face, no name. The empty sheet curls and strains away from both the nail and the wood. Here the logic of retribution is substituted for one of coming undone, of unfurling and revealing. Exposed is a knot in the wood—which is simultaneously an imperfection in the material and its linguistic counterpart—a problem to be untangled. The knot is offered as an opening, a void, a site of physical and metaphysical desire. And what is "wanted" in the drawing is neither vengeful nor memorial. There is no proper name, no picture of an individual; instead, all we see is a blank space, one haunted by the vestiges of past wrongs, but open for a new beginning. *

ENDNOTES

1. Quoted in Judith H. Dobrzynski, "Taking the Ordinary and Finding the Beautiful," *New York Times*, March 24, 1999.

2. *Untitled* was made in collaboration with Encke King and Carlos Marques da Cruz, and was originally distributed for the 2011 World AIDS Day/Day With(out) Art by Visual AIDS.

3. Artpace in San Antonio organized a Texas-wide comprehensive survey exhibition of thirteen billboards created by Gonzalez-Torres between 1989 and 1995.

4. June Howard, "What Is Sentimentality?," *American Literary History* 11, no. 1 (Spring 1999): 65–66.

5. Ibid., 70. Howard argues that recent scholarship has begun to articulate the links between sentimentality and citizenship, seeing lines of affiliation between sympathy and empathy—so necessary to the democratic project—and sentimentality. Hence, without an awareness of the public and shared nature of our emotions, social life as such and citizenship in particular are impossible.

6. Ibid.

7. See Richard Dyer, "In Defense of Disco," *Gay Left*, no. 8 (Summer 1979): 20–22.

8. Lauren Berlant and Michael Warner, "Sex in Public," *Critical Inquiry* 24, no. 2 (Winter 1998): 559.

9. At the time, ACT UP actions such as the 1989 "kiss-in" in front of St. Vincent's Hospital and Gran Fury's 1988 wheat-pasted posters of a hot sailor couple kissing exuded the kind of sex-positive "we're here, we're queer, get used to it" attitude designed to tear down the neoliberal language of "tolerance" and

put in its place a fully articulated version of citizenship in which one's desiring identity had a firm status in the public sphere.

10. Susan Sontag, "Notes on Camp," in *Against Interpretation and Other Essays* (New York: Farrar, Strauss and Giroux, 1966), 275.

11. ACT UP was rigorous in its critique of the pharmaceutical companies' exploitation of the crisis in the name of profit, calling media attention to the exorbitant price of AIDS/HIV medications. This rhymes with the antiwar and Occupy movements' attacks on high oil and gas prices and the profit margins of companies such as Halliburton, which have benefited economically from a decade of war.

12. For instance, even though there have been more than 600,000 deaths in the United States due to AIDS-related causes, there is no memorial to those who have died. This seems to constitute "proof" of an inability to properly identify, recognize, and mourn segments of American culture that were decimated by the disease. See Sarah Schulman, *The Gentrification of the Mind: Witness to a Lost Imagination* (Berkeley: University of California Press, 2012).

13. One of my favorite installation shots of Hodges's work is published in the catalogue for the 2007 exhibition *I Remember Heaven: Jim Hodges and Andy Warhol*, curated by Susan Cahan for the Contemporary Art Museum, St. Louis. It shows two of Warhol's camouflage self-portraits reflected in one of Hodges's camouflage mirror mosaics.

14. Judith Butler, *Precarious Life: The Powers of Mourning and Violence* (London and New York: Verso, 2006), 30.

145. Jim Hodges *Wanted Poster 1* 1991 ink on paper 24 1/2 x 18 1/2 in. (62.2 x 47 cm) Collection the artist Photo: Ronald Amstutz

146–157. Jim Hodges *New AIDS Drug* (details) 1990 photocopies 8 1/2 x 11 in. (21.6 x 27.9 cm) each; overall dimensions variable Collection Shelley Hirsch Photos: Ronald Amstutz

For a New AIDS Drug

Doctors study an extract from a Chinese plant

BY GINA KOLATA

For a new AIDS Drug

Doctors study an AIDS drug extract from a Chinese plant.

By GINA KOLATA

Drug is derived from root of plant, Trichosanthes kirilowii.

Patricia J. Wynne

FOR the first time, researchers have found a drug that seems to kill only those immune system cells that harbor the AIDS virus.

The drug has been tested only in the laboratory, so there are no data on its effects when administered to humans. But some experts on AIDS drugs say they are intrigued by its effectiveness in the tests and by its apparent safety in animal studies.

The drug, called GLQ223, is a purified form of a medicine derived from the root of a Chinese cucumber plant, Trichosanthes kirilowii. The plant extract has been used in China since A.D. 300 to induce abortions. Unlike other drugs that have been tested against AIDS, GLQ223 destroys only cells that are infected with the virus, leaving other cells alone.

It is also the only drug that deals directly with macrophage cells, which serve as a reservoir for the virus in the body. The macrophage cells are part of the immune system, and people with AIDS typically have tens of billions of infected macrophage cells.

Other drugs, like AZT, the only drug now licensed for the treatment of AIDS, prevent the virus from replicating in T-4 cells, which are immune system cells that are destroyed by the virus. But they do not affect the macrophages. For its part, GLQ223 also kills infected T cells.

Researchers Are Cautious

The researchers were led by Dr. Michael S. McGrath of the University of California in San Francisco and San Francisco General Hospital, and Jeffrey D. Lifson of Genelabs, a privately held biotechnology company in Redwood City, Calif. They caution that the findings are based solely on laboratory experiments.

The researchers were so afraid of raising false hopes in people with AIDS that they did not disclose their findings for two years, until they were ready to test the drug in people. Their first paper, reporting that one dose of the drug killed infected macrophages, was published Saturday in the Proceedings of the National Academy of Sciences. The infected cells had been collected in blood samples from eight AIDS patients.

"If I told you that we had found a drug that selectively kills HIV-infected cells in a single dose but then told you that it won't be available for two years, you'd go nuts," Dr.

McGrath said, explaining why he waited to publish.

Because animals cannot become infected with the AIDS virus, Dr. McGrath and his colleagues have been unable to use them to test the drug's effectiveness. But animal tests have shown no side effects.

The researchers have applied to the Food and Drug Administration to test the drug in AIDS patients and expect to hear from the agency within a week or two, Dr. McGrath said. A spokesman, Brad Stone, said the agency is reviewing the application. The trials would test only for toxicity; efficacy trials would follow if the drug seems safe in humans.

Although Dr. McGrath shares in a patent that was granted in January for the new drug, he said he will not profit from it. "I'm a University of California employee," he explained. "The university profits from my patent rights." Sandoz Ltd., a Swiss pharmaceuticals company, helped finance the research and will have exclusive rights to market the product.

The findings are "really very interesting," said Dr. Suzanne Gartner, a National Cancer Institute researcher and a discoverer of the role of macrophages in perpetuating AIDS. Although she has not yet seen the data,

In the laboratory, the drug kills only infected cells.

she said she knows and respects Dr. McGrath's work.

The American Foundation for AIDS Research ordinarily does not comment on drugs that have not yet been tested in humans. But when asked about GLQ223, a spokesman, David Corkery, said, "We think it's potentially very promising."

Dr. McGrath said that he discovered that GLQ223 might act against infected macrophages while looking for a substance that would kill all macrophages, infected or not.

About two and a half years ago, Dr. McGrath was visited by Him-Wing Yeung, a biologist from the Chinese Medicinal Material Research Center, who told him about an extract from the roots of Chinese cucumber plants. The Chinese have used the extracts for centuries to induce abortions because the protein kills trophoblasts, cells of the placenta that resemble macrophages. Dr. Yeung suggested that the protein, tricosanthin, might also kill macrophages.

Dr. Michael S. McGrath, one of the leaders of the group that discovered that the drug GLQ223 seems to kill cells harboring the AIDS virus.

Associated Press

In testing the substance with cells of the immune system, Dr. McGrath and his colleagues discovered that it enters only cells infected with the AIDS virus. "Its specificity is uncanny," Dr. McGrath said.

Inside a cell, the drug attacks ribosomes, the sites of protein synthesis, preventing a cell from making new proteins.

But Dr. McGrath and others caution people with AIDS not to go to China to get tricosanthin. He said six AIDS patients recently went to Shanghai and bought a white powder, which they were told was cucumber root. After injecting it, they suffered seizures and high fevers, and had to be hospitalized.

Dr. McGrath speculates that they bought a crude extract of plant proteins, including lectins, which cause blood cells to stick together and which can be lethal. The drug that Dr. McGrath and his colleagues studied is highly purified, consisting of a single protein from the plant root.

157

Love Saves the Day

Bill Arning

Jim Hodges emerged as an artist in the early 1990s, during a period of profound anxiety, even cynicism, surrounding the seemingly irreconcilable realities of a hyperprofessionalized and product-driven art world and the ravages of the AIDS epidemic. As artists started to emerge from graduate schools fully formed and well equipped for the newly created marketing systems, as the monetary stakes continued to climb, and as the desire to be or to discover the next art superstar became ever more pressing, people were dying. For many of us at the time, artists and curators alike, all our earlier ways of working suddenly seemed decadent and abhorrent. By 1988, for artists, both straight and gay, to make art about anything other than AIDS and the related rage, exhaustion, and sorrow was already highly suspect. Beauty, entertainment, decoration, formal explorations, titillation, storytelling, and celebrity all lessened in importance compared to the imperative to do the right thing around AIDS.

In artists' bars and grad-school seminars, the responsibility of image-makers during the early years of a plague that had such conspicuous political dimensions was hotly debated. Old friendships were frequently breached in fights over the correct response. [1] We scoured the history of political activist art for examples that could be said to have made a difference: Pablo Picasso's *Guernica*, which touched the hearts of many who had not known of that atrocity; Martha Rosler's harsh Vietnam War images set within the serene and stylish domestic spaces of perfect American Modern homes; and Andy Warhol's depiction of a demonic-looking Richard Nixon in his 1972 benefit screenprint *Vote McGovern* were starting points. We studied earlier treatments of plagues, vampires, syphilitics, and sex panics. We felt we knew that so much of the fight against AIDS would be waged in the realm of visual propaganda to change the hearts and minds of those Americans who believed the plague would never touch them personally.

With the stakes so high, most responses to AIDS, in all the arts, reflected either anger or elegy. Most often the elegiac reaction came first—the desire to meaningfully record loss and sorrow. There was no way to watch vibrant, sexy gay men at the height of their creativity and vivacity turn into walking skeletons before your eyes, sometimes within weeks of receiving their diagnosis, and not weep. Yet the seeming preventability of all this death was so unacceptable that even the most heartrendingly profound responses were soon overwhelmed by anger. If tears made one ineffective, then tears needed to be replaced by rage. ACT UP, and the many great artists who worked with the collective, [2] created some of the most iconic angry activist artworks of all time.

Both the angry and the elegiac responses were in some sense attempts to control outcomes. We employ the received public language of grief to give form to a sorrow that threatens to overwhelm us. We transform that sorrow into anger in an attempt to control and alter external realities and therefore fix ourselves. Still, there were times when neither the caustic humor of the activists nor the pious tears of the mourners felt right, neither effective nor healing enough to allow one to face another day of caring for self and others. The split between these two poles of response was profound, and few artists found ways to operate across that binary. Yet Hodges emerged at this moment as an artist whose work comes directly out of his life experiences with this heroic, tragic period. He pursued an alternative that moved swiftly through and beyond this bifurcation, setting forth a new paradigm based on principles of love and acceptance, or

158. Jim Hodges *picturing: my heart* 2004 cast crystal 3 $^{5}/_{8}$ x 14 x 8 $^{1}/_{2}$ in. (9.2 x 35.6 x 21.6 cm) Collection Glenn and Amanda Fuhrman, New York; courtesy The FLAG Foundation

159. Jim Hodges *Untitled* 1992 saliva-transferred ink on paper 29 $^{5}/_{8}$ x 22 $^{1}/_{8}$ in. (75.2 x 56.2 cm) Whitney Museum of American Art, New York; purchase, with funds from the Drawing Committee, 2007.30 Digital Image © Whitney Museum of American Art

160

160. Jim Hodges *Untitled (Near and Far)* 2002 mirror on Alucobond in twenty-four parts 77 x 79 in. (195.6 x 200.7 cm) overall Collection Marlene and David Persky

161. Jim Hodges *Latin Rose* 1989 transparent tape, tar paper 72 in. (182.9 cm) diameter Collection the artist Photo: Ronald Amstutz

more specifically, love's imperative of radical acceptance of self, of others, of circumstances.

In retrospect, there was a realization Hodges made as a young artist that, by allowing himself to follow unlikely paths, to digress, to amuse himself, to discover hidden poignant moments in simple activities, poetic reverberations would quickly multiply. His activities in the studio in the very late 1980s (in the memory of this visitor to his basement hideaway at the Dannheisser Foundation in New York) were scattered, fragile, whisper quiet, strangely fabricated, and contrary to nearly all the rules that most emerging artists of that period knew and played by. Yet they were also perfect. Some appear to be no longer extant, such as a videotape of the artist inking a fallen tree and pulling prints from its crumbly textured bark in a beautiful gesture, with Hodges straddling it—a sexy and sad way of celebrating the natural cycles of life and death that seemed so wrongly interrupted or accelerated at the time. In another work of the period, *New AIDS Drug* (1990; Nos. 8, 146–157), Hodges photocopied and rephotocopied a newspaper article on said topic until the resulting degraded image turned into a spiral galaxy, as if some sort of message from beyond the seemingly trivial accident created by the xerox process was allowed to swell into visual significance by the artist. The stacked copies themselves twirled like napkins set out at a louche cocktail lounge. The endless waiting for the development of effective therapies to treat the disease, the questions of faith that constantly rose from having to face our own and our lovers' mortality on a daily basis—all these issues hovered as psychological and spiritual ghosts over these two simple works, which shared an important, internally generated genealogy.

Many of Hodges's works are dominated by similar perfect fragility. To describe them literally is to unintentionally diminish them. "Separate the parts of artificial flowers." "Break a mirror." "Cut the leaves out of photos of trees so they flutter." "Mirror the surface of sections of boulders." All these profound experiences start with small ideas, a "what would that look like" questioning moment. Each fragile concept becomes for Hodges a key in a lock, allowing him to open a door and push, and to find beyond it a terra incognita, an endless landscape in which everything is possible.

How one gets from the period of mourning and anger, in an art world characterized by career strategies and product lines, to a studio practice of absolute acceptance, wonder, and faith in the redemptive power of creativity is a worthy and complex question. I believe it is based on one of the life-lessons of being communal caregivers to a whole culture of vibrant men facing early deaths: the absolute need for a nonjudgmental and selfless form of loving.

Dying people frequently behave badly, even toward those who love them and are devoting themselves to helping them. They rage, they strike out, they are messy emotionally and physically. It was the job of those who were not dying immediately to take care of those who were. One had to invent care techniques on the spot; even during a protest march, where you were screaming bloody murder at perceived enemies of these good dying men, the responsibility of caring for those who needed it never left. Being part of a community going to such extraordinary lengths to take care of each other and ourselves was transformative; every aspect of one's life, one's love life, friendships, and creativity would never be the same again. To have been a witness and, in a small way, a participant was

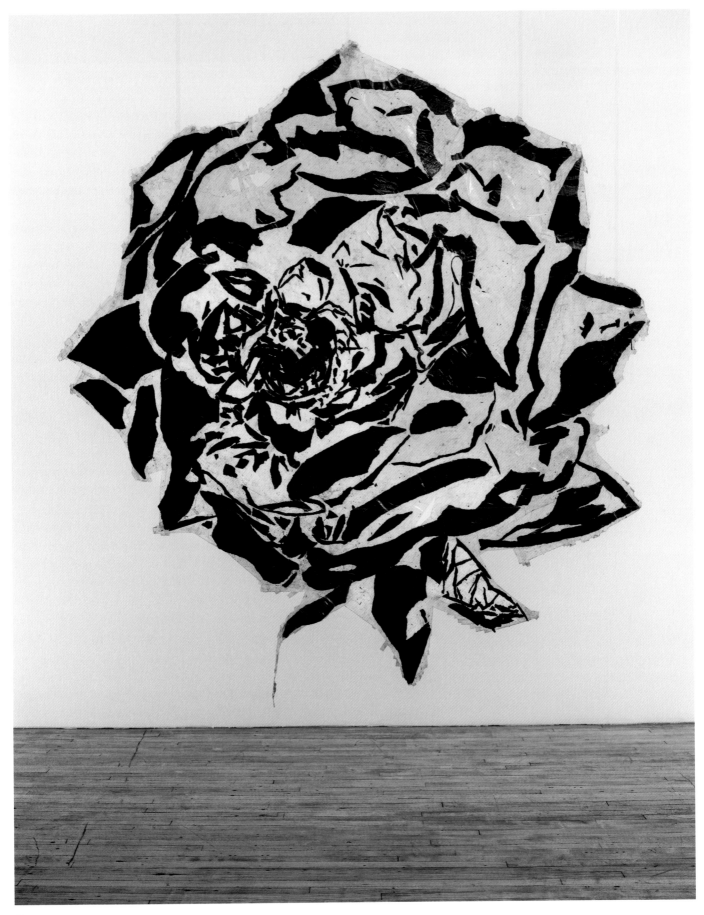

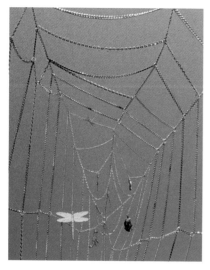

162

a spiritual experience that changed me and everyone I know who lived through those years.

In 1991, when I was director of the alternative arts space White Columns in New York, I invited Hodges to do a White Room project in a second-floor space in the landmark Archive Building on the far west end of Christopher Street, two blocks from where gay liberation officially began at the Stonewall Inn, and still at that time the gay Main Street of America. The faces of the dead and dying were also very visible there, with AIDS hospices and service centers dotting the neighborhood. But the area simultaneously bustled with the boisterous, life-affirming street life of young gay men and lesbians arriving to carouse, get high, dance, and have fun.

The piece that Hodges created, *Untitled (Gate)* (Nos. 18, 162), was extraordinary, startling in its beauty, emotional effects, and transcendent poetry. A massive spiderweb made of different gauge chains formed a securely locked gate that barred viewers from entering a room that Hodges had transformed into an emphatic blue, horizonless landscape—all sky, sea, and pure color. Though Hodges had used the spiderweb motif before in his studio, this was the grandest deployment of the theme to date, going from tiny jewelers' chains to ones that could pull a truck. Viewers were faced with an unfulfilled desire to enter the sealed room, and only after they had accepted the impossibility of attaining that blue heaven did they begin to focus on the gorgeously wrought sculptural object literally at hand as they peered through it.

Working in the space daily while the piece was on view, I was witness to many of the specific, poignant, and poetic responses to *Gate*. Almost universally, the blue was understood as a vision of paradise or heaven. Heaven was a particularly loaded concept at the time, as people were constantly facing and discussing mortality and there was renewed emphasis on faith and spirituality. Some viewers expressed aloud what beliefs in an afterlife they currently held dear, while just as many shared their feelings of doubt, fear, and anger toward the religions in which they were raised. In a period of confrontation, some even expressed outrage that they were being kept out of heaven by Hodges's complex barrier, and more than one quoted the Emily Dickinson poem that starts, "Why—did they shut me out of Heaven? Did I sing—too loud?"

As sensually and intricately decorative as it was sculpturally fierce, the chain web itself was woven through with literal and associative contradictions. Webs are deadly traps in nature; therefore, the web form is shorthand in Gothic fiction and film noir for activities that lure us toward them and have unintended or fatal consequences. The heavier chains also had a clear association with bondage, which was reinforced by the popularity of an old-school S and M bar in Amsterdam called The Web. And though webs almost always carry a negative connotation, as traps leading to doom, S and M seemed to offer a way out of the certainty of infection. The papers said if you were a gay man who had sex, it was best to assume you were already infected; thus the nongenital nature of S and M sexual play came to appear as a life-saving strategy. At the same time, the finer web of *Gate*, with its exquisite detail and occasional addition of a bejeweled insect, both trapped and gorgeous, couldn't hold anything other than our attention. The delicate and mesmerizing intricacy of webs, along with the spider's aura of mystery and danger, perfectly represents the extravagant beauty that nature gives us.

162. Jim Hodges *Untitled (Gate)* (detail) 1991 steel, aluminum, copper, brass, paint, electric lighting 78 x 60 x 2 1/4 in. (198.1 x 152.4 x 5.7 cm) gate; 96 x 120 x 96 in. (243.8 x 304.8 x 243.8 cm) room Collection the artist

163. Jim Hodges *Untitled* 1989 cut paper, transparent tape 26 x 20 in. (66 x 50.8 cm) High Museum of Art, Atlanta, Georgia; purchase with funds from Lyn and Gerald Grinstein and Museum purchase

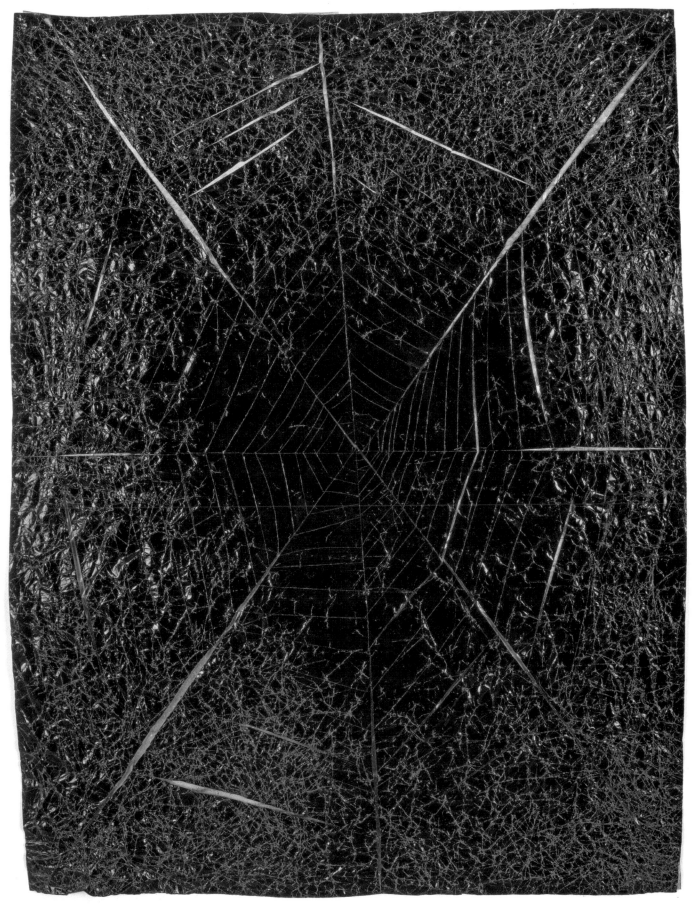

A host of other metaphors became available to those viewers who chose to let their minds wander to poems and lyrics that ruminate on webs, including Walt Whitman's "A Noiseless Patient Spider," which uses the spider as a stand-in for the artist, who launches "gossamer thread" out of his soul in an attempt to connect with something or someone:

> A noiseless patient spider,
> I mark'd where on a little promontory it stood isolated,
> Mark'd how to explore the vacant vast surrounding,
> It launch'd forth filament, filament, filament, out of itself,
> Ever unreeling them, ever tirelessly speeding them.
>
> And you O my soul where you stand,
> Surrounded, detached, in measureless oceans of space,
> Ceaselessly musing, venturing, throwing, seeking the spheres to
> connect them,
> Till the bridge you will need be form'd, till the ductile anchor hold,
> Till the gossamer thread you fling catch somewhere, O my soul. [3]

Others might have sung silently to themselves the lyrics of "Ziggy Stardust," from David Bowie's glam band album *The Rise and Fall of Ziggy Stardust and The Spiders from Mars*, asking, "Where were the spiders when the fly tried to break our balls?" Whereas others of my generation, born in the early sixties, might have recalled the oft-printed photographs of spiders dosed with all the illicit drugs popular at the time: the spider fed downers made a sad-looking, saggy mess of a web, while the speeding amphetamine creature overbuilt a staccato architecture, and the tripping LSD spider made a crazy, loopily pretty structure.

Gate is representative of Hodges at the very start of his career, and it remains indicative of many aspects of his aesthetic and processes: simplicity of concept, perfection of execution, and an open-ended invitation to endlessly complex interpretations. In subsequent years, he has continued to engage viewers with unexpected gifts, such as a lovely mural made in 2004 for the Worcester Art Museum in which the words "Don't Be Afraid" were written by some fifty collaborators from around the world and in scores of languages (No. 98). The chorus of affirmations replaced the xenophobic underside of international relations. For another project, *Here We Are* (1998), he filled a churchyard in Boston with special wind chimes meant to musically translate the sounds of harmonic social chatter in a place where communities would traditionally come together (No. 52). Perhaps the one I was most moved by was *colorsound* (2003), which took place at the Addison Gallery of American Art at the Phillips Academy in Andover and involved some high school students singing one of Hodges's music-based collages—sliced-up sheet music based on systems, their fractured stanzas falling into a jazzy, nonsensical rhythm. And yet the chance sounds were far from discordant, and the voices of the students conjured another alluring vision of heaven. They attended the Academy and were part of the community the artist had embraced there. Somehow, seemingly out of nowhere, the sound they produced brought us all together in the incorporeal joy of angelic abstract melody, as well as in a state of grace made manifest in their youthful beauty.

164. Jim Hodges *No Title* 1988 ink, tar paper, transparent tape on canvas 13 1/4 x 11 x 2 in. (33.7 x 27.9 x 5.1 cm) overall CRG Gallery, New York Photo: Susan Alzner

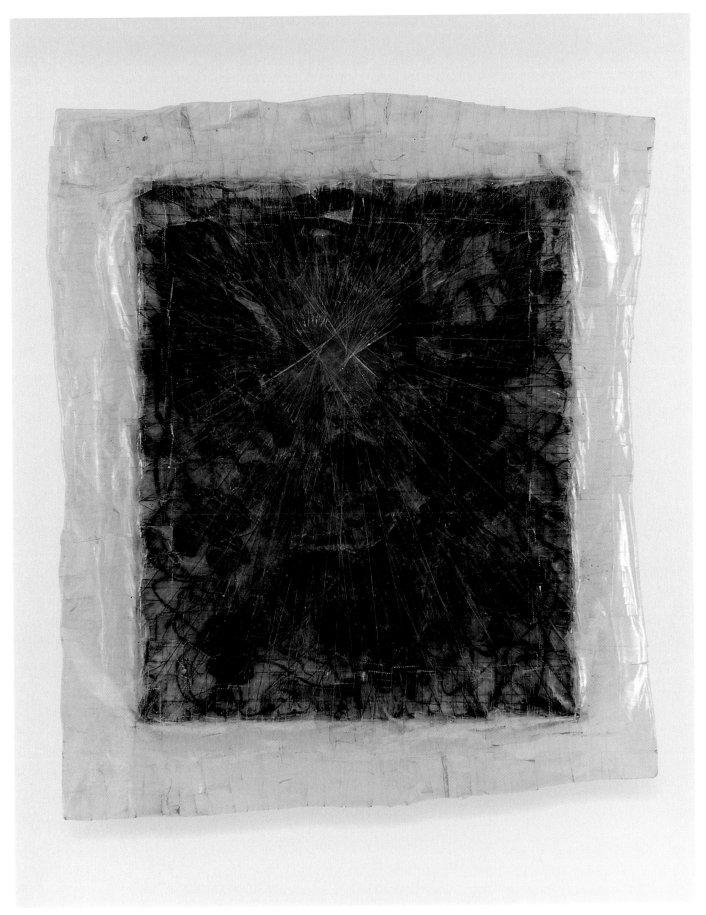

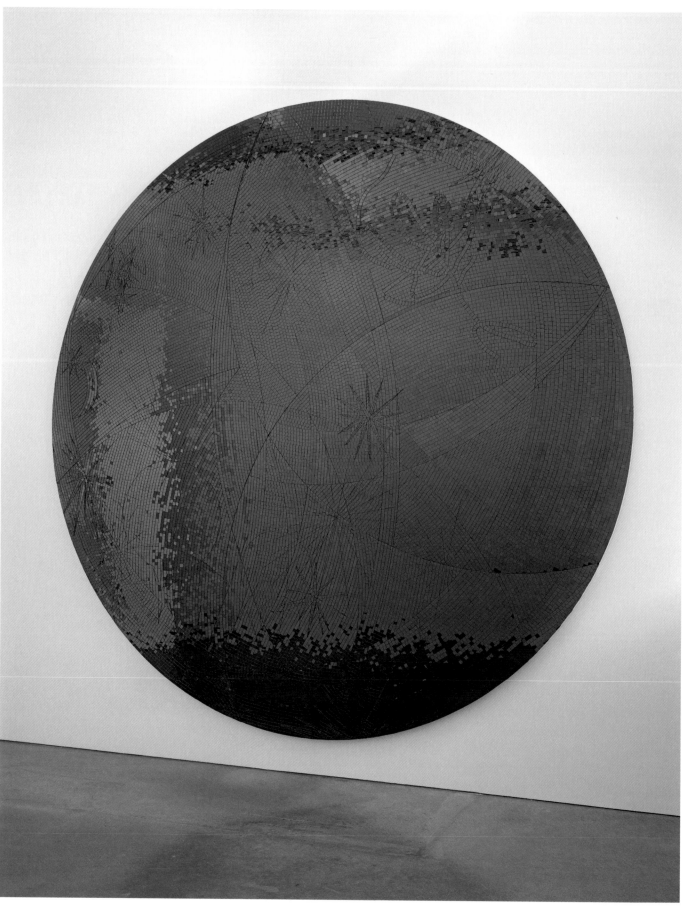

I returned to envisioning that state of a proximate heaven that I associate with Hodges in a much more recent work. For his 2011 solo exhibition at Gladstone Gallery, New York, Hodges conceptualized what was his most poetically powerful piece to date. *Untitled* was time-based and, typically for the artist, rewarded viewers who invested more time to the experience. Hanging from the ceiling, a disco ball slowly spun, reflecting dots of stellar light that circled the room (Nos. 168–171). It caused something akin to the delirium of that dance-party effect whereby one loses the sense of who or what is spinning—you, fellow dancers, or the room—but in the most languid manner. Though disco balls are most often associated with good times and festive occasions, here the pace of the spinning was lugubriously slow, almost glacial, and the silence moved viewers' thoughts toward the infinite, as *Gate* had done so many years before. Viewers might have felt as though they were in an old-school planetarium learning about the Big Bang and a future end-of-the-universe scenario (think of the opening scene in *Rebel without a Cause* in which Sal Mineo's character is terrified in the planetarium hearing about the inevitable fate of humankind's reality).

> The world is a disco ball
> And we're little mirrors
> One and all
> Remember when you feel very small
> The world is a disco ball
> From Havana to Hong Kong
> Someone's dancing all night long
> —Future Bible Heroes, "The World Is a Disco Ball"

Over the course of an hour, the mirrored ball descended into a pond of black water chiseled out roughly in the floor. As the globe sank below the surface—slowly, like a moon sinking below the horizon—the lights on the wall, one by one, fluttered and disappeared.

> The death of a disco dancer
> Well, it happens a lot 'round here
> And if you think peace
> Is a common goal
> That goes to show
> How little you know.
> —The Smiths, "Death of a Disco Dancer"

For me, each light soon came to represent one of my college-era crew: Larry, Stevie, Rob, James, Klaus. All long dead, most of them never made it out of their twenties. I have in my photo box an image in which the faces of six young men, cocktails in hand, smile out with the manic grins of uncontainable excitement of starting our adult lives, discovering sex, love, art, and careers. And, as a gay man in my fifties, I am far from unusual in knowing that I am the only one of those six men left alive.

Then the last light vanished … the quiet descended, the ball was submerged. Again, as from the very beginning with Hodges, the work offered a simple idea,

165. Jim Hodges *Untitled* 2011 mirror on canvas 144 in. (365.8 cm) diameter Collection Penny Pritzker and Bryan Traubert Photo: Ronald Amstutz

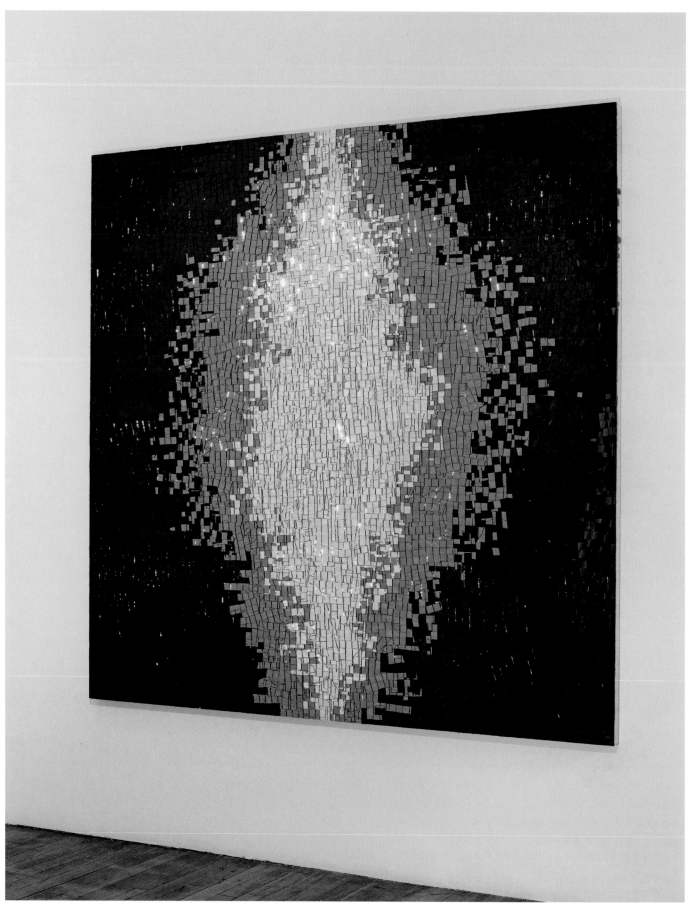

a beautiful realization, and an open invitation for viewers to interpret it through the lens of their own life experiences, as I just did. I looked around the room where many other folks sat on the floor and realized that my list of names was just one possible list to be recited that day, and that in addition to losses tied to AIDS, other losses—to cancer, accidents, drugs—were also present in the room. Just as the blanket of melancholia threatened to fall upon us, the ball began to spin again, emerging from the water....

I rarely find myself in a disco these days, but when I do, I see all the faces of those who are just starting out. I recently heard someone say that ecstasy is feeling all your feelings, the full range, from bone-breaking sorrow to the greatest joy. I believe that to be true, and as the gallery wall filled up again with dots of light, it felt for me like a prayer, a plea for the next generation that the music of ecstatic experience not be cut short.

I met with Hodges at the Gladstone show, and we started talking about our varying relationship to disco music over time, as its influence and associations have changed. I had just read a great article by Douglas Crimp, "Disss-co," describing the role of that musical genre in his own formation of self and sensibility, and ending with a discussion of the opposing camp, which was populated by gay men like me who found punk rock more liberating and who demonized what we considered mainstream gay culture. [4] A week later, Hodges sent me a copy of Tim Lawrence's *Love Saves the Day: A History of American Dance Music Culture, 1970–1979*. While reading this wonderful book, I listened to the songs that had called together an earlier generation and thought about music's power and the three qualities of a great dance song, and of a great artwork: simple concept, perfect execution, and a wide range of interpretive possibilities. These songs that became disco told simple stories against a backdrop of complicated social, sexual, and racial politics. They had great hooks and memorable melodies, yet they rarely shied away from the hard stuff of life. In so doing, they perfectly soundtracked the experience of men coming together in the 1970s, finding community. The book is full of these side stories of people who didn't know how to move forward and yet found a way.

Hodges's way of working is today quite influential, and he is a beloved teacher (I have heard first-person reports from more than one of his former Yale University students describing their experiences with him as "life changing" and his tutelage as having helped them become the artists they wanted to be). I see his impact on the next generation everywhere in my dealings with artists born in the 1980s and 1990s. So many Hodgian devices are now ubiquitous: the adoption of an aesthetics of fragility and near invisibility; the use of materials that could be tacky but when taken apart and re-presented instead convey sublime beauty; the unembarrassed embrace of natural and poetic themes; a conspicuous avoidance of irony; and, most important, a proud claiming of love, eroticism, and joy, all brought together in art. His sensibility—which in the beginning felt to me to be coming clearly from a marginal queer perspective, forged in a unique tragic and beautiful cultural situation—is mainstream today, and that transformation has been magical to watch.

I have endeavored to take the opportunity of this retrospective look at Hodges's work to understand the unlikely originary moment of one of the most poetic artists working today, knowing that my perspective at the time limits my

166. Jim Hodges *The Betweens III* 2012
mirror on canvas 60 x 60 in. (152.4 x
152.4 cm) Private collection; courtesy
Acquavella Galleries Photo: Ronald Amstutz

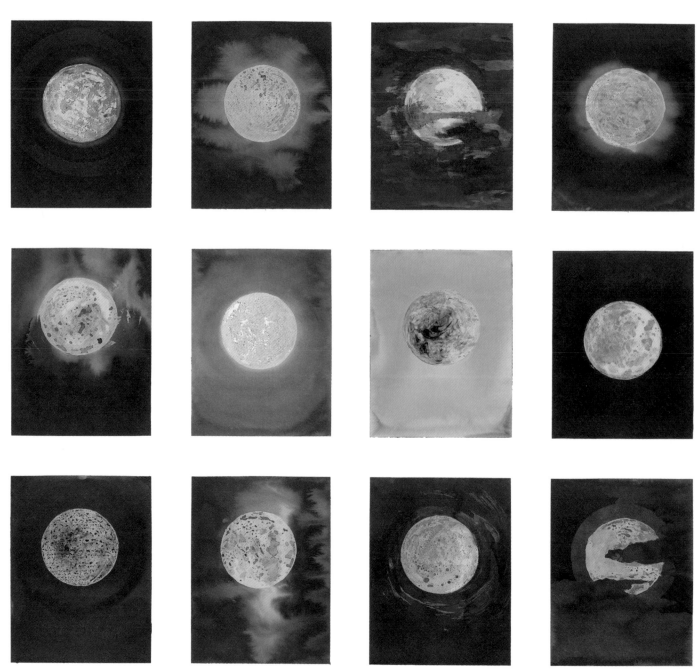

167

167. Jim Hodges *A year of love* 1993 sumi ink, gum arabic on paper in twelve parts 16 x 12 in. (40.6 x 30.5 cm) each Centre Pompidou, National Museum of Modern Art, Centre for Industrial Creation; anonymous gift, 2012
© CNAC/MNAM/Dist. RMN-Grand Palais/Art Resource, New York

attempt at explanation today, which should not in any way be understood as definitive. Hodges's artistic journey is so multivalent and lyrical that I know of no single rubric that can contain it. Yet I do shamelessly assert that throughout every work there is an aesthetic based on love and radical acceptance, and that it takes only a bit of attention to tap into the wellspring that Hodges offers us. In that there is great joy. *

ENDNOTES

1. There was the infamous falling-out of our most distinguished gay art historian, Douglas Crimp, with the cofounders of his revered *October* over the extent of that supreme journal of cultural theory's ongoing responses to the health crisis. Or the protests and counterprotests to the mainstream cultural responses to the epidemic, such as the many who felt angered that a major museum show of photographic sequences of people living with AIDS always ended in death, or when the activist collective Gran Fury's series of "Kissing Doesn't Kill" posters showed a gay male couple, among a panorama of lesbian and straight couples, with a cigarette behind one of the lover's ears, implying, some felt, that gay men had deliberately signed up for early deaths through lifestyle choices.

2. Those associated with ACT UP's artist wing, Gran Fury, are today understood as the great masters of political imaging, celebrated in the 2012 exhibition *Gran Fury: Read My Lips* at New York University's 80WSE Galleries, a powerful survey of the group's most memorable visuals, and showcased in recent career surveys of two founding members: the 2011–2012 traveling exhibition *Donald Moffett: The Extravagant Vein*, organized by the Contemporary Arts Museum, Houston, and the 2010 exhibition *Marlene McCarty: I'm Into You Now, Some Work from 1980–2010* at NYU's 80WSE Galleries.

3. Walt Whitman, "A Noiseless Patient Spider" (1868), first published in *Broadway Magazine* (London) (October 1868) and in *Leaves of Grass* (1871).

4. Douglas Crimp, "*Disss-co* (A Fragment): From *Before Pictures*, a Memoir of 1970s New York," special issue: Disco, *Criticism* 50, no. 1 (Winter 2008): 1–18.

168–171. Jim Hodges *Untitled* 2011 mirror ball, mechanics, lights, water with colorant dimensions variable Collection John and Amy Phelan Installation views, Gladstone Gallery, New York, 2011 Photos: Ronald Amstutz

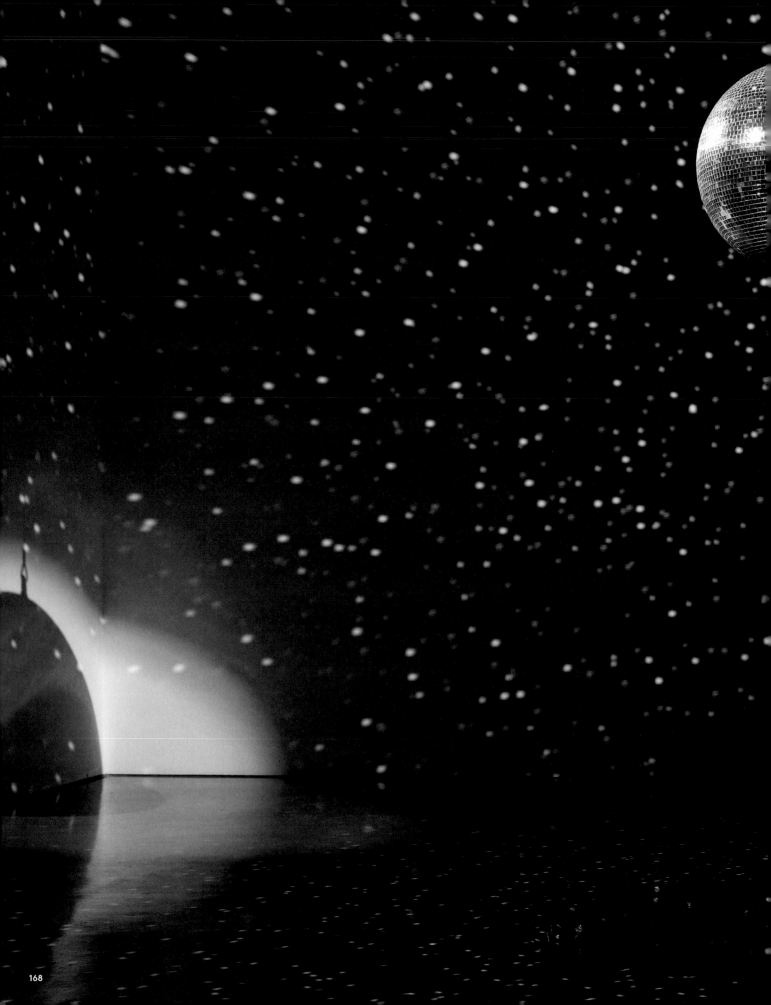

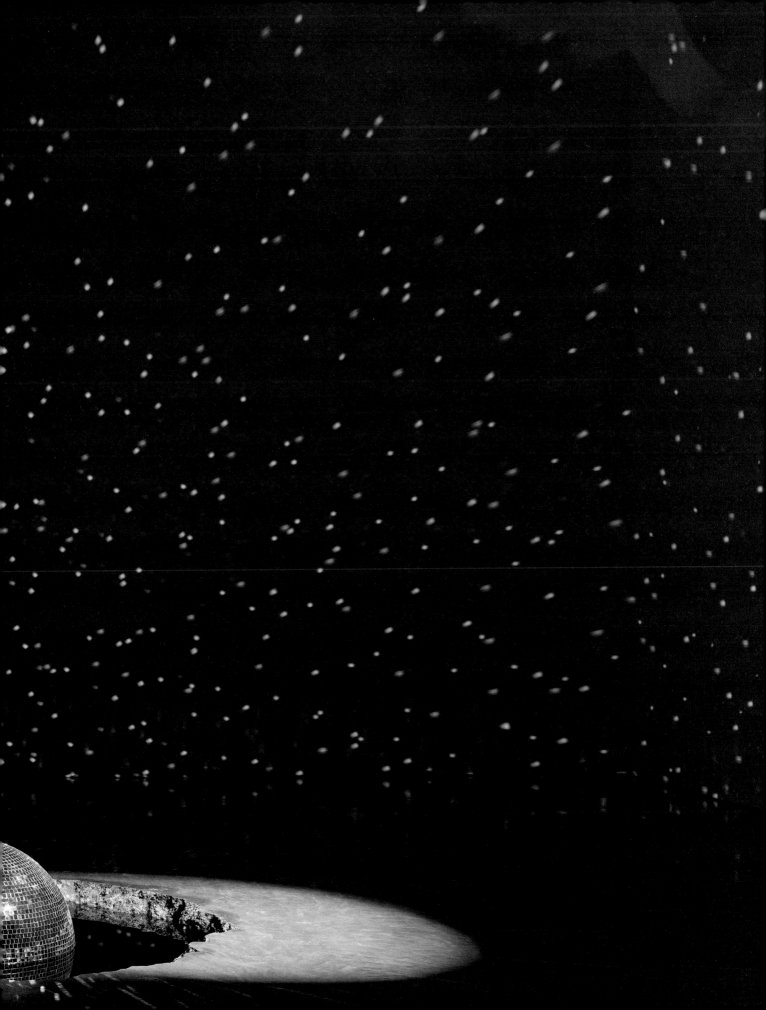

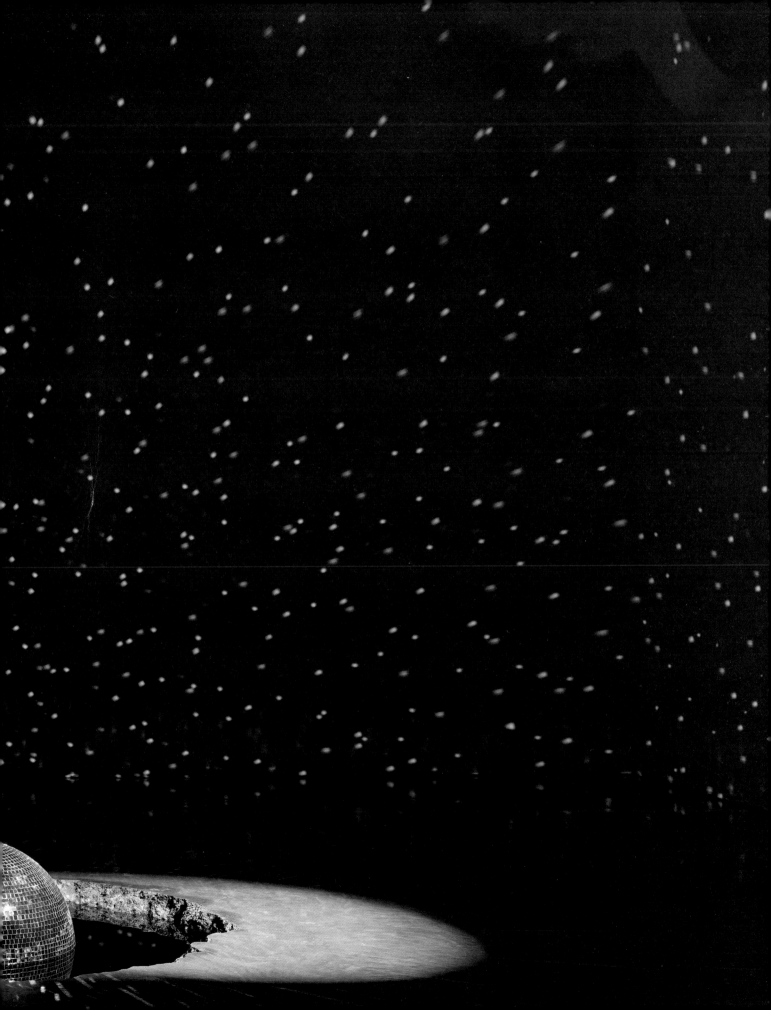

Exhibition History

Solo and Two-Person Exhibitions
Unless otherwise noted, the exhibition title is *Jim Hodges*.

1986
Master of Fine Arts Thesis Exhibition. Pratt Institute, Brooklyn, New York.

1989
Historia Abscondita. Gonzaga University Gallery, Spokane, Washington. October 6–27.

1991
White Room: Jim Hodges. White Columns, New York. December 13, 1991–January 13, 1992.

1992
New AIDS Drug. Het Apollohuis, Eindhoven, Netherlands.

1993
Brooke Alexander, New York. March 25–April 24.
Our Perfect World: An Installation by Jim Hodges. Grey Art Gallery, New York University, New York. September 14–October 30.
Jim Hodges and Bill Jacobson. Paul Morris Fine Art, New York.

1994
Jim Hodges: A Diary of Flowers. CRG Gallery, New York. January 7–February 26.
Jim Hodges: Everything for You. Interim Art, London. October 21–November 19.

1995
Center for Curatorial Studies, Bard College, Annandale-on-Hudson, New York. September 23–December 22.
CRG Gallery, New York. October 28–November 25.

1996
Jim Hodges: States. Fabric Workshop and Museum, Philadelphia. April 25–June 15.
Jim Hodges: yes. Marc Foxx Gallery, Santa Monica, California. May 18–June 15.

1997
Jim Hodges: no betweens and more. SITE Santa Fe, New Mexico. March 15–June 22. Curated by Louis Grachos.
Galerie Ghislaine Hussenot, Paris. September 20–October 11.

1998
Jim Hodges: Welcome. Kemper Museum of Contemporary Art, Kansas City, Missouri. April 9–June 14. Curated by Dana Self.
Jim Hodges: Recent Work. CRG Gallery, New York. September 11–October 10.

1999
Jim Hodges: every way. Museum of Contemporary Art, Chicago, January 16–April 11. Curated by Amanda Cruz. Traveled to Institute of Contemporary Art, Boston, September 8–October 1.
Marc Foxx Gallery, Los Angeles. May 28–June 19.
Jim Hodges: New Work. Miami Art Museum. October 22, 1999–January 9, 2000.

2000
Jim Hodges: Subway Music Box. Oliver Art Center, California College of Arts and Crafts, Oakland. April 15–May 6. Traveled to Northwest Museum of Arts and Culture, Spokane, Washington, July 25–November 3, 2002.
Anthony Meier Fine Arts, San Francisco. May 5–June 9.

2001
Jim Hodges: Three Drawings. CRG Gallery, New York. July 5–August 10.
Galeria Camargo Vilaça, São Paulo. December.

2002
Jim Hodges: like this. Dieu Donné Papermill, New York. April 24–June 1.
Jim Hodges: this and this. CRG Gallery, New York. May 9–June 22.
Jim Hodges and Shelley Hirsch: All the Way with Jim and Shel. Portland Institute for Contemporary Art, Oregon. June 26–August 24.
Jim Hodges: Constellation of an Ordinary Day. Jundt Art Museum, Gonzaga University, Spokane, Washington. September 2–November 2.

2003
Jim Hodges: Returning. Artpace, San Antonio. January 9–April 6.
Jim Hodges: colorsound. Addison Gallery of American Art, Phillips Academy, Andover, Massachusetts. April 12–July 31.
Stephen Friedman Gallery, London. June 10–July 26.

Frances Young Tang Teaching Museum and Art Gallery at Skidmore College, Saratoga Springs, New York. June 21–August 31. Curated by Ian Berry and Ron Platt. Traveled to Austin Museum of Art, February 21–May 23, 2004; Weatherspoon Art Museum, University of North Carolina, Greensboro, August 8–October 24, 2004; Museum of Contemporary Art, Cleveland, January 27–May 1, 2005.

2004
Jim Hodges: Don't be afraid. Worcester Art Museum, Massachusetts. April 2004–July 2005. Curated by Susan L. Stoops.
Shelley Hirsch and Jim Hodges. Roulette at Location One, New York. June 13.

2005
Jim Hodges: Look and See. Commissioned by Creative Time. Ritz-Carlton Plaza, Battery Park, New York. May 5–October 30.
Directions: Jim Hodges. Hirshhorn Museum and Sculpture Garden, Smithsonian Institution, Washington, DC. August 19, 2005–April 13, 2006. Curated by Kristen Hileman.
Jim Hodges: this line to you. Centro Galego de Arte Contemporánea, Santiago de Compostela, Spain. October 19, 2005–January 8, 2006. Curated by Susan Harris.

2007
I Remember Heaven: Jim Hodges and Andy Warhol. Contemporary Art Museum St. Louis, Missouri. January 26–April 22. Curated by Susan E. Cahan.
Jim Hodges: 1991, 1992. CRG Gallery at the 2007 Art Dealers Association of America Art Show, New York. February 21–26.

2008
CRG Gallery, New York. March 1–April 5.
Stephen Friedman Gallery, London. May 31–July 19.
Abandon: The Work of Jim Hodges and Storm Tharp. Saranac Art Projects, Spokane, Washington. July 16–September 6.
Anthony Meier Fine Arts, San Francisco. November 25–December 19.

2009
Jim Hodges: you will see these things. Aspen Art Museum, Colorado. February 13–May 3. Curated by Heidi Zuckerman Jacobson.
Floating a Boulder: Works by Felix Gonzalez-Torres and Jim Hodges. FLAG Art Foundation, New York. October 1, 2009–January 31, 2010. Curated by Jim Hodges.

Jim Hodges: Love et cetera. Centre Pompidou, Paris. October 14, 2009–January 18, 2010. Curated by Jonas Storsve. Traveled to Fondazione Bevilacqua La Masa, Venice, February 5–April 5, 2010; Camden Arts Centre, London, June 10–September 5, 2010.

2010
Gladstone Gallery, Brussels. March 13–May 1.
Jim Hodges: New Work. Dieu Donné, New York. June 3–July 31.

2011
Gladstone Gallery, New York. November 5–December 23.

2012
Jim Hodges: Drawings. Baldwin Gallery, Aspen, Colorado. July 27–September 3.

Selected Group Exhibitions

1988
Selections from the Artists File. Artists Space, New York. November 17, 1988–January 7, 1989. Curated by Valerie Smith.
Installation. Momenta Art Alternatives, Philadelphia.

1990
Jim Hodges, David Nyzio, Vincent Shine. Postmasters, New York. Through May 26.
Auction for Action. ACT UP Benefit, New York.
Partnership for the Homeless with AIDS. Christie's, New York.
Reclamation. Momenta Art Alternatives, Philadelphia.

1991
Lyric: Uses of Beauty at the End of the Century. White Columns, New York. March 30–April 21. Curated by Bill Arning.
Black and White. Nancy Hoffman Gallery, New York. June 7–September 3.

1992
An Ode to Gardens and Flowers. Nassau County Museum of Art, Roslyn Harbor, New York. May 10–August 9. Curated by Constance Schwartz.
Healing. Rena Bransten Gallery, San Francisco. May 12–June 13.
Update 1992. White Columns, New York. September 11–October 4. Curated by Bill Arning.
Collector's Show. Arkansas Arts Center, Little Rock. December 3–27.
The Temporary Image. S. S. White Building, Philadelphia.

1993
Sculpture and Multiples. Brooke Alexander, New York. January 8–February 13.
Selections: Spring 1993. Drawing Center, New York. February 27–March 27.
The Animal in Me. Amy Lipton Gallery, New York. February.
Paper Trails: The Eidetic Image—Contemporary Works on Paper. Krannert Art Museum, University of Illinois at Urbana-Champaign. March 17–April 18.
Beyond Loss: Art in the Era of AIDS. Washington Project for the Arts, Washington, DC. April 23–June 13.
The Art of Self-Defense and Revenge ... It's Really Hard. Momenta Art, New York. May 1–29.
Opening Exhibition. Rowles Studio, Hudson, New York. July 14–August 29.
Arachnosphere. Ramnarine Gallery, Long Island City, New York.
Museo Statale d'Arte Medievale e Moderna, Arezzo, Italy.
Outside Possibilities. Rushmore Festival, Woodbury, New York.

1994
A Garden. Barbara Krakow Gallery, Boston. March 12–April 6.
A Bouquet for Juan: An Exhibition in Honor of Juan Gonzales. Nancy Hoffman Gallery, New York. June 4–July 1.
Les fleurs de mon jardin. Galerie Alain Gutharc, Paris. Curated by Antoinette Ohannessian. September 10–October 20.
Ethereal Materialism. Apexart, New York. October 15–November 26. Curated by Susan Harris.
... It's How You Play the Game. Exit Art/ The First World, New York. November 5, 1994–January 28, 1995. Curated by Thelma Golden, Jeanette Ingberman, Papo Colo, Nancy Spector, and Robert Storr.
Desire. Charles Cowles Gallery, New York.
DYAD. Sauce Gallery, Brooklyn, New York. Curated by Annie Herron.
Matthew Benedict, Willie Cole, Jim Hodges, Doris Salcedo. Brooke Alexander, New York.
Who Chooses Who. Benefit auction for New Museum of Contemporary Art, New York.

1995
Sex Sells. Rena Bransten Gallery, San Francisco. January 5–7.
In a Different Light. University Art Museum, University of California at Berkeley. January 11–April 9. Curated by Nayland Blake and Lawrence Rinder.
Material Dreams. Gallery at Takashimaya, New York. January 14–March 11. Curated by Lynn Gumpert.

Soucis de pensées. Art:Concept/Oliver Antoine, Nice, France. March 3–April 22.
Mon Voyage à New York. Galerie Elizabeth Valleix, Paris. March 11–April 8.
Late Spring. Marc Foxx Gallery, Santa Monica, California. June 7–July 15.
Avant-Garde Walk a Venezia. Venice, Italy. June 8–12. Curated by Marc Pottier.
New Works. Feigen Gallery, Chicago. June 23–August 22.

1996
Glenn Brown, Peter Doig, Jim Hodges, Adriana Varejão. Galerie Ghislaine Hussenot, Paris. January 20–February 24.
Masculine Measures. John Michael Kohler Arts Center, Sheboygan, Wisconsin. January 28–May 12. Curated by Andrea Inselmann.
Material Matters. AOI Gallery, Santa Fe, New Mexico. July–August. Curated by Bobbie Foshay-Miller.
Just Past: The Contemporary in MOCA's Permanent Collection, 1975–1996. Museum of Contemporary Art, Los Angeles. September 29, 1996–January 19, 1997.
Universalis: 23 Bienal Internacional São Paulo. October 5–December 8.
Swag & Puddle. The Work Space, New York.

1997
Metamorphosis. Claudia Gian Ferrari Art Contemporanea, Milan. January 16–March 1.
Poetics of Obsession. Linda Kirkland Gallery, New York. January 22–February 23.
Gothic: Transmutations of Horror in Late Twentieth-Century Art. Institute of Contemporary Art, Boston. April 24–July 6. Curated by Christoph Grunenberg.
Des fleurs en mai: Selected Works from the FRAC des Pays de la Loire Collection. Maison Billaud, Fontenay-le-Comte, France. April 25–June 8.
Contemporary Projects: Longing and Memory. Los Angeles County Museum of Art, Los Angeles. June 5–September 7. Curated by Lynn Zelevansky.
7th International Sculpture and Drawing Biennial, Caldas da Rainha, Portugal. June 7–July 17.
Present Tense: Nine Artists in the Nineties. San Francisco Museum of Modern Art. September 13–January 6, 1998. Curated by Janet C. Bishop, Gary Garrels, and John S. Weber.
Hanging by a Thread. Hudson River Museum, Yonkers, New York. October 3, 1997–February 17, 1998. Curated by Ellen Keiter, Andrea Lilienthal, Jean-Paul Maitinsky, and Catherine Shiga-Gattullo.

Spiders and Webs. Barbara Krakow Gallery, Boston. November 1–December 10.

Changing Spaces: Artists' Projects from the Fabric Workshop and Museum, Philadelphia. Curated by Mary Jane Jacob. Traveled through 1998 to Miami Art Museum; Arts Festival of Atlanta; Detroit Institute of Arts; Vancouver Art Museum, British Columbia; Power Plant, Toronto.

1998

Rights of Spring. P.P.O.W, New York. May 2–30. Curated by Carrie Mae Weems.

AIDS Worlds: Between Resignation and Hope. Centre d'Art Contemporain, Geneva, Switzerland. June 6–October 15. Traveled to Centro d'Arte Contemporanea Ticino, Bellinzona, Switzerland, November 15, 1998–January 31, 1999.

Vita Brevis: Let Freedom Ring. Institute of Contemporary Art/Vita Brevis, Boston. September 10–29, 1998.

Abstract Painting, Once Removed. Contemporary Arts Museum Houston. October 3–December 6. Curated by Dana Friis-Hansen. Traveled to Kemper Museum of Contemporary Art, Kansas City, Missouri, April 23–July 18, 1999.

Political Pictures: Confrontation and Commemoration in Recent Art. Robert Hull Fleming Museum, University of Vermont, Burlington.

1999

Fresh Flowers. Bellevue Art Museum, Washington. January 29–April 11. Curated by Brian Wallace.

Flowers on Fabric: Flora and Friends. Fabric Workshop and Museum, Philadelphia. February 25, 1999–June 1, 2000.

Collectors Collect Contemporary: 1990–99. Institute of Contemporary Art, Boston. March 31–May 28. Curated by Jessica Morgan.

Matter of Time. Dorsky Gallery, New York. September 7–October 23. Curated by Andrew Perchuk.

The American Century: Art and Culture, 1900–2000, Part II. Whitney Museum of American Art, New York. September 26, 1999–February 13, 2000.

Regarding Beauty: A View of the Late Twentieth Century. Hirshhorn Museum and Sculpture Garden, Smithsonian Institution, Washington, DC. October 17, 1999–January 17, 2000. Curated by Neal Benezra and Olga Viso. Traveled to Haus der Kunst, Munich, February 11–April 30, 2000.

Natural Dependency. Jerwood Gallery, London. November 3–December 12. Curated by Stephen Hepworth with Anya Gallacio.

1999 Drawings. Alexander and Bonin, New York. December 11, 1999–January 22, 2000.

2000

Zona F: An Exploration of the Spaces Inhabited by Feminist Discourses in Contemporary Art. Espai d'Art Contemporani de Castelló, Castellón de la Plana, Spain. February 3–April 9. Curated by Helena Cabello and Ana Carceller.

Outbound: Passages from the 90's. Contemporary Arts Museum Houston. March 3–May 7. Curated by Dana Friis-Hansen, Lynn M. Herbert, Marti Mayo, and Paola Morsiani.

Vanitas: Meditations on Life and Death in Contemporary Art. Virginia Museum of Fine Arts, Richmond. March 29–June 18. Curated by John Ravenal.

Projects 70: Jim Hodges, Beatriz Milhazes, Faith Ringgold. Museum of Modern Art, New York. May 1–October 31. Curated by Fereshteh Daftari.

Art at Work: Forty Years of the Chase Manhattan Collection. Queens Museum of Art, New York. May 23–October 1.

Gardens of Pleasure. John Michael Kohler Arts Center, Sheboygan, Wisconsin. June 11–September 17. Curated by Lisa Tamiris Becker.

Of the Moment: Contemporary Art from the Permanent Collection. San Francisco Museum of Modern Art. June 30–August 29. Curated by Janet Bishop.

Et comme l'espérance est violente…. FRAC des Pays de la Loire, Carquefou, France. September 15–December 17.

Minimal Affect: Selections from the Permanent Collection. Museum of Contemporary Art, North Miami, Florida. September 16–November 26.

Age of Influence: Reflections in the Mirror of American Culture. Museum of Contemporary Art, Chicago. Curated by Francesco Bonami and Elizabeth Smith.

Trunk Show. Zoller Gallery, Penn State University, University Park, Pennsylvania. Curated by Ann Shostrom.

2001

Uncommon Threads: Contemporary Artists and Clothing. Herbert F. Johnson Museum of Art, Cornell University, Ithaca, New York. March 31–June 17. Curated by Sean Ulmer.

Somewhere over the Rainbow. FRAC Haute-Normandie, Sotteville-lès-Rouen, France. June 21–September 9.

Camera Works: The Photographic Impulse in Contemporary Art. Marianne Boesky Gallery, New York. June 28–August 10.

Patterns: Between Object and Arabesque. Kunsthallen Brandts Klædefabrik, Odense, Denmark. September 22–December 17. Curated by Lene Burkard and Karsten Ohrt. Traveled to Pori Art Museum, Finland, January 12–March 10, 2002.

2002

La Teoría del Ocio. Fundación/Colección Jumex, Ecatepec, Mexico. January 31–August 31. Curated by Dan Cameron.

Group Exhibition. CRG Gallery, New York. February 9–March 23.

Material World: From Lichtenstein to Viola, Twenty-Five Years of the Fabric Workshop and Museum. Museum of Contemporary Art, Sydney, Australia. February 28–April 28.

Pretty. ATM Gallery, New York. May 10–June 12.

Linger. Artemis Greenberg Van Doren Gallery, New York. June 13–July 26.

Contemporary American Paper Artists: An Invitational Exhibition. Center for Book and Paper Arts, Columbia College Chicago. July 12–August 23.

Chapter V. Art Resources Transfer, New York. August 1–23.

Mirror Mirror. Massachusetts Museum of Contemporary Art, North Adams. October 5, 2002–January 5, 2003. Curated by Jane Simon.

Mask or Mirror? A Play of Portraits. Worcester Art Museum, Massachusetts. October 6, 2002–January 26, 2003. Curated by Susan L. Stoops.

Archivo Pons. Koldo Mitxelena Kulturunea, San Sebastián, Spain. October 17, 2002–January 11, 2003. Curated by Mónica Amor and Carlos Basualdo.

De Kooning to Today: Highlights from the Permanent Collection. Whitney Museum of American Art, New York. October 17, 2002–November 2, 2003.

Arte Povera American Style: Funk, Play, Poetry, and Labor. Cleveland Institute of Art. October 18–December 18. Curated by Bruce Checefsky and Julie Langsam.

Miami Currents: Linking Collection and Community. Miami Art Museum. October 30, 2002–March 2, 2003. Curated by Peter Boswell, Lorie Mertes, and Cheryl Hartup.

Life Death Love Hate Pleasure Pain. Museum of Contemporary Art, Chicago. November 16, 2002–April 20, 2003. Curated by Elizabeth Smith.

Art on Paper 2002. Weatherspoon Art Museum, University of North Carolina, Greensboro. November 17, 2002–January 19, 2003.

Sugar and Cream: Wall Hangings by Contemporary Artists. Triple Candie, New York. November 24, 2002–February 2, 2003.

Summer Group Exhibition. Marc Foxx Gallery, Los Angeles.

2003

Entre-Deux. Centre d'Art Contemporain de Pontmain, France. January 8–February.

In the Making: Contemporary Drawings from a Private Collection. University Museum of Contemporary Art, University of Massachusetts, Amherst. February 1– May 16.

New Material as New Media: The Fabric Workshop and Museum at Twenty-Five Years. Fabric Workshop and Museum, Philadelphia. February 10–April 19. Curated by Anne d'Harnoncourt.

Edén. Colección Jumex at Antiguo Colegio San Ildefonso, Centro Histórico, Mexico City. March 18–June 15. Curated by Patricia Martín and Patrick Charpenel.

Site and Insight: An Assemblage of Artists. P.S.1 Contemporary Art Center, Long Island City, New York. June 29–September 22. Curated by Agnes Gund.

Legacy: A Benefit Exhibition of Works by Capp Street Project Alumnae. Anthony Meier Fine Arts, San Francisco. July 11–August 22.

In Full View. Andrea Rosen Gallery, New York. July 15–September 13.

Drawing Modern: Works from the Agnes Gund Collection. Cleveland Museum of Art. October 26, 2003–January 11, 2004. Curated by Carter Foster and Jeffrey Grove.

Fast Forward: Twenty Years of White Rooms. White Columns, New York. November 1– December 7. Curated by Lauren Ross.

Staff Selections: Permanent Collection. Kemper Museum of Contemporary Art, Kansas City, Missouri. December 12, 2003– February 22, 2004.

Tracing the Sublime. Addison Gallery of American Art, Phillips Academy, Andover, Massachusetts. December 16, 2003–March 21, 2004.

2004

Whitney Biennial 2004. Whitney Museum of American Art, New York. March 11–May 30. Curated by Chrissie Iles, Shamim M. Momin, and Debra Singer.

La Colmena. Fundación/Colección Jumex, Ecatepec, Mexico. March 18–October 30. Curated by Guillermo Santamarina.

Treble. Sculpture Center, Long Island City, New York. May 6–August 1. Curated by Regine Basha.

Hidden Histories. The New Art Gallery, Walsall, England. May 14–July 11. Curated by Michael Petry.

Off the Wall: Works from the J. P. Morgan Chase Collection. Bruce Museum of Arts and Sciences, Greenwich, Connecticut. May 15–September 12. Curated by Stacey B. Gershon and Nancy Hall-Duncan.

Flowers Observed, Flowers Transformed. Andy Warhol Museum, Pittsburgh. May 16– September 5. Curated by John Smith.

Love/Hate: From Magritte to Cattelan. Villa Manin Centro d'Arte Contemporanea, Codroipo, Italy. May 30–November 7. Curated by Francesco Bonami.

MCA Unpacked II: Selections from the MCA Collection by Michelle Nikou (SA) and Joan Grounds (NSW). Anne and Gordon Samstag Museum of Art, University of South Australia, Adelaide. June 10–July 17.

2005

Landscape Confection. Wexner Center for the Arts, Ohio State University, Columbus. January 29–May 1. Curated by Helen Molesworth. Traveled to Contemporary Arts Museum Houston, July 23–September 11; Orange County Museum of Art, Newport Beach, California, February 5–May 7, 2006.

Universal Experience: Art, Life, and the Tourist's Eye. Museum of Contemporary Art, Chicago. February 12–June 5. Curated by Francesco Bonami. Traveled to Hayward Gallery, Southbank Centre, London, October 6–December 11.

Visual Music: Synaesthesia in Art and Music Since 1900. Museum of Contemporary Art, Los Angeles. February 13–May 23. Curated by Kerry Brougher, Jeremy Strick, Ari Wiseman, and Judith Zilczer. Traveled to Hirshhorn Museum and Sculpture Garden, Smithsonian Institution, Washington, DC, June 23–September 11.

Ten Year Anniversary Exhibition. Stephen Friedman Gallery, London. March 29– April 23.

Summer Group Show. Russell Bowman Art Advisory, Chicago. June 24–September 3.

Drawing from the Modern, 1975–2000. Museum of Modern Art, New York. September 14, 2005–January 9, 2006. Curated by Jordan Kantor.

Suspended Narratives. Lora Reynolds Gallery, Austin. October 15–November 19. Curated by Maureen Mahony.

Looking at Words: The Formal Use of Text in Modern and Contemporary Works on Paper. Andrea Rosen Gallery, New York. November 2, 2005–January 26, 2006.

The Fluidity of Time: Selections from the MCA Collection. Museum of Contemporary Art, Chicago. November 25, 2005–March 5, 2006. Curated by Elizabeth Smith.

Art Inside the Park. Memorial Park, Jefferson City, Missouri. Curated by Carla Steck/ Atelier CMS, Inc.

Structure. Lucas Schoormans Gallery, New York.

2006

Twice Drawn. Frances Young Tang Teaching Museum and Art Gallery at Skidmore College, Saratoga Springs, New York. Part 1: March 11–June 4; Part 2: October 7– December 30. Curated by Ian Berry and Jack Shear.

The Last Time They Met. Stephen Friedman Gallery, London. April 28–May 27.

The Name of This Show Is Not: Gay Art Now. Paul Kasmin Gallery, New York. June 8–July 14. Curated by Jack Pierson.

The Missing Peace: Artists Consider the Dalai Lama. Fowler Museum, University of California, Los Angeles, June 11–September 10. Curated by Randy Rosenberg. Traveled to Loyola University Museum of Art, Chicago, October 28, 2006–January 15, 2007; Rubin Museum of Art, New York, March 9–September 3, 2007; Emory Visual Arts Gallery, Atlanta, September 29– October 27, 2007; Yerba Buena Center for the Arts, San Francisco, December 1, 2007– March 16, 2008; Daikanyama Gallery, Tokyo, October 17–November 9, 2008; Fundación Canal, Madrid, January 30–April 12, 2009; Frost Art Museum, Miami, October 9, 2009– January 10, 2010; Brukenthal National Museum, Sibiu, Romania, May 18–July 18, 2010; San Antonio Museum of Art, March 12–July 31, 2011.

Big Juicy Paintings (and More): Selections from the Permanent Collection. Miami Art Museum. June 16–September 17. Curated by Peter Boswell.

Shiny. Wexner Center for the Arts, Ohio State University, Columbus. September 16–December 31. Curated by Helen Molesworth.

Out of Line: Drawings from the Collection of Sherry and Joel Mallin. Herbert F. Johnson Museum of Art, Cornell University, Ithaca, New York. November 4–December 17. Curated by Nancy E. Green.

Artpeace at the Schoolhouse: For Rosa Parks and Martin Luther King. Schoolhouse Gallery, Provincetown, Massachusetts. Curated by Donna Flax and Harriet Jerusha Korim.

2007

Like Color in Pictures. Aspen Art Museum, Colorado. February 15–April 15. Curated by Heidi Zuckerman Jacobson.

Pure (A Group Exhibition). Sean Kelly Gallery, New York. March 23–April 28.

Sparkle Then Fade. Tacoma Art Museum, Washington. May 17–September 3. Curated by Rock Hushka.

Rouge Baiser: Selected Works from the FRAC des Pays de la Loire Collection. Hangar à Bananes, Nantes, France. June 1–September 30. Curated by Laurence Gateau.

Silkscreens: New Prints 2007. International Print Center, New York. June 29–August 3. Curated by Richard Anderman, Donald Baechler, Venetia Kapernekas, Jean-Yves Noblet, Nadine Orenstein, and Yasha Wallin.

Ensemble. Institute of Contemporary Art, University of Pennsylvania, Philadelphia. September 7–December 16. Curated by Christian Marclay.

Deaf 2: "From the Audible to the Visible." Galerie Frank Elbaz, Paris. September 8–October 13. Curated by Peter Coffin.

For Ree. Marc Foxx Gallery, Los Angeles. October 20–November 10.

Delicatessen. Schmidt Center Gallery, Florida Atlantic University, Boca Raton. November 9, 2007–January 26, 2008. Curated by Diana Shpungin.

2008

Attention to Detail. FLAG Art Foundation, New York. January 5–August 1. Curated by Chuck Close.

Drawn Together. FLAG Art Foundation, New York. April–June.

New Prints: Spring 2008. International Print Center, New York. May 1–June 7. Traveled to New York School of Interior Design, New York, June 17–July 24. Curated by Jane Hammond.

A Year in Drawing. Galerie Lelong, New York. June 12–August 1.

Call It What You Like! Collection Rik Reinking. Kunst Centret Silkeborg Bad, Silkeborg, Denmark. June 14–September 28.

Microwave, Six. Josée Bienvenu Gallery, New York. July 10–September 13.

Order, Desire, Light: An Exhibition of Contemporary Drawing. Irish Museum of Modern Art, Dublin. July 25–October 19. Curated by Enrique Juncosa.

All of This Is Melting Away. Royal-T, Culver City, California. August 14, 2008–February 20, 2009. Curated by Jay Sanders.

Intimacy. Fireplace Project, East Hampton, New York. August 15–25. Curated by Anne Pasternak.

An Unruly History of the Readymade. Fundación/Colección Jumex, Ecatepec, Mexico. September 8, 2008–March 6, 2009. Curated by Jessica Morgan.

Wall Rockets: Contemporary Artists and Ed Ruscha. FLAG Art Foundation, New York. October 3, 2008–April 18, 2009. Curated by Lisa Dennison. Traveled to Albright-Knox Art Gallery, Buffalo, New York, July 24–October 25, 2009.

La invención de lo cotidiano. Museo Nacional de Arte, Mexico City, and Fundación/Colección Jumex, Ecatepec, Mexico. November 27, 2008–March 22, 2009. Curated by Frédéric Bonnet.

2009

Compass in Hand: Selections from the Judith Rothschild Foundation Contemporary Drawings Collection. Museum of Modern Art, New York. April 22, 2009–January 4, 2010. Curated by Christian Rattemeyer. Traveled to Martin-Gropius-Bau, Berlin, March 11–May 29, 2011.

La nada y el ser. Fundación/Colección Jumex, Ecatepec, Mexico. April–July. Curated by Shamim M. Momin.

Between Art and Life: The Contemporary Painting and Sculpture Collection. San Francisco Museum of Modern Art. May 10, 2009–January 3, 2010. Curated by Gary Garrels.

Private Universes. Dallas Museum of Art. May 24–August 30. Curated by María de Corral.

The Passionate Pursuit: Gifts and Promised Works from Donna and Cargill MacMillan, Jr. Palm Springs Museum, California. September 5, 2009–June 20, 2010. Curated by Daniell Cornell.

A Tribute to Ron Warren. Mary Boone Gallery, New York. September 12–October 24.

Collection: MOCA's First Thirty Years. Museum of Contemporary Art, Los Angeles. November 15, 2009–July 12, 2010. Curated by Paul Schimmel.

Event Horizon. Walker Art Center, Minneapolis. November 21, 2009–May 22, 2011. Curated by Darsie Alexander and Elizabeth Carpenter.

2010

Floor Corner Wall: Selected Work from the Rachofsky Collection. Fort Worth Contemporary Arts, Texas. January 23–February 21. Curated by Thomas Feulmer and Christina Rees.

Conversations II. Travesia Cuatro, Madrid. February 19–April 27.

Shut Your Eyes in Order to See. Galerie Praz-Delavallade, Paris. May 8–June 26.

Keeping It Real: An Exhibition in Four Acts: Act 1, The Corporeal. Whitechapel Gallery, London. June 10–September 5. Curated by Achim Borchardt-Hume.

Contemporary Collecting: Selections from the Donna and Howard Stone Collection. Art Institute of Chicago. June 25–September 19. Curated by James Rondeau.

Le sourire du chat (opus 2). FRAC des Pays de la Loire, Carquefou, France. June 30–October 31.

Grass Grows by Itself. Marlborough Chelsea, New York. July 15–September 9. Curated by Sima Familant.

A Shot in the Dark. Walker Art Center, Minneapolis. August 12, 2010–April 24, 2011. Curated by Eric Crosby.

Contemporary Prints. CRG Gallery, New York. September 10–October 16.

The Jewel Thief. Frances Young Tang Teaching Museum and Art Gallery at Skidmore College, Saratoga Springs, New York. September 18, 2010–February 27, 2011. Curated by Ian Berry and Jessica Stockholder.

Inquiring Eyes: Greensboro Collects Art. Weatherspoon Art Museum, University of North Carolina, Greensboro. October 16–December 12. Curated by Xandra Eden.

2011

Object as Multiple: 1960–2000. Stephen Wirtz Gallery, San Francisco. January 25–March 12.

Making a Mark: Drawings from the Contemporary Collection. High Museum of Art, Atlanta. February 24–August 21.

I Am Still Alive: Politics and Everyday Life in Contemporary Drawing. Museum of Modern Art, New York. March 23–September 19. Curated by Christian Rattemeyer.

CLAP. CCS Bard Hessel Museum, Annandale-on-Hudson, New York. March 27–May 22. Curated by Nova Benway, Michelle Hyun, Nathan Lee, and Dylan Peet.

Wishing and Praying. CRG Gallery, New York. April 7–30.

All That Glisters. Stephen Friedman Gallery, London. June 10–July 30.

Collecting for the Future: The Safeco Gift and New Acquisitions. Tacoma Art Museum, Washington. June 25, 2011–January 2012. Curated by Margaret Bullock.

One, Another. FLAG Art Foundation, New York. June 29–August 31. Curated by Stephanie Roach.

Contemporary Collection. Centre Pompidou, Paris.

Linde Family Wing for Contemporary Art.
 Museum of Fine Arts, Boston.

2012
Secret Garden. Philadelphia Museum of Art.
 March 3–August 26. Curated by Dilys E.
 Blum.
First Among Equals. Institute of Contemporary
 Art, University of Pennsylvania,
 Philadelphia. March 14–August 12. Curated
 by Alex Klein and Kate Kraczon.
San Antonio Collects: Contemporary. San
 Antonio Museum of Art. March 24–July 1.
 Curated by David S. Rubin.
Bower. Hiram Butler Gallery, Houston. June
 2–30.
Paramor. FRAC des Pays de la Loire,
 Carquefou, France. June 2–October 14.
Shapeshift. Stephen Friedman Gallery,
 London. June 9–July 28.
The Living Years: Art after 1989. Walker Art
 Center, Minneapolis. September 6, 2012–
 August 11, 2013 Curated by Siri Engberg and
 Clara Kim.
Funny. FLAG Art Foundation, New York.
 September 21–October 27. Curated by Heidi
 Zuckerman Jacobson.
Shock of the News. National Gallery of Art,
 Washington, DC. September 23, 2012–
 January 27, 2013. Curated by Judith Brodie.

2013
*More Love: Art, Politics, and Sharing since the
 1990s*. Ackland Art Museum, University of
 North Carolina at Chapel Hill. February 1–
 March 31. Curated by Claire Schneider.
*Drawing Line into Form: Works on Paper
 by Sculptors from the Collection of BNY
 Mellon*. Tacoma Art Museum, Washington.
 February 23–May 26. Curated by Rock
 Hushka.
Nur Skulptur! Kunsthalle Mannheim,
 Germany. March 16–November 17.
*Over, Under, Next: Experiments in Mixed
 Media, 1913–Present*. Hirshhorn Museum
 and Sculpture Garden, Smithsonian
 Institution, Washington, DC. April 18–
 September 8. Curated by Evelyn Hankins.
Fruits of Captiva. Rauschenberg Foundation
 Project Space, New York. July 12–August 18.

Compiled by Eric Crosby

172–174. Jim Hodges *Untitled* (details) 2013
(in progress) denim fabric, thread 144 x 288 in.
(365.8 x 731.5 cm) Courtesy the artist and
Gladstone Gallery Photos: Ronald Amstutz

Selected Bibliography

Solo and Two-Person Exhibition Catalogues and Brochures

Berry, Ian, and Ron Platt, eds. *Jim Hodges*. Saratoga Springs, NY: Frances Young Tang Teaching Museum and Art Gallery at Skidmore College, 2003. Texts by Ron Platt and Allan Schwartzman. Interview by Ian Berry.

Cahan, Susan E., ed. *I Remember Heaven: Jim Hodges and Andy Warhol*. Saint Louis, MO: Contemporary Art Museum St. Louis, 2007. Texts by Susan E. Cahan and José Esteban Muñoz.

Capp Street Project: Jim Hodges: Subway Music Box. Oakland, CA: Oliver Art Center at California College of Arts and Crafts, 2000. Brochure. Interview by Lawrence Rinder.

Cruz, Amanda, ed. *Jim Hodges: every way*. Chicago: Museum of Contemporary Art, 1999. Text by Amanda Cruz.

Floating a Boulder: Works by Felix Gonzalez-Torres and Jim Hodges. New York: FLAG Art Foundation, 2010. Texts by Bill Arning, Justin Bond, David Deitcher, Jim Hodges, and Joel Wachs.

Harris, Susan, ed. *Jim Hodges: this line to you*. Santiago de Compostela, Spain: Centro Galego de Arte Contemporánea, 2005. Texts by Susan Harris, Manuel Olveira, and Lynne Tillman.

Hileman, Kristen. *Jim Hodges: don't be afraid*. Washington, DC: Hirshhorn Museum and Sculpture Garden, 2005. Brochure.

Jacobson, Heidi Zuckerman. *Thank You Very Much*. Aspen, CO: Aspen Art Museum, 2009. http://aspenartmuseum.org /archive/archive_hodges_zuckerman _jacobson.html. Online essay.

Jim Hodges. New York: CRG Gallery, 1995. Artist's book. Text by Julie Ault.

Jim Hodges. São Paulo: Galeria Camargo Vilaça, 2001. Brochure.

Jim Hodges: 1991, 1992. New York: CRG Gallery, 2007. Text by Nayland Blake.

Jim Hodges: colorsound. Andover, MA: Addison Gallery of American Art, Phillips Academy, 2004. Interactive CD-ROM.

Jim Hodges: Drawings. Aspen, CO: Baldwin Gallery, 2012. Poem by John Masterson.

Jim Hodges: no betweens and more. Santa Fe, NM: SITE Santa Fe, 1997. Brochure.

Littman, Brett. *Jim Hodges: like this*. New York: Dieu Donné, 2002. Brochure.

Self, Dana. *Jim Hodges: Welcome*. Kansas City, MO: Kemper Museum of Contemporary Art, 1998. Brochure.

Stoops, Susan L. *Jim Hodges: Don't be afraid*. Worcester, MA: Worcester Art Museum, 2004. Brochure.

Storsve, Jonas, ed. *Jim Hodges: Love et cetera*. Paris: Centre Pompidou, 2009. Texts by Jonas Storsve and Colm Tóibín.

Group Exhibition Catalogues and General Literature

Aguilar, Nelson, ed. *Universalis: 23 Bienal Internacional São Paulo*. São Paulo: Fundação Bienal de São Paulo, 1996.

Arning, Bill. "Sure, everyone might be an artist ... but only one artist gets to be the guy who says that everyone else is an artist." In *What We Want Is Free: Generosity and Exchange in Recent Art*, edited by Ted Purves, 11–16. Albany, NY: State University of New York Press, 2005.

_____. *Update 1992*. New York: White Columns, 1992.

Benezra, Neal, and Olga Viso, eds. *Regarding Beauty: A View of the Late Twentieth Century*. Washington, DC: Hirshhorn Museum and Sculpture Garden in association with Hatje Cantz, 1999.

Berry, Ian, and Jack Shear, eds. *Twice Drawn: Modern and Contemporary Drawings in Context*. Saratoga Springs, NY: Frances Young Tang Teaching Museum and Art Gallery at Skidmore College, 2011.

Bishop, Janet C., Gary Garrels, and John S. Weber, eds. *Present Tense: Nine Artists in the Nineties*. San Francisco: San Francisco Museum of Modern Art, 1997.

Blake, Nayland, Lawrence Rinder, and Amy Scholder, eds. *In a Different Light: Visual Culture, Sexual Identity, Queer Practice*. San Francisco: City Lights Books, 1995.

Bonami, Francesco, ed. *Universal Experience: Art, Life, and the Tourist's Eye*. Chicago: Museum of Contemporary Art, 2005.

Bonami, Francesco, and Sarah Cosulich Canarutto, eds. *Love/Hate: From Magritte to Cattelan*. Passariano, Italy: Villa Manin, 2004.

Brodie, Judith, ed. *Shock of the News*. Washington, DC: National Gallery of Art in association with Lund Humphries, 2012.

Brougher, Kerry, et al., eds. *Visual Music: Synaesthesia in Art and Music Since 1900*. Washington, DC: Hirshhorn Museum and Sculpture Garden; Los Angeles: Museum of Contemporary Art, in association with Thames & Hudson, 2005.

Burkard, Lene, and Karsten Ohrt, eds. *Patterns: Between Object and Arabesque*. Odense, Denmark: Kunsthallen Brandts Klædefabrik, 2001.

Buskirk, Martha. *The Contingent Object of Contemporary Art*. Cambridge, MA: MIT Press, 2003.

Cabello, Helena, and Ana Carceller, eds. *Zona F*. Valencia: Generalitat Valenciana, 2000.

Checefsky, Bruce, and Julie Langsam, eds. *Arte Povera American Style: Funk, Play, Poetry, and Labor*. Cleveland: Cleveland Institute of Art, 2002.

Converge 2. Miami: Miami Art Museum, 2005.

Daftari, Fereshteh. *Projects 70: Jim Hodges, Beatriz Milhazes, Faith Ringgold*. New York: Museum of Modern Art, 2000. Brochure.

Dennison, Lisa, ed. *Wall Rockets: Contemporary Artists and Ed Ruscha*. New York: FLAG Art Foundation, 2008.

Foster, Carter, and Jeffrey Grove, eds. *Drawing Modern: Works from the Agnes Gund Collection*. Cleveland: Cleveland Museum of Art, 2003.

Friis-Hansen, Dana, ed. *Abstract Painting, Once Removed*. Houston: Contemporary Arts Museum, 1998.

Friis-Hansen, Dana, et al., eds. *Outbound: Passages from the 90's*. Houston: Contemporary Arts Museum, 2000.

Gershon, Stacey B., and Nancy Hall-Duncan, eds. *Off the Wall: Works from the J. P. Morgan Chase Collection*. Greenwich, CT: Bruce Museum of Arts and Sciences, 2004.

Gian Ferrari, Claudia, ed. *Metamorphosis*. Milan: Charta, 1997.

Gonzalez-Torres, Felix. *A Selection of Snapshots Taken by Felix Gonzalez-Torres*. New York: A.R.T. Press, 2010.

Grosenick, Uta, ed. *Art Now Vol. 2: The New Directory to 136 International Contemporary Artists*. Cologne and London: Taschen, 2005.

Grunenberg, Christoph, ed. *Gothic: Transmutations of Horror in Late Twentieth-Century Art*. Boston: Institute of Contemporary Art; Cambridge, MA: MIT Press, 1997.

Gumpert, Lynn, ed. *Material Dreams*. New York: Gallery at Takashimaya with the cooperation of the Fabric Workshop and Museum, 1995.

Iles, Chrissie, Shamim M. Momin, and Debra Singer, eds. *Whitney Biennial 2004*. New York: Whitney Museum of American Art, 2004.

Jacobson, Heidi Zuckerman, ed. *Like Color in Pictures*. Aspen, CO: Aspen Art Museum, 2007.

Juncosa, Enrique, ed. *Order, Desire, Light: Contemporary Drawing*. Dublin: Irish Museum of Modern Art, 2008.

Kantor, Jordan, ed. *Drawing from the Modern, 1975–2000*. New York: Museum of Modern Art, 2005.

Keiter, Ellen J. *Hanging by a Thread*. Yonkers, NY: Hudson River Museum, 1997.

Marclay, Christian, ed. *Ensemble*. Philadelphia: Institute of Contemporary Art, University of Pennsylvania, 2008. Audio CD and pamphlet.

Marcoci, Roxana, Diana Murphy, and Eve Sinaiko, eds. *New Art*. London: Harry N. Abrams, 1997.

Medvedow, Jill, and Carole Anne Meehan, eds. *Vita Brevis: History, Landscape, and Art, 1998–2003*. Boston: Institute of Contemporary Art; Göttingen: Steidl, 2004.

Molesworth, Helen, ed. *Landscape Confection*. Columbus: Wexner Center for the Arts, Ohio State University, 2005.

Morgan, Jessica, ed. *Collectors Collect Contemporary: 1990–99*. Boston: Institute of Contemporary Art, 1999.

Muñoz, José Esteban. *Cruising Utopia: The Then and There of Queer Futurity*. New York: New York University Press, 2009.

Painting and Works on Paper: National Endowment for the Arts Regional Fellowships, 1992. Baltimore: Mid Atlantic Arts Foundation, 1992.

Pasternak, Anne, et al. *Creative Time: The Book*. New York: Princeton Architectural Press, 2007.

Perchuk, Andrew. *Matter of Time: Jim Hodges, Charles LeDray, Michelle Segre, and Jonathan Seliger*. New York: Dorsky Gallery, 1999. Brochure.

Phillips, Lisa. *The American Century: Art and Culture, 1950–2000*. New York: Whitney Museum of American Art in association with W. W. Norton, 1999.

Pottier, Marc, ed. *Avant-Garde Walk a Venezia*. Venice: Edizioni d'Arte Fratelli Pozzo, 1995.

Rattemeyer, Christian, ed. *Compass in Hand: Selections from the Judith Rothschild Foundation Contemporary Drawings Collection*. New York: Museum of Modern Art, 2009.

Ravenal, John B., ed. *Vanitas: Meditations on Life and Death in Contemporary Art*. Richmond: Virginia Museum of Fine Arts, 2000.

Richards, Judith Olch, ed. *Inside the Studio: Two Decades of Talks with Artists in New York*. New York: Independent Curators International, 2004.

Roach, Stephanie, ed. *One, Another*. New York: FLAG Art Foundation, 2011.

Rondeau, James, ed. *Contemporary Collecting: The Donna and Howard Stone Collection*. Chicago: Art Institute of Chicago, 2010.

Rosenthal, Mark, ed. *Regarding Warhol: Sixty Artists, Fifty Years*. New York: Metropolitan Museum of Art, 2012.

Ross, Lauren, ed. *Fast Forward: Twenty Years of White Rooms*. New York: White Columns, 2003.

Schneider, Claire, ed. *More Love: Art, Politics, and Sharing since the 1990s*. Chapel Hill: Ackland Art Museum, University of North Carolina at Chapel Hill, 2013.

SFMOMA Painting and Sculpture Highlights. San Francisco: San Francisco Museum of Modern Art, 2002.

Smith, Elizabeth, et al., eds. *Life Death Love Hate Pleasure Pain: Selected Works from the Museum of Contemporary Art, Chicago, Collection*. Chicago: Museum of Contemporary Art, 2002.

Smith, Valerie, ed. *Selections from the Artists File*. New York: Artists Space, 1988.

Stoops, Susan L., ed. *Mask or Mirror? A Play of Portraits*. Worcester, MA: Worcester Art Museum, 2002.

Stroud, Marion Boulton, ed. *New Material as New Media: The Fabric Workshop and Museum*. Cambridge, MA: MIT Press, 2002.

Thompson, Don. *The $12 Million Stuffed Shark: The Curious Economics of Contemporary Art*. New York: Palgrave Macmillan, 2008.

Ulmer, Sean M., ed. *Uncommon Threads: Contemporary Artists and Clothing*. Ithaca, NY: Herbert F. Johnson Museum of Art, Cornell University, 2001.

Zelevansky, Lynn. *Contemporary Projects: Longing and Memory*. Los Angeles: Los Angeles County Museum of Art, 1997. Brochure.

Periodicals and Newspapers

Arning, Bill. "Jim Hodges: An Artist's Mirror Image." *Out*, no. 58 (September 1998): 38.

Baker, Kenneth. "Capp Street Benefit Show." *San Francisco Chronicle*, August 16, 2003.

————. "Musical Gifts from Underground." *San Francisco Chronicle*, April 22, 2000.

Benjamin, Marina. "One Sensation after Another." *Evening Standard* (London), November 5, 1999.

Bensinger, Ken. "Art and Money." *Wall Street Journal*, December 22, 2000.

Bonetti, David. "I Remember Heaven: Jim Hodges and Andy Warhol." *St. Louis Post-Dispatch*, February 2, 2007.

Boyce, Roger. "Neither Here Nor There: Mirror Mirror at MASS MoCA." *Art New England* (February–March 2003): 16–17, 74.

Brown, Glen R. "Jim Hodges: Kemper Museum of Contemporary Art." *New Art Examiner* 26, no. 1 (September 1998): 46.

Canning, Susan M. "Ethereal Materialism." *New Art Examiner* 22, no. 6 (February 1995): 43–44.

Carey-Kent, Paul. "White Works." *Art World*, no. 8 (December 2008–January 2009): 42–47.

Carrier, David. "Jim Hodges: Museum of Contemporary Art, Cleveland." *Artforum* 43, no. 8 (April 2005): 192–193.

Chambers, Christopher. "Jim Hodges." *Flash Art* 41 (January–February 2008): 162.

Chattopadhyay, Collette. "Visual Music in the Key of Three D." *Sculpture* 24, no. 6 (July–August 2005): 77–79.

Clemmer, David. "SITE Santa Fe, Santa Fe, New Mexico." *Flash Art*, no. 195 (Summer 1997): 98.

Cohen, Joyce. "Public Space Private Encounters: The Wall(s) at WAM." *Art New England* 26, no. 2 (April–May 2005): 18–19.

Cooper, Harry. "An Eye for an Ear: Art and Music in the Twentieth Century." *Artforum* 43, no. 10 (Summer 2005): 310–315, 366.

Cotter, Holland. "Art in Review: Jim Hodges." *New York Times*, September 25, 1998.

_____. "Art Review: Messages Woven, Sewn or Floating in the Air." *New York Times*, January 9, 1998.

_____. "Matter of Time." *New York Times*, September 10, 1999.

_____. "New Sparkle for an Abstract Ensemble." *New York Times*, January 7, 2011.

Darling, Michael. "Doodle Dandy, Just Say Yes to Jim Hodges." *Los Angeles Reader*, May 31, 1996.

_____. "Review: Longing and Memory." *LA Weekly*, June 20–26, 1997.

Decter, Joshua. "Jim Hodges: Marc Foxx." *Artforum* 35, no. 3 (November 1996): 104–105.

Deitcher, David. "Death and the Marketplace." *Frieze*, no. 29 (June–August 1996): 40–45.

Dobrzynski, Judith H. "Taking the Ordinary and Finding the Beautiful." *New York Times*, March 24, 1999.

Ebony, David. "Art Show Shines in Big Apple." *Art in America* 93, no. 4 (April 2005): 47.

Edelman, Robert G. "Jim Hodges." *Artpress*, no. 189 (March 1994): 94–95.

Goodell, Jennifer Wulffson. "Hey, Good Looking." *X-TRA: Contemporary Art Quarterly* 8, no. 4 (July 2006): 41–44.

Finkelstein, Alix. "Crossing the Line: A Year in Drawing." *New York Sun*, July 31, 2008.

"Generator: Interview with Jim Hodges." *Art Review*, no. 29 (January–February 2009): 44–45.

Gopnick, Blake. "Here and Now." *Washington Post*, September 4, 2005.

Grabner, Michelle. "A Different Kind of Animal." *Art Review*, no. 56 (2005): 38–39.

Grundberg, Andy. "Present Tense: Nine Artists in the Nineties." *Artforum* 36, no. 6 (February 1998): 87.

Harris, Susan. "Jim Hodges at CRG." *Art in America* 91, no. 1 (January 2003): 107.

_____. "Jim Hodges: CRG." *Art News* 93, no. 4 (April 1994): 173.

Harrison, Helen A. "'Flowers' and Modern Masters." *New York Times*, June 28, 1992.

Hart, Jane. "Eve Andreé Laramée, Jim Hodges." *Zing Magazine*, no. 3 (Autumn–Winter 1996–1997).

Hartman, Carl. "Art Work Addresses Fear in Scores of Languages." *Washington Times*, August 20, 2005.

Heartney, Eleanor. "Jim Hodges at CRG." *Art in America* 86, no. 5 (November 1998): 135.

Hegarty, Laurence. "Jim Hodges: CRG Gallery." *New Art Examiner* 26, no. 5 (February 1999): 54–55.

Hodges, Jim. "India." *Art in America* 99, no. 10 (November 2011): 54–55.

Horodner, Stuart. "Jim Hodges." *Bomb*, no. 79 (Spring 2002): 100–102.

"Horror Art." *Flash Art* (May 1996): 52.

Hossenally, Rooksana. "Jim Hodges: Love Et Cetera." *Uneexpo.com*, December 11, 2009.

Hudson, Suzanne Perling. "Beauty and the Status of Contemporary Criticism." *October* 104 (Spring 2003): 115–130.

Hughes, Robert J. "All the Way with Jim and Shel." *Wall Street Journal*, August 2, 2002.

"Jim Hodges." *Art on Paper* 6, no. 6 (July–August 2002): 44–45.

"Jim Hodges." *New Yorker*, November 28, 2011, 11.

Johnson, Ken. "Alumni Return, Juxtaposing Past and Present." *New York Times*, November 28, 2003.

_____. "Art Guide: Linger." *New York Times*, June 28, 2002.

_____. "Art in Review: Jim Hodges." *New York Times*, May 31, 2002.

_____. "Gathering a Flock of Quirky Grown-Ups." *New York Times*, July 18, 2003.

_____. "Jim Hodges." *New York Times*, March 28, 2008.

Johnson, Patricia C. "'Outbound' Captures Moments of a Decade." *Houston Chronicle*, March 18, 2000.

Jowitt, Deborah. "Slow Down!" *Village Voice*, November 12, 2002, 61.

_____. "What Price Love?" *Village Voice*, February 29, 2000, 67.

Kandel, Susan. "Jim Hodges." *Los Angeles Times*, June 6, 1996.

Kastner, Jeffrey. "Jim Hodges: CRG Gallery, New York." *Art/Text*, no. 64 (February–April 1999): 96–97.

Keats, Jonathon. "Letters to a Young Artist." *San Francisco Magazine* (February 2000): 56–57.

Killam, Brad. "Masculine Measures." *New Art Examiner* 24, no. 1 (September 1996): 49.

Kimmelman, Michael. "Touching All Bases at the Biennial." *New York Times*, March 12, 2004.

Klein, Jennie. "Cleveland." *Art Papers* 29, no. 4 (July–August 2005): 50–51.

Klein Zandvoort, Bernke. "Seduction Is a Voluntary Act." *Mister Motley*, no. 26 (2010).

Knight, Christopher. "Adventurers Enticed by the Landscape." *Los Angeles Times*, February 28, 2006.

_____. "The Exhibition: Beguiled by 'Longing and Memory.'" *Los Angeles Times*, June 7, 1997.

Kutner, Janet. "The Rachofskys Talk About Their Top 10." *Dallas Morning News*, August 28, 2005.

LaBelle, Charles. "Jim Hodges." *Frieze*, no. 54 (September–October 2000): 119–120.

Laffer, Christine. "Present Tense: Nine Artists in the Nineties." *Art Papers* 22, no. 2 (March–April 1998): 36.

Levin, Kim. "Choices." *Village Voice*, November 28, 1995.

_____. "Short List." *Village Voice*, August, 7, 2001.

Mack, Joshua. "The Art of Letting Go." *Modern Painters* (July–August 2005): 94–97.

Mahoney, Robert. "Jim Hodges." *Time Out New York*, August 9–16, 2001.

Marquis, Cate. "'I Remember Heaven' Offers Intriguing Pairing of Artists." *The Current* (St. Louis), March 2, 2007.

May, Stephen. "Headline Grabbers." *Art News* 111, no. 11 (December 2012): 30.

McClure, Lissa. "Jim Hodges." *Review*, February 1, 1997.

McKenna, Kristine. "The Contemporary Not Temporary at LACMA." *Los Angeles Times*, June 7, 1997.

Millett, Ann. "Jim Hodges: Weatherspoon Art Museum." *Sculpture* 24, no. 1 (January–February 2005): 75–76.

Moreno, Gean. "Interview: Jim Hodges." *New Art Examiner* 27, no. 9 (June 2000): 13–15.

————. "Miami." *Art Papers* 24, no. 4 (July–August 2000): 33–34.

Moriarity, Bridget. "Jim Hodges: Aspen Art Museum." *Modern Painters* 21, no. 6 (September 2009): 73.

Musgrave, David. "Natural Dependency." *Art Monthly* (November–December 2000): 232.

Myers, Terry. "He's Not Here: Terry Myers Visits Jim Hodges' Studio in New York." *Trans> Arts, Cultures, Media*, no. 6 (1999): 174–177.

Nichols, Matthew. "Jim Hodges." *Art in America* 100, no. 1 (January 2012): 93–94.

Ostow, Saul. "Jim Hodges: CRG." *Art in America* 96, no. 8 (September 2008): 159–160.

Perchuk, Andrew. "Jim Hodges: CRG Gallery." *Artforum* 37, no. 4 (December 1998): 131–132.

Princenthal, Nancy. "The Jewel Thief." *Art in America*, January 5, 2011, http://www.artinamerica magazine.com/reviews /the-jewel-thief.

Richard, Paul. "Beauty Is Back! And She's Got Quite an Attitude in the Hirshhorn's Look at What Pleases the Human Eye." *Washington Post*, October 10, 1999.

Rizk, Mysoon. "Arte Povera American Style." *Art Papers* 27, no. 2 (March–April 2003): 44.

Rosenberg, Karen. "Simple Truths in Matters of Life and Death." *New York Times*, March 25, 2011.

Rothkopf, Scott. "Subject Matters." *Artforum* 42, no. 9 (May 2004).

Rugoff, Ralph. "Beauty Bites Back." *Harper's Bazaar* (October 1999): 234–237.

Schmelzer, Paul. "Chaos and Creativity: Jim Hodges on AIDS, Social Change, and Felix Gonzalez-Torres' Art." Walkerart .org, November 29, 2011, http://www .walkerart.org/magazine/2011 /chaos-and-creativity.

Schütz, Heinz. "Beauty Now." *Kunstforum International*, no. 151 (July–September 2000): 381–384.

Sheets, Hilarie M. "The Oranges Are Alive." *Art News* 99, no. 3 (March 2000): 118–120.

Smith, Roberta. "Also of Note." *New York Times*, November 24, 1995.

————. "At Shows Painted with Sound, Be Prepared to See with Your Ears." *New York Times*, May 21, 2004.

————. "The Horror: Updating the Heart of Darkness." *New York Times*, June 1, 1997.

————. "Jim Hodges." *New York Times*, February 11, 1994.

————. "Jim Hodges." *New York Times*, November 18, 2011.

————. "The New, Irreverent Approach to Mounting Exhibitions." *New York Times*, January 6, 1995.

————. "Quick as a Shutter, Group Shows Shatter Conventional Wisdom." *New York Times*, July 6, 2001.

Spears, Dorothy. "Evidence of a Life Lived." *Art on Paper* 10, no. 3 (January–February 2006): 64–69.

————. "Hidden Pleasures and Public Treasures." *Art News* 103, no. 5 (May 2004): 100–104.

————. "Wall Flowers." *I.D.* 54, no. 2 (March–April 2007): 23.

Spector, Nancy. "Peripheral Visions: Jim Hodges and Siobhan Liddell." *Guggenheim Magazine* (Fall 1996): 33.

Tagliafierro, Marco. "Jim Hodges: Fondazione Bevilaqua la Masa." Translated by Marguerite Shore. *Artforum* 48, no. 10 (Summer 2010): 372.

Temin, Christine. "His Sound Art Echoes in the Mind." *Boston Globe*, July 9, 2003.

————. "Thurber, Hodges Limn a Landscape of Loss." *Boston Globe*, September 10, 1999.

Tranberg, Dan. "Jim Hodges at Museum of Contemporary Art." *Art on Paper* 9, no. 5 (May–June 2005): 79.

————. "Look and See." *Bomb*, no. 92 (Summer 2005): 21.

Tuck, Mike. "Jim Hodges: A Matter of Matter." *Artslant*, June 27, 2010, http://www .artslant.com/lon/articles/show/17372.

Turner, Elisa. "Why Don't You Come and Install It?" *Art News* 106, no. 9 (October 2007): 162–165.

Upshaw, Reagan. "Jim Hodges at CRG Art." *Art in America* 82, no. 5 (May 1994): 109–110.

Weinstein, Matthew. "Jim Hodges." *Artforum* 32, no. 9 (May 1994): 102.

"Working Proof." *Art on Paper* 3, no. 6 (July–August 1999): 50–54.

Zaza, Tony. "No More Super-Sizing: Sizing the Biennial." *New York Arts* 9, nos. 5–6 (May–June 2004): 17.

Zimmer, William. "Works That Are Made from Textiles." *New York Times*, January 18, 1998.

Compiled by Eric Crosby

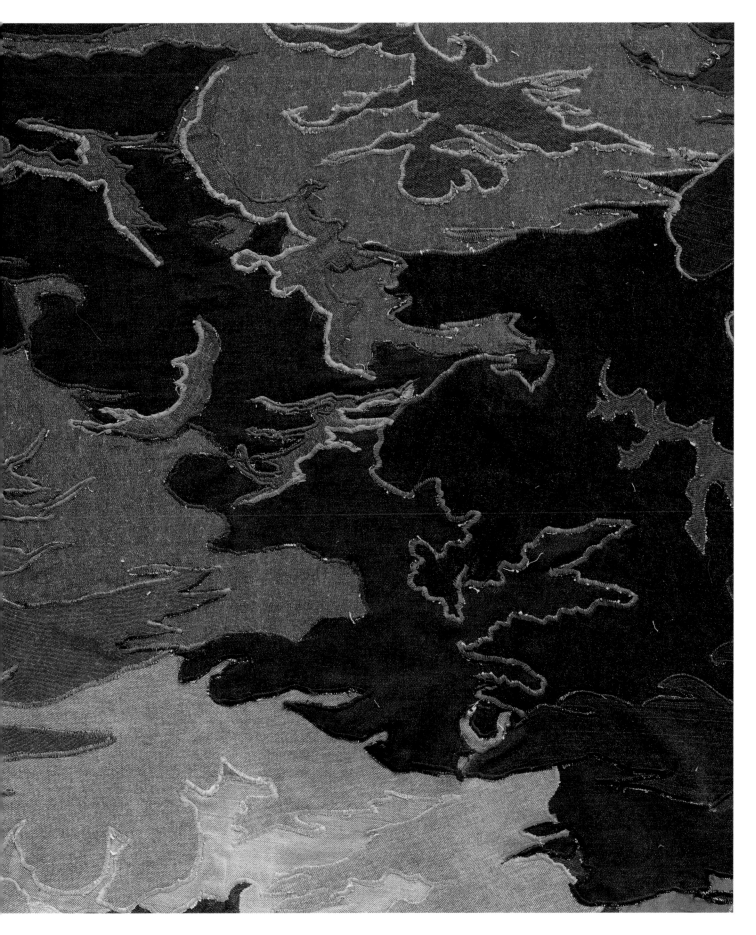

Exhibition Checklist

Height precedes width precedes depth.
For works on paper, dimensions indicate
sheet size.

Good Luck 1987
altered ski mask
approx. 18 x 19 in. (45.7 x 48.3 cm)
Collection the artist

No Title 1988
ink, tar paper, transparent tape on canvas
13 ¼ x 11 x 2 in. (33.7 x 27.9 x 5.1 cm) overall
CRG Gallery, New York

Deformed 1989
altered shopping bag
30 ½ x 34 in. (77.5 x 86.4 cm)
Collection the artist

Latin Rose 1989
transparent tape, tar paper
72 in. (182.9 cm) diameter
Collection the artist

Untitled 1989
cut paper, transparent tape
26 x 20 in. (66 x 50.8 cm)
High Museum of Art, Atlanta, Georgia;
purchase with funds from Lyn and Gerald
Grinstein and Museum purchase

Untitled (Gate) 1991
steel, aluminum, copper, brass, paint, electric
lighting
78 x 60 x 2 ¼ in. (198.1 x 152.4 x 5.7 cm) gate;
96 x 120 x 96 in. (243.8 x 304.8 x 243.8 cm) room
Collection the artist

Wanted Poster 1 1991
ink on paper
24 ½ x 18 ½ in. (62.2 x 47 cm)
Collection the artist

Untitled 1992
saliva-transferred ink on paper
29 ⁵/₈ x 22 ⅛ in. (75.2 x 56.2 cm)
Whitney Museum of American Art, New
York; purchase, with funds from the Drawing
Committee, 2007.30

what's left 1992
white brass chain, clothing
dimensions variable
Private collection

A year of love 1993
sumi ink, gum arabic on paper in twelve parts
16 x 12 in. (40.6 x 30.5 cm) each
Centre Pompidou, National Museum of
Modern Art, Centre for Industrial Creation;
anonymous gift, 2012

Eyes (For Traveling) 1993
ink on paper
13 x 10 in. (33 x 25.4 cm)
Collection the artist

untitled (Eagle and Butterflies) 1993
plastic decals on paper
16 x 12 in. (40.6 x 30.5 cm)
Collection the artist

A Diary of Flowers (When We Met) 1994
ink on paper napkins in seventy-two parts
70 x 74 in. (177.8 x 188 cm) overall
Collection Barbara and Michael Gamson

a line to you 1994
silk, plastic, wire with thread
211 in. (535.9 cm) length overall
Collection Glenn and Amanda Fuhrman, New
York; courtesy The FLAG Art Foundation

Here's where we will stay 1995
printed nylon, painted chiffon and silk head
scarves with thread, embroidery, sequins
216 x 204 in. (548.6 x 518.2 cm) overall
Courtesy the artist and Stephen Friedman
Gallery

Arranged 1996
book, metal paperclips
13 x 6 ½ x 10 ¼ in. (33 x 16.5 x 26 cm) overall
Collection Heidi L. Steiger

No Dust 1996
mirror on canvas
28 x 22 in. (71.1 x 55.9 cm)
Collection Sheila and Bill Lambert; courtesy
Neal Meltzer Fine Art, New York

Untitled (Happy Valentine's Day) 1996
ballpoint pen, gouache on paper
8 x 14 ½ in. (20.3 x 36.8 cm)
Collection the artist

A Far Away Corner 1997
white brass chain
dimensions variable
Collection John and Amy Phelan

Changing Things 1997
silk, plastic, wire, pins in 342 parts
76 x 148 in. (193 x 375.9 cm) overall
Dallas Museum of Art; Mary Margaret Munson
Wilcox Fund and gift of Catherine and Will
Rose, Howard Rachofsky, Christopher Drew
and Alexandra May, and Martin Posner and
Robyn Menter-Posner

Untitled (Study for One with the other)
1997
contact paper on paper
38 ½ x 50 in. (97.8 x 127 cm)
Cejas Art, Ltd.

With the Wind 1997
scarves, thread
90 x 99 in. (228.6 x 251.5 cm) overall
Collection Glenn and Amanda Fuhrman, New
York; courtesy The FLAG Art Foundation

You 1997
silk, cotton, polyester, thread
192 x 168 in. (487.7 x 426.7 cm) overall
Fabric Workshop and Museum, Philadelphia

As close as I can get 1998
Pantone color chips with adhesive tape
81 x 81 in. (205.7 x 205.7 cm)
Collection Eileen Harris Norton

He and I 1998
Prismacolor pencil on wall
70 ¼ x 102 ½ in. (178.4 x 260.4 cm)
Collection the artist

Landscape 1998
cotton, silk, polyester, vinyl, wool, plastic
5 x 63 ¾ x 32 ½ in. (12.7 x 161.9 x 82.6 cm)
overall
Courtesy the artist and Stephen Friedman
Gallery

On Earth 1998
mirror on canvas
40 x 60 in. (101.6 x 152.4 cm)
Pizzuti Collection

Another Turn 1999
wood, metal, ceramic sockets, lightbulbs in
four parts
31 ½ x 31 ½ in. (80 x 80 cm) each
Pérez Art Museum Miami; promised gift of
Mimi and Bud Floback

Untitled (Love) 2000–2001
sheet music collage
21 x 33 ½ in. (53.3 x 85.1 cm)
Whitney Museum of American Art, New York;
purchase, with funds from Faith Golding
Linden, 2002.199

Happy—A World in the World 2001
Prismacolor pencil on paper
47 ³/₈ x 34 ¹⁵/₁₆ in. (120.3 x 88.7 cm)
Collection Jeff, Mary, and Martha
Rathmanner

Slower than this 2001
cut photograph on paper in six parts
22 x 30 in. (55.9 x 76.2 cm) each; 66 x 60 in.
(167.6 x 152.4 cm) overall
Collection Adrienne and Peter Biberstein

Picturing That Day 2002
sheet music, Color-aid paper on nylon in two
parts
84 x 72 in. (213.4 x 182.9 cm) overall
The Art Institute of Chicago; Ada S. Garrett
Prize Fund

Untitled (bells) 2002
blown glass in eighteen parts
dimensions variable
Pizzuti Collection

Untitled (Near and Far) 2002
mirror on Alucobond in twenty-four parts
77 x 79 in. (195.6 x 200.7 cm) overall
Collection Marlene and David Persky

all in the field 2003
embroidered fabric
72 x 48 in. (182.9 x 121.9 cm)
Cranford Collection, London

See II 2003
mirror on canvas in two parts
60 x 40 in. (152.4 x 101.6 cm) each
Collection Sharon and Michael Young

picturing: tracing form 2004
cast crystal
5 3/4 x 5 5/8 x 7 3/4 in. (14.6 x 14.3 x 19.7 cm)
Collection Marilyn and Larry Fields

Untitled (It's already happened) 2004
cut chromogenic print
102 1/4 x 70 3/4 in. (259.7 x 179.7 cm)
Collection Andrea and Jim Gordon

"I am building a wall of brilliant color" 2005
Color-aid paper with Beva adhesive on paper
15 x 11 3/4 in (38.1 x 29.8 cm)
Collection Annabel Fuhrman, New York

Movements (Stage 1) 2005
mirror on canvas
96 x 66 in. (243.8 x 167.6 cm)
Private collection

and still this 2005–2008
23.5k and 24k gold with Beva adhesive on
gessoed linen
89 x 200 x 185 in. (226.1 x 508 x 469.9 cm)
overall
The Rachofsky Collection and the Dallas
Museum of Art through the DMA/amfAR
Benefit Auction Fund

Movements (Stage II) 2006
mirror on canvas
84 x 96 in. (213.4 x 243.8 cm)
Collection Glenn and Amanda Fuhrman, New
York; courtesy The FLAG Art Foundation

Even Here (Horizon) 2008
archival pigment print on Crane portfolio rag
paper with varnish overlay; ed. 1/5
16 x 21 in. (40.6 x 53.3 cm)
Collection the artist

ghost 2008
glass sculpture in multiple parts
35 x 22 x 22 in. (88.9 x 55.9 x 55.9 cm) overall
Private collection, London

movements (variation III) 2008
mirror on canvas
84 x 60 in. (213.4 x 152.4 cm)
Collection Glenn and Debbie August

the dark gate 2008
wood, steel, electric light, perfume, paint,
flooring
96 x 96 x 96 in. (243.8 x 243.8 x 243.8 cm)
structure; overall dimensions variable
Private collection

When I Believed, What I Believed 2008
stained glass, steel
81 1/2 x 56 x 56 in. (207 x 142.2 x 142.2 cm)
Courtesy the artist, Gladstone Gallery,
Stephen Friedman Gallery, and Anthony Meier
Fine Arts

here it comes 2009
charcoal, 24k gold, pastel, saliva on paper in
seven parts
30 1/4 x 179 in. (76.8 x 454.7 cm) overall
Collection Meryl Lyn and Charles Moss

Movements (Stage IV) 2009
mirror on canvas
57 x 96 in. (144.8 x 243.8 cm)
Collection Barbara Zomlefer Herzberg;
courtesy McCabe Fine Art

on the way between places 2009
charcoal, saliva on paper in twenty-one parts
30 x 22 1/2 in. (76.2 x 57.2 cm) each
1–7: Collection Flavia and Guilherme Teixeira
8–21: Collection the artist

Anymore 2010
handmade paper, cast paper with Beva
adhesive
28 x 18 x 5 1/2 in. (71.1 x 45.7 x 14 cm) overall
Collection Lillian and Billy Mauer

Just this (the end) 2010
cut chromogenic print
98 3/8 x 65 3/4 in. (249.9 x 167 cm)
Collection James Van Damme, Brussels

Untitled 2011
mirror on canvas
144 in. (365.8 cm) diameter
Collection Penny Pritzker and Bryan Traubert

Untitled (scratched sky IV) 2011
scratched and incised archival pigment print
80 x 59 1/2 in. (203.2 x 151.1 cm)
Collection Gayle and Paul Stoffel

The Betweens III 2012
mirror on canvas
60 x 60 in. (152.4 x 152.4 cm)
Private collection; courtesy Acquavella
Galleries

Untitled 2013
denim fabric, thread
144 x 288 in. (365.8 x 731.5 cm)
Courtesy the artist and Gladstone Gallery

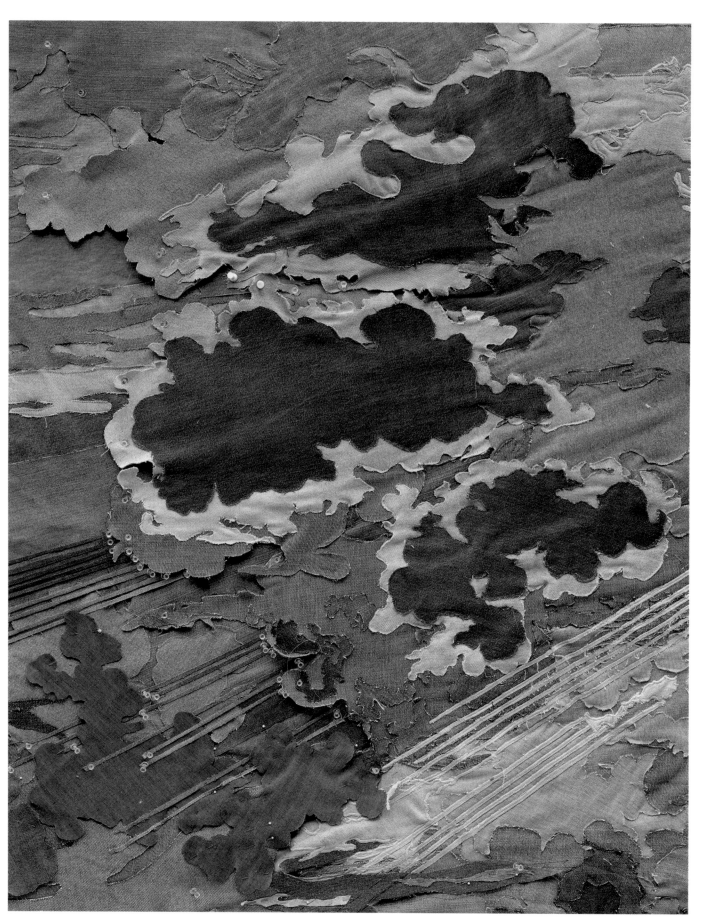

Artist's Acknowledgments

Thank you Jeffrey and Olga for your enthusiastic commitment to this exhibition and publication. It has been a privilege to work with you both and with the dedicated staff at your respective museums who helped bring this ambitious project to life. I also thank the staff at the other institutions for embracing the idea of this exhibition, especially Annie Philbin at the Hammer and Jill Medvedow and Helen Molesworth at the ICA, Boston. Thank you Bill Arning, Susan Griffin, and Helen Molesworth for your thoughtful and insightful writing in the catalogue. Thank you Emmet Byrne and Eric Crosby for your dedication in making a book that reflects my practice, as well as to Meg Smith and Reagan Duplisea for your hard work on the exhibition. I am also grateful to the lenders and supporters whose generosity made this all possible. Special thanks go to my friends who work with me so tirelessly in the studio: Carlos Marques da Cruz, Jessie Henson, Lara Day, Eric Sharff, Glen Baldridge, Brent Birnbaum, and Cary Zimmerman. Additional thanks go to the collaborators and fabricators who dedicate so much expertise to making my ideas a reality, especially Dave Willis, Nellie Davis, Tim Hailand, Ron Amstutz, Dave Nyzio, Robert Valenciano, Encke King, Alex Dodge, Craig Ducote, Alec Gessner, Luther Davis, Louise Hunnicutt, Andrea Detwiler, Kelsey Knight Mohr, Reggie Bielamowicz, Stephen Palma, Damien Jalet, Alexandra Gilbert, David Dawson, Raphaël Coumes-Marquet, François Chat, Shelley Hirsch, Gretchen Bennett, Patrick Evans, Dick Polich, Andrew Pharmer, and everyone at Polich/Tallix, Marty Chafkin and his crew at Perfection Electricks, Pranayama Art, Simon Liu, the Fabric Workshop, David Adamson, Jim Burnard, all the amazing people in my glass studio, Kazue Taguchi, Alberto Cortes, Jarrod Anderson, Schuyler Maclay, Patrick Goth, Michael Carpenter, Everett Williams, Randy Bretzin, Brandon Israels, Anthony Zollo, Tom Morrill, Jayme Thaler, and Megan Biddle. Thank you to the Robert Rauschenberg Residency program for providing me with a month of focused time of solitude to dedicate to the denim sky. It was a dream to work in Bob's studio and to benefit from the glorious surroundings of Captiva.

It's impossible to imagine any of this without the continued support of the galleries that have worked with me from the very beginning. My deep appreciation goes to Barbara Gladstone, Tony Meier, and Stephen Friedman for your friendship, generosity, trust, and continued support. Thank you Carla Chammas, Richard Desroche, and Glenn McMillan for your friendship and for partnering with me for so many years. Thanks also to Richard Edwards and to Marc Foxx, Maureen Paley, Ghislaine Hussenot, and Paul Morris for your support and early commitment to my work. Special thanks to Molly Epstein, David Hubbard, and Rebecca Camacho.

During the process of making this exhibition and while looking back over the expanse of work recorded in these pages, I have often thought of Elaine Dannheisser, who is no longer with us, and the generosity she showed me. Meeting Elaine in 1986 was a life-changing moment, and the studio she provided me for nine years in the basement of the Dannheisser Foundation is where this story begins. I can never thank her enough for the luxury of time and space that basement studio allowed, and there is no way to imagine this moment without her.

Being a collaborator by nature, it's no surprise that over the years many people have influenced and inspired my work. Curiosity and good fortune have led me to many dynamic individuals who have in one way or another informed my practice and changed my life— sometimes directly and at other times through their own work, creations, support, and examples of living. The work I've managed to make over the years has been profoundly influenced by this ever-expanding spectrum of generous spirits, too numerous to name without running the risk of omission, and I am grateful to each and every person who has shared some of their brilliance with me. I express my heartfelt thanks to all my family, friends, and colleagues who add to the fullness of my life through their presence in it. The work I make is dedicated to each of you with my deepest love and gratitude for adding your beauty to this jewel box we share.

Jim Hodges

Index of Titles

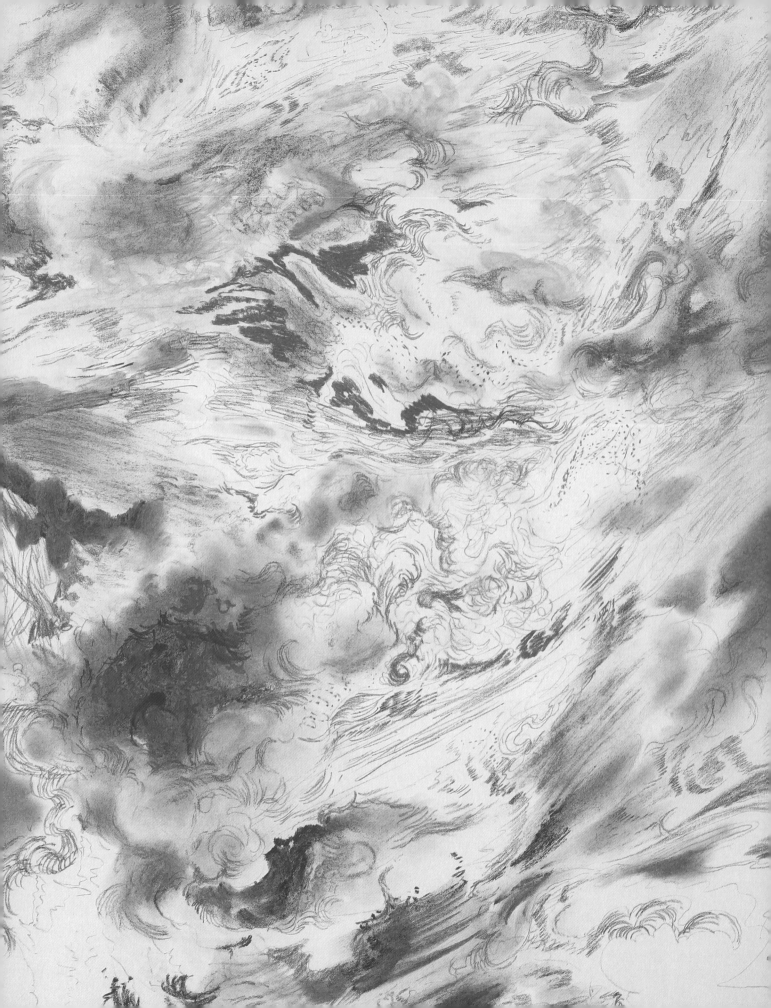

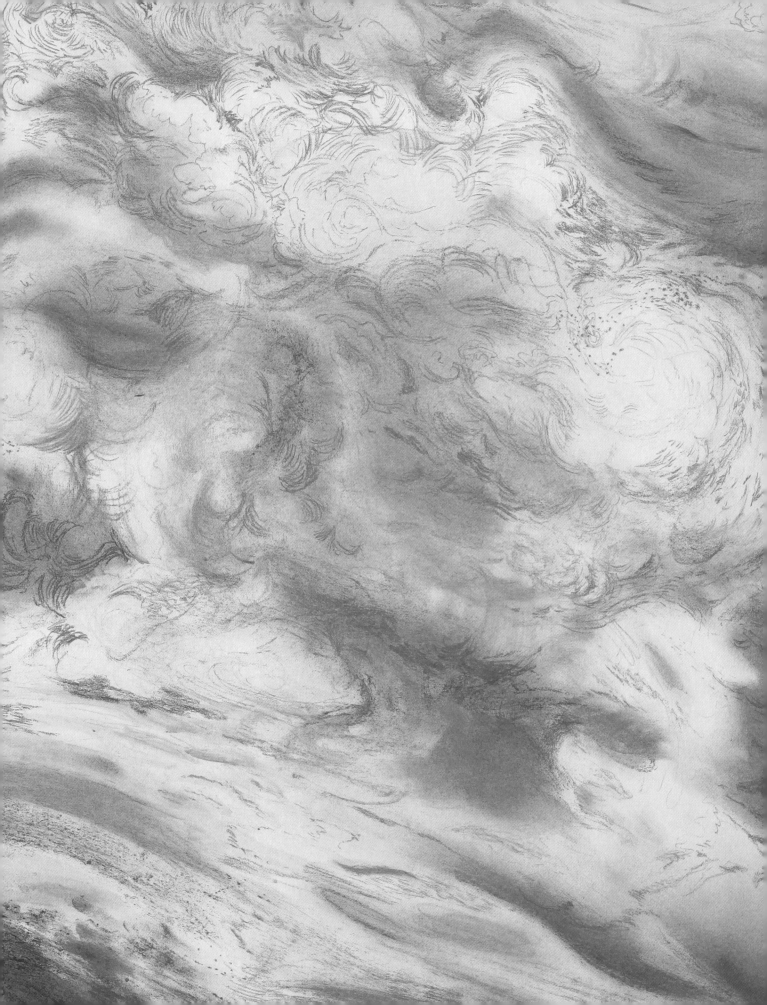